THE
QUESTION
CONCERNING
TECHNOLOGY
AND OTHER
ESSAYS

MARTIN HEIDEGGER

WORKS

Coeditors

J. Glenn Gray
Colorado College

Joan Stambaugh
Hunter College of City University of New York

ALSO AVAILABLE BY MARTIN HEIDEGGER
FROM HARPER PERENNIAL

Basic Writings
The Question Concerning Technology and Other Essays
Being and Time
Discourse on Thinking
Nietzsche
On the Way to Language
What Is Called Thinking?

ALSO BY MARTIN HEIDEGGER

Early Greek Thinking
The End of Philosophy
Hegel's Concept of Experience
Identity and Difference
On Time and Being

THE QUESTION CONCERNING TECHNOLOGY

AND OTHER ESSAYS

MARTIN HEIDEGGER

TRANSLATED AND WITH AN
INTRODUCTION BY WILLIAM LOVITT

HARPER**PERENNIAL** MODERN**THOUGHT**

NEW YORK • LONDON • TORONTO • SYDNEY • NEW DELHI • AUCKLAND

HARPER**PERENNIAL** ✕ MODERN**THOUGHT**

A hardcover edition of this book was published in 1977 by Garland Publishing, Inc.

THE QUESTION CONCERNING TECHNOLOGY AND OTHER ESSAYS. English translation copyright © 1977 by Harper & Row Publishers, Inc. All rights reserved. Printed in the United States of America. No part of this book may be used or reproduced in any manner whatsoever without written permission except in the case of brief quotations embodied in critical articles and reviews. For information address HarperCollins Publishers, 195 Broadway, New York, NY 10007.

HarperCollins books may be purchased for educational, business, or sales promotional use. For information please e-mail the Special Markets Department at SPsales@harpercollins.com.

First Harper paperback published 1977.

First Harper Perennial edition published 1982. Reissued in Harper Perennial Modern Thought in 2013.

Library of Congress Cataloging-in-Publication data is available upon request.

ISBN 978-0-06-229070-0 (reissue)

15 16 17 RRD 8 7 6 5 4 3

Contents

Acknowledgments

I am greatly indebted to Professor J. Glenn Gray for initiating me into the demanding art of translating Heidegger and for our close association over the past two years, in the course of which his meticulous reviewing of my translations for this volume has rescued me from many dangers but left me largely free to build my own way.

To Professor Gray, as well as to Professor Heidegger himself, I owe thanks for access to the unpublished transcripts of two seminars conducted by Heidegger in France: "Séminaire tenu par le Professeur Heidegger sur le *Differenzschrift* de Hegel" and "Séminaire tenu au Thor en septembre 1969 par le Professeur Martin Heidegger." The latter has helped provide the perspective for my Introduction, and both have enhanced my understanding of the five essays included here.

Those on the faculty and staff at California State University, Sacramento, who have helped and supported me in my work on this volume are too numerous to be acknowledged each individually, but I am particularly grateful to my colleague in German, Professor Olaf K. Perfler, for hours of intense conversation in which many secrets of the German idiom were revealed to me.

To Moira Neuterman, who was my typist from the beginning of this project almost to the last, and to Mary Ellyn McGeary,

her successor, are due my special thanks for exceptional skill and care.

Every page of this book owes its final shaping in very large measure to the imaginative and rigorous scrutiny of my wife, Dr. Harriet Brundage Lovitt, who, though trained in another discipline, has now become indisputably a scholar and interpreter of Heidegger in her own right.

WILLIAM LOVITT

Preface

The essays in this book were taken with Heidegger's permission from three different volumes of his works: *Die Technik und die Kehre* (Pfullingen: Günther Neske, 1962); *Holzwege* (Frankfurt: Vittorio Klostermann, 1952); and *Vorträge und Aufsätze* (Pfullingen: Günther Neske, 1954). "The Question Concerning Technology" is contained in both *Die Technik und die Kehre* and *Vorträge und Aufsätze*.

In *Die Technik und die Kehre* the following prefatory note appears regarding the two essays, "The Question Concerning Technology" ("Die Frage nach der Technik") and "The Turning" ("Die Kehre"):

Under the title "Insight into That Which Is," the author gave, on December 1, 1949, in the Club at Bremen, four lectures, which were repeated without alterations in the spring of 1950 (March 25 and 26) at Bühlerhöhe. The titles were "The Thing ["Das Ding"], "Enframing" ["Das Gestell"], "The Danger" ["Die Gefahr"], "The Turning" ["Die Kehre"].*

The first lecture was given in an expanded version on June 6, 1950, before the Bavarian Academy of Fine Arts. (See *Vorträge und Aufsätze*, 1954, pp. 163 ff.)†

* Throughout the translations in this volume parenthetical elements interpolated by me are shown in brackets, while those present in the author's original text are given in parentheses.

† "The Thing" has been published in *Poetry, Language, Thought*, trans. Albert Hofstadter (New York: Harper & Row, 1971), pp. 165–186.

The second lecture was given on November 18, 1955, also in an expanded version, under the title "The Question Concerning Technology," in the series entitled "The Arts in the Technological Age." (See *Vorträge und Aufsätze*, 1954, pp. 13 ff.). The present volume repeats this text unaltered.

The third lecture remains still unpublished.

The fourth lecture, "The Turning," is published here for the first time according to the first unaltered version.

At the end of *Holzwege* Heidegger makes the following observations concerning "The Word of Nietzsche: 'God Is Dead' " ("Nietzsches Wort 'Gott ist tot' ") and "The Age of the World Picture ("Die Zeit des Weltbildes"):

"The Word of Nietzsche: 'God Is Dead' ": The major portions were delivered repeatedly in 1943 for small groups. The content is based upon the Nietzsche lectures that were given between 1936 and 1940 during five semesters at the University of Freiburg im Breisgau. These set themselves the task of understanding Nietzsche's thinking as the consummation of Western metaphysics from out of Being.

"The Age of the World Picture": The lecture was given on June 9, 1938, under the title "The Establishing by Metaphysics of the Modern World Picture," as the last of a series that was arranged by the Society for Aesthetics, Natural Philosophy, and Medicine at Freiburg im Breisgau, and which had as its theme the establishing of the modern world picture. The appendixes were written at the same time but were not delivered.

Of all the essays in *Holzwege* Heidegger remarks:

In the intervening time these pieces have been repeatedly revised and, in some places, clarified. In each case the level of reflection and the structure have remained, and so also, together with these, has the changing use of language.

And at the end of *Vorträge und Aufsätze* Heidegger gives the following notes:

"The Question Concerning Technology" ["Die Frage nach der Technik"]: Lecture held on November 18, 1955, in the main auditorium of the Technische Hochschule, Munich, in the series "The Arts in the Technological Age," arranged by the Bavarian Academy of Fine Arts under the leadership of President Emil Preetorius; published in volume III of the *Yearbook of the Academy* (ed. Clemens Graf Podewils), R. Oldenbourg, Munich, 1954, pp. 70 ff.

"Science and Reflection" ["Wissenschaft und Besinnung"]: Lecture, in its present version given in August, 1954, before a small group, in preparation for the above-mentioned conference in Munich.

WILLIAM LOVITT

Sacramento, California

Introduction

To read Heidegger is to set out on an adventure. The essays in this volume—intriguing, challenging, and often baffling the reader—call him always to abandon all superficial scanning and to enter wholeheartedly into the serious pursuit of thinking.

Every philosopher demands to be read in his own terms. This is especially true of Heidegger. One must not come to him with ready-made labels, although these are very often given. Thus Heidegger is not an "existentialist." He is not concerned centrally or exclusively with man. Rather he is centrally concerned with the relation between man and Being, with man as the *openness* to which and in which Being presences and is known. Heidegger is not a "determinist." He does not believe that man's actions are completely controlled by forces outside him or that man has no effective freedom. To Heidegger man's life does indeed lie under a destining sent from out of Being. But to him that destining can itself call forth a self-orienting response of man that is real and is a true expression of human freedom. Again, Heidegger is not a "mystic." He does not describe or advocate the experiencing of any sort of oneness with an absolute or infinite. For him both man *and* Being are finite, and their relationship never dissolves in sheer oneness. Hence absolute, infinite, or the One can appear to him only as abstractions of man's thinking, and not as realities of essential power.

Heidegger is not a "primitive" or a "romantic." He is not one
who seeks escape from the burdens and responsibilities of con-
temporary life into serenity, either through the re-creating of
some idyllic past or through the exalting of some simple ex-
perience. Finally, Heidegger is not a foe of technology and
science. He neither disdains nor rejects them as though they
were only destructive of human life.

The roots of Heidegger's thinking lie deep in the Western
philosophical tradition. Yet that thinking is unique in many of
its aspects, in its language and in its literary expression. In the
development of his thought Heidegger has been taught chiefly
by the Greeks, by German idealism, by phenomenology, and by
the scholastic theological tradition. These and other elements
have been fused by his genius of sensitivity and intellect into
very individual philosophical expression.

In approaching Heidegger's work the reader must ask not only
what he says, but how he says it. For here form and content are
inextricably united. The perceptive reader will find at hand in
the literary form of each one of these essays many keys to un-
lock its meaning. He will also find the content of each continually
shaping for itself forms admirably suited to its particular ex-
pression.

For Heidegger true thinking is never an activity performed in
abstraction from reality. It is never man's ordering of abstrac-
tions simply in terms of logical connections. Genuine thinking is,
rather, man's most essential manner of being man. Rigorously
demanding and but rarely attained, it manifests the relation be-
tween man and Being. In true thinking man is used by Being,
which needs man as the *openness* that provides the measure and
the bounds for Being's manifesting of itself in whatever is. Man
in thinking is called upon to lend a helping hand to Being. In-
deed, Heidegger can refer to thinking as handcraft. As such,
thinking is man's fundamental responding to whatever offers
itself to him. Informed by recollection, it brings forth into aware-
ness and efficacy whatever is presented to it to know. It is the
caretaking hand that receives and holds and shapes everything
that truly comes to be and to be known. Through that receiving
and shaping of whatever is present, thinking, as belonging to

and needed by Being, cooperates in the handing out of limits and the setting of bounds.

Here Being is in no sense to be thought of as an entity of some sort. Nor is it to be simply identified with any element or aspect or totality of the reality that we ordinarily know. Rather Being is the Being *of* whatever is. Ruling in whatever is, yet transcending and governing the latter in the particularity of its presencing, Being may perhaps best be said to be the ongoing manner in which everything that is, presences; i.e., it is the manner in which, in the lastingness of time, everything encounters man and comes to appearance through the openness that man provides. Hence for Heidegger Being is the very opposite of an abstraction fashioned by human thought. Rather it is "what is given to thinking to think." True thinking should not concern itself with some arcane and hidden meaning, but with "something lying near, that which lies nearest," which, in virtue of that very nearness, man's thinking can readily fail to notice at all (WN 111).* Being rules in whatever is—in the particular and in the far-ranging complexity of the whole—thereby constantly approaching and concerning man. "In the 'is,'" spoken of anything real whatever, " 'Being' is uttered" (T 46).

Being manifests itself continually anew. In keeping with this, thinking can never be for Heidegger a closed system. Rather it is the traveling of a road. Each thinker goes along a way that is peculiarly his own. In a fundamental sense it is the way and not the individual that assembles what is thought, that provides bounds and lets everything stand in relation to everything else.

Heidegger's writings exemplify this centrality of the *way* for

* The five essays in this volume are referred to in the Introduction and in the footnotes with the following symbols:

QT: "The Question Concerning Technology"
T: "The Turning"
WN: "The Word of Nietzsche: 'God Is Dead' "
AWP: "The Age of the World Picture"
SR: "Science and Reflection"

The abbreviation "Pr. Iden." refers to the essay "The Principle of Identity," in Heidegger's *Identity and Difference*, trans. Joan Stambaugh (New York: Harper & Row, 1969), pp. 23 ff. In all quotations from this work slight modifications of the translation have been made. "Sem" refers to the unpublished transcript of the "Séminaire tenu au Thor en septembre 1969 par le Professeur Martin Heidegger."

him. Characteristically he writes essays, excursions of thought. Each of the five essays in the present volume is of this nature. The five center around the theme of technology and the modern age, yet in reading each of them we travel a particular path. Each is distinctive and self-contained, and must be read in and for itself. In each, innumerable details of word and phrase and structure at once both arise from and reveal what Heidegger is saying.

Heidegger is primarily a teacher. He does not wish to travel alone and then report what he has seen, nor does he wish to go as a guide merely pointing out objects along the road. He wishes the reader to accompany him on the way, to participate with him, and even to begin to build his own way through thinking, and not merely to hear about what it is or should be.

Being approaches and concerns us in whatever is, yet Being characteristically conceals itself even in so doing. Hence thinking cannot readily find it out. The way through thinking to that place where man can open himself to the ruling of Being is difficult. It leads often through unfamiliar and even perilous country. We modern men are far from that open clearing. We are trapped and blinded by a mode of thought that insists on grasping reality through imposed conceptual structures. We cannot and will not come to that place where we can let what is, *be.* We do not perceive that the way by which true thinking proceeds can itself prove to be the source of that unity which we, often frenziedly, strive after in our philosophy, in our science, and in every aspect of our activity.

In order to prepare us truly to think, Heidegger, in keeping with the best speculative tradition, often carries us beyond our facile conceiving to seek the ground of our thinking. But he does more. He confronts us repeatedly with an abyss. For he strives to induce us to leap to new ground, to think in fresh ways. Hence, again and again, as we travel with him through these essays some precipice will confront us. One must often clamber through dark sayings and scale absurdities if one would follow on these paths. This is a daunting prospect. Yet Heidegger has hope for those who go with him. For the ground he seeks to achieve belongs fundamentally to man as man. Hence he calls each of us who reads to come and find it out.

Heidegger's writing is intrinsically sequential, always moving in some particular direction. Therefore one must discover meaning as one moves forward. One must experience the turnings of these paths just where they happen. No element can properly be excerpted and considered in isolation, and none can properly be left out of account; for each element plays its part in the forward movement. Words and sentences must always be read in context if one hopes to apprehend the meaning that they bear.

In this building forward of thinking there is always a pattern. Sometimes it is closely and intricately woven, as in "The Turning." Sometimes, as in "The Question Concerning Technology" or "The Word of Nietzsche: 'God Is Dead,' " it is far-ranging, involving long, complex discussions whose interconnections can be hard to discern. At times bewilderment may seize even the thoughtful reader. Yet he must remember that, on each particular path, Heidegger himself never loses his way and never forgets in what direction he is going. He never abandons the sequence of his themes, never forgets what he has previously said, and never forsakes the pattern of his work. Everything fits, often with great precision, into that pattern. For Heidegger is always working out of the wholeness provided by the delimiting way pursued.

Heidegger must build and is content to build finitely. However intricate the relationships to be expressed, however manifold the given meaning, he must set forth one facet at a time. There is tremendous rigor in his work. Therefore he makes great demands on those who follow him. Yet the reader who perseveres may hope to experience the excitement of discovery as he finds himself intimately engaged in the pursuit of thinking.

Because Heidegger is eager that the reader should follow him and sensible that the way is hard, again and again he speaks so as to evoke a response that will carry his companion forward. Often at some key point he will ask a question, seeking to force the reader to come to grips with what is being said, to think, to reply, and then to listen for an answer that will send the discussion forward: "Does this mean that man, for better or worse, is helplessly delivered over to technology?" (T 37). "In what does the essence of modern science lie?" (AWP 117). "What is hap-

pening to Being?" (WN 104). When we come upon such questions we must listen alertly. A question may be answered in an immediately ensuing sentence, or its answer may emerge only after an involved exposition. But an answer will come. And it will be important to the whole discussion.

Sometimes Heidegger speaks with sharp emphasis, to indicate that a point *must* be heard: "never can it be sufficiently stressed . . ." (SR 160), "a confrontation with Christendom is absolutely not in any way . . ." (WN 64), "never does the Being of that which is consist . . ." (AWP 130). Such words demand our closest attention.

Again, Heidegger has many devices for catching the reader up and jolting him from his habitual frame of mind. "But where have we strayed to?" he will ask, after a sequence of thought has drawn to an expected conclusion (QT 12). Or he will interject some sharp assertion: "for centuries we have acted as though the doctrine of the four causes had fallen from heaven as a truth as clear as daylight" (QT 6)—and he thereby calls in question our unconsidered assumptions. At one point he will echo what we are thinking, only to amplify it with a word that moves it into another dimension: Yes, the instrumental definition of technology is "correct"; it is "indeed so uncannily correct"—and the word "uncanny," even if forgotten, hangs over the portrayal of the skeletal power into whose domain we look in words that eventually follow (QT 5, 19 ff.). At another point he will thrust at the foundations of our thinking with a quick reversal of thought, hoping to dislodge us and bring us to new ground: "Modern physics is called mathematical because, in a remarkable way, it makes use of a quite specific mathematics. But it can proceed mathematically in this way only because, in a deeper sense, it is already itself mathematical" (AWP 118)—and we are compelled to ask, What is he saying with this puzzling assertion?

Sometimes such thrusts are all but beyond our comprehension: "The essence of technology is by no means anything technological" (QT 4); "Physics as physics can make no assertions about physics" (SR 176). Such words may even, when heard superficially, sound like mere cleverness or arrogant nonsense. More seriously confronted, such statements may fairly halt the reader in dismay and exasperation. "I know this man must be

wrong," he may protest, "if he says that the essence of technology has nothing to do with technology. He can't be saying that. But what is he saying? I am willing to do as I was asked, to follow, to question, to build a way. But what can I do with an opaque statement like that? 'The essence of technology is by no means anything technological'!" Yet in such opaque statements the meaning of the way is often most deeply lodged. Again the reader has been forced to ask, to look for the ranges of meaning within seemingly familiar words. Never should it be thought that at such junctures Heidegger is merely playing with words. For him, rather, language plays with us. The swiftly turned phrase is not a roadblock. It is another, if enigmatic, signpost. It is a statement opaque only by reason of fullness, intended to guide the reader forward in search of the meaning that it bodies forth.

Access to the way to which Heidegger wishes to introduce us, the way to thinking and to a free relationship with Being, lies through language. For thinking is man's according with and responding to Being, and "language is the primal dimension" in which that responsive corresponding takes place (T 41).

Heidegger has a poet's ear for language and often writes in a poetic way. For him the proper function of words is not to stand for, to signify. Rather, words point to something beyond themselves. They are translucent bearers of meaning. To name a thing is to summon it, to call it toward one. Heidegger's words are rich in connotation. Once inclined to invent words to carry needed meanings, he has more recently become concerned with the rehabilitation of language, with the restoring of its original, now obliterated force.

Repeatedly he tells us of the ancient and fundamental meanings of words, carefully setting forth nuances or tracing historical changes that took place as thought passed from one language to another. Our word "technology," we learn, rests back upon the Greek *technē*. Our "cause," from the Latin *causa*, translates the Greek *aition*, which has a very different meaning. "Essence," "theory," "reflection," the "real"—word after word is searched out to its roots and defined and used according to its latent meanings. In all this Heidegger is of course no mere antiquarian.

He has said that language is the house of Being. The reciprocal relation between Being and man is fulfilled through language. Hence to seek out what language *is*, through discovering what was spoken in it when it first arose and what has been and can be heard in it thereafter, is in fact to seek out that relationship. It is to endeavor to place oneself where the utterance of Being may be heard and expressed.

Heidegger chooses—he himself might say "discovers"—words that are as expressive as possible. Often he defines them with great precision. Sometimes he points out facets of meaning that are clearly present in a German word, as in *verschulden* (to be responsible or indebted), *wirken* (to work or bring about), or *besinnen* (to reflect; from *sinnen*, to scent out or sense) QT 7; SR 159, 180). Sometimes he presses a word forward to encompass new meanings that he hears within it, as with *Bestand* (stock, now become standing-reserve), or *Gestell* (frame, now become Enframing), or *Geschick* (fate, now become the self-adaptive destining of Being) (QT 17, 19, 24; T 37–38).

Heidegger's use of words is very often peculiar to himself. It is characteristically demanding and often strange to our thought. The words that meet us in his essays are not intended to mystify his readers or to attract devotees who will facilely repeat esoteric speech. Yet Heidegger is acutely aware that his words may well be seized upon and used in just such ways: we must, he says, keep from "hastily recasting the language of the thinker in the coin of a terminology," immediately repeating some new and impressive word "instead of devoting all our efforts to thinking through what has been said."[1]

Since words are in no sense abstractions, but rather show the Being of that of which they speak, Heidegger can and does employ them variously so as to bring out particular aspects of their meaning at particular points. But he uses them consistently according to his understanding of the meaning that they carry; and nuances that fall away at any given time nevertheless always remain alive and must be continually heard. We must read Heidegger's definitions and study his ways of using words with care. For these alone, and not our own preconceptions and in-grained notions of meaning, will tell us what words like "truth"

1. "The Onto-theo-logical Constitution of Metaphysics," in *Identity and Difference*, pp. 73–74.

or "essence" or "technology" or "metaphysics" are conveying here.

In this situation the non-German reader is of course at a peculiar disadvantage. A translator is inexorably forced to choose among many aspects of connotation for word upon word and to recast sentence after sentence into a very different mold. Parallel words and even rather lengthy phrases have sometimes been used here to render single German words in order to display adequately their breadth of meaning. Every attempt has been made to maintain consistency in the translation of given words and to mirror as faithfully as possible the inner emphases of construction resident in the German text. Yet despite all such efforts, the evocative power of the original word, as often of the original stress and turn of phrase, can scarcely be preserved for the English-speaking reader. In these essays, footnotes and citations of the original German have been provided to help the reader at crucial points. The essays have been translated with care, and it is hoped that much of Heidegger's meaning lies within these pages, even though the fullness of the original German must be lacking. It goes without saying that anyone who wishes to know Heidegger's work well must read and study the German text.

When all this has been said, it must be added that the first problem of the reader of this English volume is apt to lie, not in the fact that he is reading Heidegger in translation, but in the fact that in reading Heidegger he is encountering words that he must learn to let come to him with fresh meaning. Definition and context remain to give considerable aid. Moreover, even in the language of translation the expressiveness of many of Heidegger's words can reach us with genuine power. If we can learn, with whatever difficulty, to think truth as unconcealment or essence as the manner in which something endures in coming to presence; if we can let words like "technology" or "destining" or "danger" sound with the meaning Heidegger intends, then something of that power will be present for us.

Very often Heidegger uses words that point to realities or relations beyond those of which they immediately speak. On occasion a pair of words will be found, each of which, if we are truly listening, more or less clearly suggests and reenforces the other. Words like "unconcealing" and "concealing," "pres-

encing" and "withdrawing," are intended variously to act in this way. More importantly, such words, like many others, also have a two-wayness that permits them to point at once to Being and to man. Thus "presencing" and "revealing" speak simultaneously of a moving into presence or unconcealment and of one toward whom that movement takes place, while "concealing" and "withdrawing" tell of a movement away and remind of one who is being deprived of that which might be present or revealed.

Often this breadth of expressiveness possessed by Heidegger's language can help the attentive reader to make his way through difficult passages. In "The Turning," for example, throughout the especially difficult sequence in which we are told of what comes to pass in the turning of the danger that is the essence of technology, almost no overt allusion is made to the role of man (T 41–47). That role is set forth in the opening pages of the essay (pp. 36–41), but it could easily be let slip from view as the reader follows the intricate discussion. Throughout that very discussion, however, a whole series of words—"light," "in-flashing," "glance," "insight"—appears. And these can serve to remind one of a lighting up that both shines forth and is seen. These words speak specifically of what happens in the turning within Being itself. But they also sustain for us, if but hiddenly, the memory of man's necessary involvement in what is coming to pass, until the human role is again taken up and brought forward (T 47).

Heidegger makes particular use of prepositions and adverbs, standing either alone or as components of verbs, to speak thus of fundamental relations, even when those relations themselves are not under discussion. Such words as "into," "from out of," "toward," "forth," "out," and "hither" will be met with frequently in these pages. They should be carefully noted, for they can embody with peculiar force the apprehension of reality out of which Heidegger is speaking.

Poet that he is, Heidegger often speaks the same words again and again and again. Repetition gives emphasis. A word introduced at one point and then taken up only later into full discussion gains in richness through that early introduction, for its presence threads all but unnoticed through the pattern of intervening thought. The same phrases are used now, then used again;

yet they are not really the same. The later phrase is always fuller in meaning by reason of all that has been said since its words were first spoken. This cumulative power of repetition can be seen strikingly when Heidegger returns at the close of an essay to words and themes that sound toward its beginning (cf. T, WN). Such words speak with new eloquence when we find them thus at the conclusion of an arduous path.

Above all, the reader must not grow deaf to Heidegger's words; he must not let their continual repetition or their appearance in all but identical phrases lull him into gliding effortlessly on, oblivious to the subtle shifts and gatherings of meaning that are constantly taking place.

A number of terms that we have used thus far point to funda-mental characteristics in Heidegger's thinking that must become integral to one's own outlook if one would enter into and gain some understanding of his work. We have spoken of the "way" that "assembles" and relates things to one another. We have alluded to "wholeness," to "pattern," to the expressing of facets of thought in finite "sequence." We have discussed the "two-wayness" of particular words, and the "richness of connotation" inherent in Heidegger's language generally. All these are but particular manifestations of a thinking that is essentially inclu-sive and essentially rooted in the discerning of relations. On the ground where Heidegger moves, reality does not appear as com-posed of discrete elements or aspects that are linked by cause and effect connections. For Heidegger thinking is not primarily deductive, although he often shows himself to be a master at elucidating the implications of a statement or thought. For him the primary question to be asked is always *how* and never *why*. His is descriptive and evocative thinking, in the sense that it tells us of what *is* and of what is taking place, and seeks to bring it before us. The reality described is manifold. Aspects impinge upon one another. Movements and interactions are what must fundamentally be recounted.

But these interrelations always involve some intricate unity. The inherence of something in something else or the manifesta-tion in the present of what has long been present, the sameness of various and even opposite manifestations or the oneness of

subtly diverse occurrences—such things are here to be met with
at every turn.

Once more the reader may be tempted to say, "What non-
sense!" One should be wary, however, of leaping hastily to any
such conclusion. So pervasively does unitive, relational thinking
inform every aspect of Heidegger's work that one who dismissed
such thinking out of hand would risk extinguishing for himself
any hope of understanding what Heidegger is saying. The reader
must in fact become so alert to inclusive complexities of thought
that he will be sensitive to their presence even when they do not
manifestly appear.

Heidegger, as is typical of him, is concerned in the essays
before us with the understanding of Western history and West-
ern thought. We ordinarily think of the modern age, "the age of
science and technology," as one that began a few centuries ago
and that is unquestionably new. Heidegger too can speak of a
new departure in the modern age; yet for him to say this is to
point at the same time to the coming into overt expression of a
tendency whose true origin lies decisively if hiddenly in Greek
antiquity.

The fundamental Greek experience of reality was, Heidegger
believes, one in which men were immediately responsive to what-
ever was presencing to them. They openly received whatever
spontaneously met them (AWP 131).

For the Greeks the coming into the "present" out of the "not-
present" was *poisēsis* (QT 10). This "bringing forth" was mani-
fest first of all in *physis*, that presencing wherein the bursting-
forth arose from within the thing itself. *Technē* was also a form
of this bringing forth, but one in which the bursting-forth lay
not in the thing itself but in another. In *technē*, through art and
handcraft, man participated in conjunction with other contribut-
ing elements—with "matter," "aspect," and "circumscribing
bounds"—in the bringing forth of a thing into being (QT 7-8).
Moreover the arts of the mind were called *technē* also (QT 13).

Greek man openly received and made known that which
offered itself to him. Yet nevertheless he tended in the face of
the onrush of the revealing of Being in all that met him to seek
to master it. It is just this tendency toward mastery that shows
itself in Greek philosophy. Philosophy sprang from the funda-

mental Greek experience of reality. The philosopher wondered at the presencing of things and, wondering, fixed upon them. (That, Heidegger remarks, is why Thales tumbled into a well! [Sem 11]). The philosopher sought to grasp and consider reality, to discover whatever might be permanent within it, so as to know what it truly was. But precisely in so doing he distanced himself from Being, which was manifesting itself in the presencing of all particular beings. For in his seeking, he reached out not simply to receive with openness, but also to control. Here, to Heidegger's thinking, lies the real origin of the modern technological age. *Technē* was a skilled and thorough knowing that disclosed, that was, as such, a mode of bringing forth into presencing, a mode of revealing. Philosophy, as a thinking that considered reality and therewith made it manifest in its Being, was *technē* also in its own way. In the Western tradition, the metaphysical thinking born of that philosophy carried forward the expression of *technē* into modern times.

Heidegger finds Christian theology to be wholly dominated by metaphysics during the centuries after the beginning of the Christian era. In the medieval period men were preoccupied with the question of how they might be in right relationship with God, how they might be assured of salvation, i.e., how they might find enduring security. At the close of that period the overt theological undergirding of these questions fell away, but the quest for security remained. Man needed a new basis for his self-assurance, his assurance of rightness. The work of Descartes, itself an expression of the shift in men's outlook that had already taken place, set forth that basis in philosophical terms (WN 88–90).

In the *ego cogito* [*ergo*] *sum* of Descartes, man found his self-certainty *within himself*. Man's thinking (*cogitare*), which Heidegger says was also a "driving together" (*co-agitare*), was found to contain within itself the needed sureness. Man could *represent* reality to himself, that is, he could set it up over against himself, as it *appeared* to him, as an *object* of thought. In so doing, he felt assured at once of his own existence and of the existence of the reality thus conceived (AWP 131).

It is in this that Heidegger sees the focal point for the beginning of the modern age. The tendency present in metaphysics from its inception here begins to come to fulfillment. Man, once

concerned to discover and decisively to behold the truly real, now finds himself certain of himself; and he takes himself, in that self-certainty, to be more and more the determining center of reality.

This stance of man in the midst of all that is bespeaks the fact that man has become "subject." The phenomenon of the "subject" is itself not new. It was present among the Greeks. But there subject, *hypokeimenon*, that-which-lies-before (for the Greeks, that which looms up, e.g., an island or mountain), meant the reality that confronted man in the power of its presence (cf. Sem. 7). With Descartes at the beginning of the modern period, this meaning of *hypokeimenon*, subject, was decisively transformed.

Descartes fixed his attention not on a reality beyond himself, but precisely on that which was present *as* and *within* his own consciousness. At this point human self-consciousness became subject *par excellence*, and everything that had the character of subject—of that-which-lies-before—came to find the locus and manner of its being precisely in that self-consciousness, i.e., in the unity of thinking and being that was established by Descartes in his *ego cogito* [*ergo*] *sum*, through which man was continually seeking to make himself secure. Here man became what he has been increasingly throughout our period. He became subject, the self-conscious shaper and guarantor of all that comes to him from beyond himself (AWP 147 ff.).

Modern science is for Heidegger a work of man as subject in this sense. Modern man as scientist, through the prescribed procedures of experiment, inquires of nature to learn more and more about it. But in so doing he does not relate himself to nature as the Greek related himself to the multitudinous presencing of everything that met him spontaneously at every turn. He does not relate to nature in the openness of immediate response. For the scientist's "nature" is in fact, Heidegger says, a human construction. Science strikingly manifests the way in which modern man as subject *represents* reality. The modern scientist does not let things presence as they are in themselves. He arrests them, objectifies them, sets them over against himself, precisely by representing them to himself in a particular way. Modern theory, Heidegger says, is an "entrapping and securing refining

of the real" (SR 167). Reality as "nature" is represented as a manifold of cause and effect coherences. So represented, nature becomes amenable to experiment. But this does not happen simply because nature intrinsically *is* of this character; rather it happens, Heidegger avers, specifically because man himself *represents* nature as of this character and then grasps and investigates it according to methods that, not surprisingly, fit perfectly the reality so conceived.

Here, science (*Wissenschaft*) means any discipline or branch of knowledge. In speaking of science, Heidegger can refer as often to the discipline of history, with its representing of historical events as causal sequences, as he does to physics and its related disciplines with their respective ways of representing nature.

The intricate system of techniques and apparatus that we call modern technology belongs essentially to this same realm. In it contemporary man's inveterate drive to master whatever confronts him is plain for all to see. Technology treats everything with "objectivity." The modern technologist is regularly expected, and expects himself, to be able to impose order on all data, to "process" every sort of entity, nonhuman and human alike, and to devise solutions for every kind of problem. He is forever getting things under control.

Heidegger's portrayal of the beginnings of the modern age and of its characteristic phenomena often so sharply stresses the self-exalting and restrictive role of man that his thinking can seem not unlike that of those who unconditionally condemn "Cartesian abstraction" and decry the pernicious tendency of science and technology to cut man off from vital awareness of the real (AWP 118 ff., SR 169 ff.). But for Heidegger that simple stress never stands alone. Its seeming simplicity in fact masks a concomitant hidden truth that actually belies any such simplicity. *Always* for Heidegger—even when he most vividly describes how man as subject has brought the modern age into being and how he now shapes and dominates its phenomena—the primal relationship between man and Being lies as near at hand and demands as much to be taken into account as it does when he speaks of the ancient Greeks and of their immediate responsiveness to the ruling of Being in whatever was presencing

to them. However extensively Heidegger may speak about man, his thinking and his doing, he never loses sight of the truth that "in the 'is' " of everything that is, " 'Being' is uttered."

Modern technology, like ancient *technē*, from which it springs —and like science and metaphysics, which are essentially one with it—is a mode of revealing. Being, through its manner of ruling in all that is, is manifesting itself within it.

That which has come to fruition in Descartes and in all of us, his modern successors, not only took its rise long before in a temporal sense. It also took its rise long in advance from beyond man (QT 14). For in its fulfillment Heidegger sees the holding-sway of a "destining" or "sending forth" of Being, that has come upon man and molded him and his world (QT 24).

In the time of the Greeks the philosophers did not simply impose categories like *idea* upon reality so as to make it accessible to themselves in the way they wished. Rather, that which everywhere met them in its Being so offered itself as to call forth their thought in just those ways. In the same manner, in the modern "Cartesian" scientific age man does not merely impose his own construction upon reality. He does indeed represent reality to himself, refusing to let things emerge as they are. He does forever catch reality up in a conceptual system and find that he must fix it thus before he can see it at all. But man does this *both* as his own work *and* because the revealing now holding sway at once in all that is and in himself brings it about that he should do so. This simultaneous juxtaposing of the destining of Being and the doing of man is absolutely fundamental for Heidegger's thinking.

We ordinarily understand modern technology as having arisen subsequently to science and as subordinate to it. We consider it to be a phenomenon brought about through scientific advance. Heidegger points out that, on the contrary, modern science and machine technology are mutually dependent upon one another. More importantly, technology, in its essence, precedes and is more fundamental than science. This is no mere statement concerning chronological priority, for the "essence of technology" is the very mode of Being's revealing of itself that is holding sway in all phenomena of the modern age. Man's arrogation to himself of the role of subject in philosophy; his objectifying of

nature, life, and history in dealing with them in the sciences; and his calculating and cataloguing and disposing of all manner of things through machine technology—all these alike are expressions of that essence and of that revealing. Technology, so understood, is in no sense an instrument of man's making or in his control. It is rather that phenomenon, ruled from out of Being itself, that is centrally determining all of Western history.

Modern technology in its essence is a "challenging revealing." It involves a contending with everything that is. For it "sets upon" everything, imposing upon it a demand that seizes and requisitions it for use. Under the dominion of this challenging revealing, nothing is allowed to appear as it is in itself.

The rule of such a way of revealing is seen when *man* becomes subject, when from out of his consciousness he assumes dominion over everything outside himself, when he represents and objectifies and, in objectifying, begins to take control over everything. It comes to its fulfillment when, as is increasingly the case in our time, things are not even regarded as objects, because their only important quality has become their readiness for use. Today all things are being swept together into a vast network in which their only meaning lies in their being available to serve some end that will itself also be directed toward getting everything under control. Heidegger calls this fundamentally undifferentiated supply of the available the "standing-reserve" (QT 17).

The ordering of everything as standing-reserve, like objectifying itself, is once more a manifestation of a destining. It is first of all the bringing to fruition of a way of appearing that is given to everything that is, from out of Being itself. But as such, it does not, of course, take place simply outside of or apart from man. The same destining that gives this mode of appearing to whatever is also rules in him, provoking him to order everything in just this way, as standing-reserve. The challenging claim that now summons man forth, that "gathers man thither to order the self-revealing as standing-reserve," Heidegger calls *das Ge-stell* (Enframing) (QT 19). As "Enframing," that claim ceaselessly brings both men and things to take their places in the stark configuration that is being wrought out through ordering for use.

This challenging summons, ruling in modern technology, is

a mode of Being's revealing of itself. Yet in it, also, Being withdraws, so that the summons that thus "enframes" is all but devoid of Being as empowering to be. Compelled by its claim, ordered and orderer alike are denuded. All that is and man himself are gripped in a structuring that exhibits a mere skeleton of their Being, of the way in which they intrinsically are. In all this the essence of technology rules.

The dominion of Enframing as the essence of modern technology and the concomitant presence of the standing-reserve are most clearly seen in the realm of machine technology, where no object has significance in itself and where the "orderability" of everything, from energy and statistics to machines and persons, is all-important. It can be found also, Heidegger says, in the sphere of science, namely, in modern physics. There again, the object, otherwise the hallmark of the sciences, has disappeared. In its stead the relation between subject and object comes to the fore and "becomes a standing-reserve" to be controlled (SR 173).

In metaphysics too the rule of the essence of technology appears. Perhaps rather surprisingly, Heidegger finds in Nietzsche the culmination of the movement of modern metaphysics begun in Descartes and carried forward by subsequent thinkers. Standing within the modern metaphysical outlook, Nietzsche, in asking concerning the reality of the real, found the will to be fundamentally determinative. The self-consciousness of the subject, which Descartes established as normative, is raised in Nietzsche to full metaphysical expression. Self-consciousness is here the self-consciousness of the will willing itself. The will to power, fundamental for Nietzsche, is no mere human willing. It is the mode of Being now ruling in everything that is, which must find accomplishment through man (WN 96–97).

In striving ever forward in and to greater power, the will to power must—indeed in the most extreme manner—act in the very way that Heidegger finds characteristic of metaphysical thinking as such. In positing for itself the preservation-enhancement conditions of life that attend its own necessary advance, the will to power cannot and does not receive what comes to it and leave it to its spontaneously flowing presencing. Rather it must arrest it, delimit it, make it into a constant reserve, into that on the basis of which it itself moves forward (WN 83 ff.).

The establishing of the conditions necessary for the will to power's willing of itself is thought of by Nietzsche as value-positing.

Nietzsche designates as "nihilism" the devaluing of the transcendent values imposed on man by traditional metaphysical thinking; and he calls "completed nihilism" the "revaluing," accomplished in his own thinking, that at once guards against a slipping back into those former values and provides an affirmative basis for the positing of new values. For Heidegger, Nietzsche actually displays in his "completed nihilism" a yet more extreme form of nihilism whose character he does not himself suspect. Despite his desire to overcome metaphysics, Nietzsche stands squarely in the metaphysical tradition, for he continues to think in terms of valuing. He can indeed take Being to be a value, a condition posited in the will to power for its own preservation and enhancement. The Being of everything, far from being a revealing presencing to be freely received, becomes a determinative aim in view that must lead always to some further end. Here self-consciousness—which as subject sets itself and everything present to it before itself, that it may make itself secure—comes, in the mode of the will to power, to take disposal, in its value-positing, even over Being.

It is just this thinking that is for Heidegger in the highest degree "nihilistic." In it Being has been degraded into a value (cf. WN 102–104); Being cannot be Being; i.e., the power of everything whatever to presence directly in its Being has been destroyed by a thinking that would find every aspect and characteristic of reality to be at the disposal and service of the final expression of the subjectness of the subject as self-securing self-consciousness—the will to power. Nietzsche's anticipated "overman," embodying in himself the determining power once supposed to lie in the realm of transcendent values, would actualize this subjectness.

In this way Heidegger sees in Nietzsche's philosophy the completion and consummation of metaphysics, and that must mean also the consummation of the essence of technology. Nietzsche's overman might be said to be technological man *par excellence*. The name "overman" does not designate an individual. Rather it names that humanity which, as modern humanity, is now be-

ginning to enter upon the consummation of the modern age (cf. WN 96). Overman would consciously will and would have dominion and disposal over all things as the one fully manifesting the will to power.

Once again the thinking that degrades Being and in effect destroys it as Being is not a merely human doing. Indeed, Heidegger sees in the fact that Nietzsche's work, for all its bold newness, only brings to culmination tendencies present in metaphysics from its beginning, striking evidence that the obstructing, yes, the very absence, of Being in its manifestation in Western thinking derives from Being itself. Precisely as with the challenging revealing of Enframing, the power that, even in his highest metaphysical thinking, thrusts man forward as value-positing and hence fundamentally as "ordering for use"—and that simultaneously brings it about that nothing that is can appear as it is in itself, and that man must conceive and determine everything in this controlling way—is the very destining of Being itself that is holding sway more and more pervasively in the modern age.

Heidegger sees every aspect of contemporary life, not only machine technology and science but also art, religion, and culture understood as the pursuit of the highest goods, as exhibiting clear marks of the ruling essence of technology that holds sway in the dominion of man as self-conscious, representing subject. Everywhere is to be found the juxtaposing of subject and object and the reliance on the experience and the evaluating judgment of the subject as decisive. The presencing of everything that is has been cut at its roots. Men speak, significantly enough, of a "world picture" or "world view." Only in the modern age could they speak so. For the phrase "world picture" means just this: that what is, in its entirety—i.e., the real in its every aspect and element—now is "taken in such a way that it first *is in being* and *only* is in being to the extent that it is set up by man, who represents and sets forth" (AWP 129–130, italics mine). Were contemporary man seriously to become aware of this character of his life and of his thinking, he might, with the modern physicist, well say, "It seems as though man everywhere and always encounters only himself" (QT 27).

Such a judgment would, however, be a delusion. Man in fact *"can never* encounter only himself" (QT 27). For man is summoned, claimed, in the challenging revealing of Enframing even when he knows it not, even when he thinks himself most alone or most dreams of mastering his world. Man's obliviousness to that claim is itself a manifestation of the rule of Enframing. So completely has he been drawn into that dominion that he is actually cut off from awareness of his own essence. For he is estranged from Being even while Being, in the self-withdrawnness of its challenging self-revealing, is so encountering him that he is in fact being constrained to bring about the dominion of that revealing—i.e., is being claimed by it. For this reason, man does not know himself as the one who is being brought into relation to Being; that is, he does not know himself as man. Ruled in this way, man today, despite what seems true to him, *never* encounters himself, i.e., his essence.

Man needs above all in our age to know himself as the one who *is* so claimed. The challenging summons of Enframing "sends into a way of revealing" (QT 24). So long as man does not know this, he cannot know himself; nor can he know himself in relation to his world. As a consequence he becomes trapped in one of two attitudes, both equally vain: either he fancies that he can in fact master technology and can by technological means— by analyzing and calculating and ordering—control all aspects of his life; or he recoils at the inexorable and dehumanizing control that technology is gaining over him, rejects it as the work of the devil, and strives to discover for himself some other way of life apart from it. What man truly needs is to know the destining to which he belongs and to know it *as* a destining, as the disposing power that governs all phenomena in this technological age.

A destining of Being is never a blind fate that simply compels man from beyond himself. It is, rather, an opening way in which man is called upon to move to bring about that which is taking place. For man to know himself as the one so called upon is for him to be free. For Heidegger freedom is not a matter of man's willing or not willing particular things. Freedom is man's opening himself—his submitting himself in attentive awareness—to the

summons addressed to him and to the way on which he is already
being sent. It is to apprehend and accept the dominion of Being
already holding sway, and so to be "taken into a freeing claim"
(QT 26).

The truth of modern man's situation must become known to
him. This does not mean at all that man can be presented with
some "truth" that, if it were once brought to his attention, he
might then grasp, assent to, and act upon. For Heidegger such
"truth," the corresponding of a statement with a situation, would
be mere correctness. *Truth* is unconcealment. That is not to say
that it is something immediately accessible. *Unconcealment is
simultaneously concealment.* Unconcealment, truth, is never
nakedly present to be immediately known. The truth of modern
man's situation is a revealing that comes upon him, but it comes
upon him veiled.

Enframing is a mode of revealing, a destining of Being. Yet
precisely under its dominion nothing whatever, including man
himself, appears as it intrinsically is; the truth of its Being re-
mains concealed. Everything exists and appears as though it
were of man's making.

Because Enframing, as a revealing of Being, rules in this way,
it is a danger beyond any danger that man otherwise knows. The
essence of Enframing, its manner of coming to presence, "is that
setting-upon gathered into itself which entraps the truth of its
own coming to presence with oblivion. This entrapping disguises
itself, in that it develops into the setting in order of everything
that presences as standing-reserve, establishes itself in the
standing-reserve, and rules as the standing-reserve" (T 37–38).
In this "oblivion" that blocks the self-manifesting of Being, man's
danger lies. The danger is real that every other way of revealing
will be driven out and that man will lose his true relation to
himself and to all else. Language, the primal mode through which
man may experience and think and know whatever is, in its
Being, may be bereft of its power, to become only a mere instru-
ment of information. And man may be divested of his true
essence and become one who "manufactures himself" (Sem. 34;
cf. QT 26 ff.). Man himself, through whom the ordering char-
acteristic of Enframing takes place, may even be wholly sucked
up into the standing-reserve and may come to exist not as the

"openness-for-*Being*" ("Da-*sein*"), but as a merely self-conscious
being knowing himself only as an instrument ready for use.[2]

Yet this stark eventuality need not befall man. For Enframing
necessarily and intrinsically rules not merely as danger but also
as that which saves. These are not two discrete aspects of its
holding sway. The danger "is the saving power" (T 42). En-
framing is a revealing. It manifests first of all the withdrawnness
of Being. It estranges man from Being. Yet it remains a revealing.
In it Being is still confronting man. Therefore Enframing bears
within itself simultaneously with its endangering of man that
other possibility, that man will be delivered from his estrange-
ment and that it will be granted to him to come into an essential
relationship with Being, recollectingly to receive what is present
to him in all that is and thoughtfully to guard it (QT 32 ff.).

In this twofoldness of Enframing as danger and saving power,
and not in any merely human effort, lies the possibility that
technology may be overcome. This does not mean that technology
will be done away with. It means, rather, that technology will be
surmounted from within itself, in such a way as to be restored
to and fulfilled in its own essence. The unconcealment, the truth,
concealed in the rule of technology will flash forth in that very
concealing. Being will reveal itself in the very ongoing of tech-
nology, precisely in that flashing. But not without man. For man
is needed for this as for every revealing of Being. Man must come
to that place where, through language, through thinking, this
revealing may come to pass. Yet man cannot bring it about, and
he cannot know when it will take place (T 39, 41–42).

What comes to pass happens suddenly. Heidegger speaks of
it as a "turning." It is a turning within Enframing, within the
essence of technology as the danger. It is the entrapping of the
truth of Being in oblivion, i.e., in concealment. The truth, the
unconcealment, of Being, is, in the very instant of its revealing,

2. In a letter to Professor J. Glenn Gray (October 10, 1972) concerning
this work, Heidegger states: "Everything that I have attempted is misunder-
stood without the turning from 'consciousness' *into* the '*openness-for-Being*'
that was being prepared in *Being and Time*." ("Ohne die in *Sein und Zeit*
sich anbahnende Wendung vom 'Bewusstsein' *in* das '*Da-sein*' wird alles,
was ich versuchte, missverstanden.") Heidegger has emphatically expressed
his preference for "openness" and his disapprobation of "there" as a trans-
lation of *da* in *Dasein*.

caught up in concealing. Yet the revealing of the truth of Being is concealed *as revealing*. Hence, "when this *entrapping-with-oblivion* does come expressly to pass, then oblivion as such turns in and abides"; that is, concealment is *revealed as concealment* (T 43)—for it conceals that which is itself simultaneously shown as *being* concealed.

Here Enframing, a destining of Being that denies to everything its Being, becomes simultaneously that which saves, that which bestows Being. For in it the truth of Being, Being's own unconcealment, turns about and enters into whatever is (cf. T 41).

In this "turning," Being reveals itself solely from out of itself; yet it necessarily does so in such a way as to reach man. For without man, Being cannot come freely into the open, as the Being of what is. This turning about of concealing and unconcealing, which so closely involves Being and man, is a granted gift.

The sudden flashing of the truth of Being into once truthless Being, which comes to pass in the essence of technology, in Enframing, is an "entering flashing look," is "insight into that which is"—i.e., into Being itself (T 46). This is no human looking, no human seeing. Quite to the contrary, it is Being's disclosing of itself. In it men are the ones beheld in their essence, *so that* they behold (cf. T 47). Heidegger uses for that in-flashing which is the self-revealing turning within Being itself the word *Ereignis*. It is a disclosing bringing to pass, a "bringing to sight that brings into its own" (T 45, 38 n. 4). Taking place within Being, it returns Being to itself—here, restoring the essence of technology to itself as a revealing—and it simultaneously brings man, glimpsed in his essence, to glimpse the revealing given appropriately to *him*.

This disclosing brings itself to pass always uniquely. Being and man belong together. The disclosing here named is the fulfilling of that relation. It brings man and Being into their own in entrusting them to one another. It is a "letting belong together" of man and Being (Pr. Iden. 39).

Enframing and the "disclosing that brings into its own" are in truth one. Heidegger can speak of Enframing as the "photographic negative" of that disclosing (Sem. 42). In enframing, Being and man confront each other, but they meet in estrangement. In the unique disclosing that brings them into their own,

they meet in the very same relationship; but now, *instead of and yet within* the skeletal darkness of Enframing, there flashes *also* the light of that disclosing which brings them to belong together, which grants them what is truly their own.

Here there can be disclosed to modern man something beyond what was known to the Greeks. The Greeks knew the togetherness of man and Being. But now, in our age, it can be possible to "glimpse a first oppressing flash" of the disclosing bringing-to-pass that brings man and Being into a constellation that is new and newly known (Pr. Iden. 38). In Enframing, precisely in its character as "the mutual challenge of man and Being to enter upon the calculating of the calculable," that newness of relationship appears (Pr. Iden. 40). When we catch sight of the turning in the essence of Enframing, we do not simply catch sight of the belonging together of man and Being. We do more: "We witness a *belonging* together of man and Being in which the *letting belong first determines* the manner of the 'together' and its unity" (Pr. Iden. 38, second italics mine). Within and beyond the looming presence of modern technology there dawns the possibility of a fuller relationship between man and Being—and hence between man and all that is—than there has ever been.

In looking upon the present, our thinking can hope to see, over and beyond the immediate, evident situation of man, the relation of Being and man "from out of that which gives them to belong to one another, from out of the disclosing bringing-to-pass that brings them into their own" (Pr. Iden. 40). Such thinking is completely different from the sort of instantaneous calculating on which we more and more rely. It is a thinking within the sphere of tradition, a learning through what has been thought. As such, it is freed by tradition from being a mere thinking back, to become a thinking forward that is totally removed from planning, ordering, and setting up for use.

It has sometimes been said that Heidegger exhibits in his philosophical work extreme arrogance. True, he does not, like Descartes, put forth his thinking as possessed of the compelling certainty of self-evident truth; nor does he, like Hegel, believe himself capable of surveying and expressing the truth about all human history and all reality. But does he not consider himself

to have insight into reality such as none before him has ever had? It is a fact that his thinking is confined to Western history and Western thought. But within that scope does he not, as in his treatment of Nietzsche, believe himself able on the basis of that insight to think that which is "unthought" in the thought of others, to discover the true meaning that those before him could not themselves see? He does. Yet is this arrogance, or is there insight here?

Surely Heidegger himself would say that whatever insight he has is not of his own discovering but comes to him from out of reality itself. Clearly he continually feels himself summoned to respond to the revealing that comes to him and to call others to the same path. Deeply conscious as he is of his place within a tradition, Heidegger doubtless regards what seems to some like the proud reinterpreting of others' work as being, rather, the discovery in that work of far more meaning than those before him who accomplished it were given to see. Certainly, although Heidegger speaks with assurance of his insight, and though it ranges far, he also holds it to be but a glimpse, a beginning, an entering of modern man upon a thinking that, in its own time, may be granted to see far more clearly and to see anew (cf. WN 55–56). In his philosophical work he has moved forward and ever forward, not bound by any given formulation of his thought. To Heidegger true thinking always remains a revealing, and he must follow where that revealing leads. The openness of his thinking shows itself fittingly enough in the fact that each of the essays in this volume ends, not with a declarative statement of what is incontrovertibly true, but with actual questions or with a pointing to some way or reality needed beyond what is now known. Each essay, whole though it be in itself, remains a part of an unfinished *way*. Where Descartes built glass palaces inviolable and Hegel a mansion finished for all time, Heidegger builds, as it were, sandcastles, ready to be reshaped or swept away in the next responsive on-working of thought.

Heidegger has written:

At the close of a lecture called "The Question Concerning Technology," given some time ago, I said: "Questioning is the piety of thinking." "Piety" is meant here in the ancient sense: obedient, or

submissive, and in this case submitting to what thinking has to
think about. One of the exciting experiences of thinking is that at
times it does not fully comprehend the new insights it has just
gained, and does not properly see them through. Such, too, is the
case with the sentence just cited that questioning is the piety of
thinking. The lecture ending with that sentence was already in the
ambience of the realization that the true stance of thinking cannot
be to put questions, but must be to listen to that which our ques-
tioning vouchsafes—and all questioning begins to be a questioning
only in virtue of pursuing its quest for essential Being.[3]

This is Heidegger's own way and his quest. This is the intrigu-
ing adventure to which he summons us in the essays that follow.
Has he glimpsed truth that might lighten our stricken age? To
judge of that we must pursue with him the paths of his own
thinking.

3. "The Nature of Language," in *On the Way to Language,* trans. Peter
D. Hertz (New York: Harper & Row, 1971), p. 72.

Part I

The Question
Concerning Technology

In what follows we shall be *questioning* concerning technology. Questioning builds a way. We would be advised, therefore, above all to pay heed to the way, and not to fix our attention on isolated sentences and topics. The way is a way of thinking. All ways of thinking, more or less perceptibly, lead through language in a manner that is extraordinary. We shall be questioning concerning *technology*, and in so doing we should like to prepare a free relationship to it. The relationship will be free if it opens our human existence to the essence of technology.[1] When we

1. "Essence" is the traditional translation of the German noun *Wesen*. One of Heidegger's principal aims in this essay is to seek the true meaning of essence through or by way of the "correct" meaning. He will later show that *Wesen* does not simply mean *what* something is, but that it means, further, the way in which something pursues its course, the way in which it remains through time as what it is. Heidegger writes elsewhere that the noun *Wesen* does not mean *quidditas* originally, but rather "enduring as presence" (*das Währen als Gegenwart*). (See *An Introduction to Metaphysics*, trans. Ralph Manheim [New York: Doubleday, 1961], p. 59.) *Wesen* as a noun derives from the verb *wesen*, which is seldom used as such in modern German. The verb survives primarily in inflected forms of the verb *sein* (to be) and in such words as the adjective *anwesend* (present). The old verbal forms from which *wesen* stems meant to tarry or dwell. Heidegger repeatedly identifies *wesen* as "the same as *währen* [to last or endure]." (See p. 30 below and SR 161.) As a verb, *wesen* will usually be translated

can respond to this essence, we shall be able to experience the technological within its own bounds.

Technology is not equivalent to the essence of technology. When we are seeking the essence of "tree," we have to become aware that That which pervades every tree, as tree, is not itself a tree that can be encountered among all the other trees.

Likewise, the essence of technology is by no means anything technological. Thus we shall never experience our relationship to the essence of technology so long as we merely conceive and push forward the technological, put up with it, or evade it. Everywhere we remain unfree and chained to technology, whether we passionately affirm or deny it. But we are delivered over to it in the worst possible way when we regard it as something neutral; for this conception of it,[2] to which today we particularly like to do homage, makes us utterly blind to the essence of technology.

According to ancient doctrine, the essence of a thing is considered to be *what* the thing is. We ask the question concerning technology when we ask what it is. Everyone knows the two statements that answer our question. One says: Technology is a means to an end. The other says: Technology is a human activity. The two definitions of technology belong together. For to posit ends and procure and utilize the means to them is a human activity. The manufacture and utilization of equipment, tools, and machines, the manufactured and used things themselves, and the needs and ends that they serve, all belong to what tech-

here with "to come to presence," a rendering wherein the meaning "endure" should be strongly heard. Occasionally it will be translated "to essence," and its gerund will be rendered with "essencing." The noun *Wesen* will regularly be translated "essence" until Heidegger's explanatory discussion is reached. Thereafter, in this and the succeeding essays, it will often be translated with "coming to presence." In relation to all these renderings, the reader should bear in mind a point that is of fundamental importance to Heidegger, namely, that the root of *wesen*, with its meaning "to dwell," provides one integral component in the meaning of the verb *sein* (to be). (Cf. *An Introduction to Metaphysics*, p. 59.)

2. "Conception" here translates the noun *Vorstellung*. Elsewhere in this volume, *Vorstellung* will usually be translated by "representation," and its related verb *vorstellen* by "to represent." Both "conception" and "representation" should suggest a placing or setting-up-before. Cf. the discussion of *Vorstellung* in AWP 131–132.

nology is. The whole complex of these contrivances is technology. Technology itself is a contrivance, or, in Latin, an *instrumentum*.[3]

The current conception of technology, according to which it is a means and a human activity, can therefore be called the instrumental and anthropological definition of technology.

Who would ever deny that it is correct? It is in obvious conformity with what we are envisioning when we talk about technology. The instrumental definition of technology is indeed so uncannily correct that it even holds for modern technology, of which, in other respects, we maintain with some justification that it is, in contrast to the older handwork technology, something completely different and therefore new. Even the power plant with its turbines and generators is a man-made means to an end established by man. Even the jet aircraft and the high-frequency apparatus are means to ends. A radar station is of course less simple than a weather vane. To be sure, the construction of a high-frequency apparatus requires the interlocking of various processes of technical-industrial production. And certainly a sawmill in a secluded valley of the Black Forest is a primitive means compared with the hydroelectric plant in the Rhine River.

But this much remains correct: modern technology too is a means to an end. That is why the instrumental conception of technology conditions every attempt to bring man into the right relation to technology. Everything depends on our manipulating technology in the proper manner as a means. We will, as we say, "get" technology "spiritually in hand." We will master it. The will to mastery becomes all the more urgent the more technology threatens to slip from human control.

But suppose now that technology were no mere means, how would it stand with the will to master it? Yet we said, did we

3. *Instrumentum* signifies that which functions to heap or build up or to arrange. Heidegger here equates it with the noun *Einrichtung*, translated "contrivance," which can also mean arrangement, adjustment, furnishing, or equipment. In accordance with his dictum that the true must be sought by way of the correct, Heidegger here anticipates with his identification of technology as an *instrumentum* and an *Einrichtung* his later "true" characterization of technology in terms of setting-in-place, ordering, Enframing, and standing-reserve.

not, that the instrumental definition of technology is correct? To be sure. The correct always fixes upon something pertinent in whatever is under consideration. However, in order to be correct, this fixing by no means needs to uncover the thing in question in its essence. Only at the point where such an uncovering happens does the true come to pass.[4] For that reason the merely correct is not yet the true. Only the true brings us into a free relationship with that which concerns us from out of its essence. Accordingly, the correct instrumental definition of technology still does not show us technology's essence. In order that we may arrive at this, or at least come close to it, we must seek the true by way of the correct. We must ask: What is the instrumental itself? Within what do such things as means and end belong? A means is that whereby something is effected and thus attained. Whatever has an effect as its consequence is called a cause. But not only that by means of which something else is effected is a cause. The end in keeping with which the kind of means to be used is determined is also considered a cause. Wherever ends are pursued and means are employed, wherever instrumentality reigns, there reigns causality.

For centuries philosophy has taught that there are four causes: (1) the *causa materialis*, the material, the matter out of which, for example, a silver chalice is made; (2) the *causa formalis*, the form, the shape into which the material enters; (3) the *causa finalis*, the end, for example, the sacrificial rite in relation to which the chalice required is determined as to its form and matter; (4) the *causa efficiens*, which brings about the effect that is the finished, actual chalice, in this instance, the silversmith. What technology is, when represented as a means, discloses itself when we trace instrumentality back to fourfold causality.

But suppose that causality, for its part, is veiled in darkness with respect to what it is? Certainly for centuries we have acted as though the doctrine of the four causes had fallen from heaven as a truth as clear as daylight. But it might be that the time has come to ask, Why are there just four causes? In relation to the aforementioned four, what does "cause" really mean? From

4. "Come to pass" translates *sich ereignet*. For a discussion of the fuller meaning of the verb *ereignen*, see T 38 n. 4, 45.

whence does it come that the causal *character* of the four causes is so unifiedly determined that they belong together?

So long as we do not allow ourselves to go into these questions, causality, and with it instrumentality, and with the latter the accepted definition of technology, remain obscure and groundless.

For a long time we have been accustomed to representing cause as that which brings something about. In this connection, to bring about means to obtain results, effects. The *causa efficiens*, but one among the four causes, sets the standard for all causality. This goes so far that we no longer even count the *causa finalis*, telic finality, as causality. *Causa, casus*, belongs to the verb *cadere*, "to fall," and means that which brings it about that something falls out as a result in such and such a way. The doctrine of the four causes goes back to Aristotle. But everything that later ages seek in Greek thought under the conception and rubric "causality," in the realm of Greek thought and for Greek thought per se has simply nothing at all to do with bringing about and effecting. What we call cause [*Ursache*] and the Romans call *causa* is called *aition* by the Greeks, that to which something else is indebted [*das, was ein anderes verschuldet*].[5] The four causes are the ways, all belonging at once to each other, of being responsible for something else. An example can clarify this.

Silver is that out of which the silver chalice is made. As this matter (*hyle*), it is co-responsible for the chalice. The chalice is indebted to, i.e., owes thanks to, the silver for that out of which it consists. But the sacrificial vessel is indebted not only to the silver. As a chalice, that which is indebted to the silver appears in the aspect of a chalice and not in that of a brooch or a ring. Thus the sacrificial vessel is at the same time indebted to the aspect (*eidos*) of chaliceness. Both the silver into which the aspect is admitted as chalice and the aspect in which the silver appears are in their respective ways co-responsible for the sacrificial vessel.

5. *Das, was ein anderes verschuldet* is a quite idomatic expression that here would mean to many German readers "that which is the cause of something else." The verb *verschulden* actually has a wide range of meanings—to be indebted, to owe, to be guilty, to be responsible for or to, to cause. Heidegger intends to awaken all these meanings and to have connotations of mutual interdependence sound throughout this passage.

But there remains yet a third that is above all responsible for the sacrificial vessel. It is that which in advance confines the chalice within the realm of consecration and bestowal.[6] Through this the chalice is circumscribed as sacrificial vessel. Circumscribing gives bounds to the thing. With the bounds the thing does not stop; rather from out of them it begins to be what, after production, it will be. That which gives bounds, that which completes, in this sense is called in Greek *telos*, which is all too often translated as "aim" or "purpose," and so misinterpreted. The *telos* is responsible for what as matter and for what as aspect are together co-responsible for the sacrificial vessel.

Finally there is a fourth participant in the responsibility for the finished sacrificial vessel's lying before us ready for use, i.e., the silversmith—but not at all because he, in working, brings about the finished sacrificial chalice as if it were the effect of a making; the silversmith is not a *causa efficiens*.

The Aristotelian doctrine neither knows the cause that is named by this term nor uses a Greek word that would correspond to it.

The silversmith considers carefully and gathers together the three aforementioned ways of being responsible and indebted. To consider carefully [*überlegen*] is in Greek *legein*, *logos*. *Legein* is rooted in *apophainesthai*, to bring forward into appearance. The silversmith is co-responsible as that from whence the sacrificial vessel's bringing forth and resting-in-self take and retain their first departure. The three previously mentioned ways of being responsible owe thanks to the pondering of the silversmith for the "that" and the "how" of their coming into appearance and into play for the production of the sacrificial vessel.

Thus four ways of being responsible hold sway in the sacrificial vessel that lies ready before us. They differ from one another, yet they belong together. What unites them from the beginning? In what does this playing in unison of the four ways of being

6. Literally, "confines into"—the German preposition *in* with the accusative. Heidegger often uses this construction in ways that are unusual in German, as they would be in English. It will ordinarily be translated here by "within" so as to distinguish it from "in" used to translate *in* with the dative.

responsible play? What is the source of the unity of the four causes? What, after all, does this owing and being responsible mean, thought as the Greeks thought it?

Today we are too easily inclined either to understand being responsible and being indebted moralistically as a lapse, or else to construe them in terms of effecting. In either case we bar to ourselves the way to the primal meaning of that which is later called causality. So long as this way is not opened up to us we shall also fail to see what instrumentality, which is based on causality, actually is.

In order to guard against such misinterpretations of being responsible and being indebted, let us clarify the four ways of being responsible in terms of that for which they are responsible. According to our example, they are responsible for the silver chalice's lying ready before us as a sacrificial vessel. Lying before and lying ready (*hypokeisthai*) characterize the presencing of something that presences. The four ways of being responsible bring something into appearance. They let it come forth into presencing [*An-wesen*].[7] They set it free to that place and so start it on its way, namely, into its complete arrival. The principal characteristic of being responsible is this starting something on its way into arrival. It is in the sense of such a starting something on its way into arrival that being responsible is an occasioning or an inducing to go forward [*Ver-an-lassen*].[8] On the

7. By writing *An-wesen*, Heidegger stresses the composition of the verb *anwesen*, translated as "to presence." The verb consists of *wesen* (literally, to continue or endure) with the prepositional prefix *an-* (at, to, toward). It is man who must receive presencing, man *to* whom it comes as enduring. Cf. *On Time and Being*, trans. Joan Stambaugh (New York: Harper & Row, 1972), p. 12.

8. *Ver-an-lassen* is Heidegger's writing of the verb *veranlassen* in noun form, now hyphenated to bring out its meaning. *Veranlassen* ordinarily means to occasion, to cause, to bring about, to call forth. Its use here relates back to the use of *anlassen* (to leave [something] on, to let loose, to set going), here translated "to start something on its way." *Anlassen* has just been similarly written as *an-lassen* so as to emphasize its composition from *lassen* (to let or leave) and *an* (to or toward). One of the functions of the German prefix *ver-* is to intensify the force of a verb. André Préau quotes Heidegger as saying: "*Ver-an-lassen* is more active than *an-lassen*. The *ver-*, as it were, pushes the latter toward a doing [*vers un faire*]." Cf. Martin Heidegger, *Essais et Conférences* (Paris: Gallimard, 1958), p. 16 n.

basis of a look at what the Greeks experienced in being responsible, in *aitia*, we now give this verb "to occasion" a more inclusive meaning, so that it now is the name for the essence of causality thought as the Greeks thought it. The common and narrower meaning of "occasion" in contrast is nothing more than striking against and releasing, and means a kind of secondary cause within the whole of causality.

But in what, then, does the playing in unison of the four ways of occasioning play? They let what is not yet present arrive into presencing. Accordingly, they are unifiedly ruled over by a bringing that brings what presences into appearance. Plato tells us what this bringing is in a sentence from the *Symposium* (205b): *hē gar toi ek tou mē onton eis to on ionti hotōioun aitia pasa esti poiēsis.* "Every occasion for whatever passes over and goes forward into presencing from that which is not presencing is *poiēsis*, is bringing-forth [*Her-vor-bringen*]."⁹

It is of utmost importance that we think bringing-forth in its full scope and at the same time in the sense in which the Greeks thought it. Not only handcraft manufacture, not only artistic and poetical bringing into appearance and concrete imagery, is a bringing-forth, *poiēsis*. *Physis* also, the arising of something from out of itself, is a bringing-forth, *poiēsis*. *Physis* is indeed *poiēsis* in the highest sense. For what presences by means of *physis* has the bursting open belonging to bringing-forth, e.g., the bursting of a blossom into bloom, in itself (*en heautōi*). In contrast, what is brought forth by the artisan or the artist, e.g.,

9. The full gamut of meaning for the verb *hervorbringen*, here functioning as a noun, includes to bring forth or produce, to generate or beget, to utter, to elicit. Heidegger intends that all of these nuances be heard. He hyphenates the word in order to emphasize its adverbial prefixes, *her-* (here or hither) and *vor-* (forward or forth). Heidegger elsewhere makes specific the meaning resident in *Her-vor-bringen* for him by utilizing those prefixes independently. Thus he says (translating literally), "Bringing-forth-hither brings hither out of concealment, forth into unconcealment" (cf. below, p. 11); and—after identifying working (*wirken*) and *her-vor-bringen*—he says that working must be understood as "bringing *hither*—into unconcealment, *forth*—into presencing" (SR 161). Because of the awkwardness of the English phrase "to bring forth hither," it has not been possible to include in the translation of *her-vor-bringen* the nuance of meaning that *her-* provides.

the silver chalice, has the bursting open belonging to bringing-forth not in itself, but in another (*en allōi*), in the craftsman or artist.

The modes of occasioning, the four causes, are at play, then, within bringing-forth. Through bringing-forth, the growing things of nature as well as whatever is completed through the crafts and the arts come at any given time to their appearance.

But how does bringing-forth happen, be it in nature or in handwork and art? What is the bringing-forth in which the fourfold way of occasioning plays? Occasioning has to do with the presencing [*Anwesen*] of that which at any given time comes to appearance in bringing-forth. Bringing-forth brings hither out of concealment forth into unconcealment. Bringing-forth comes to pass only insofar as something concealed comes into unconcealment. This coming rests and moves freely within what we call revealing [*das Entbergen*].[10] The Greeks have the word

10. The verb *entbergen* (to reveal) and the allied noun *Entbergung* (revealing) are unique to Heidegger. Because of the exigencies of translation, *entbergen* must usually be translated with "revealing," and the presence of *Entbergung*, which is rather infrequently used, has therefore regrettably been obscured for want of an appropriate English noun as alternative that would be sufficiently active in meaning. *Entbergen* and *Entbergung* are formed from the verb *bergen* and the verbal prefix *ent-*. *Bergen* means to rescue, to recover, to secure, to harbor, to conceal. *Ent-* is used in German verbs to connote in one way or another a change from an existing situation. It can mean "forth" or "out" or can connote a change that is the negating of a former condition. *Entbergen* connotes an opening out from protective concealing, a harboring forth. For a presentation of Heidegger's central tenet that it is only as protected and preserved—and that means as enclosed and secure—that anything is set free to endure, to continue as that which it is, i.e., to be, see "Building Dwelling Thinking" in *Poetry, Language, Thought*, trans. Albert Hofstadter (New York: Harper & Row, 1971), p. 149, and cf. p. 25 below.

Entbergen and *Entbergung* join a family of words all formed from *bergen*—*verbergen* (to conceal), *Verborgenheit* (concealment), *das Verborgene* (the concealed), *Unverborgenheit* (unconcealment), das *Unverborgene* (the unconcealed)—of which Heidegger makes frequent use. The lack of viable English words sufficiently numerous to permit a similar use of but one fundamental stem has made it necessary to obscure, through the use of "reveal," the close relationship among all the words just mentioned. None of the English words used—"reveal," "conceal," "unconceal"—evinces with any adequacy the meaning resident in *bergen* itself; yet the reader should be constantly aware that the full range of connotation present in *bergen* sounds for Heidegger within all these, its derivatives.

alētheia for revealing. The Romans translate this with *veritas*. We say "truth" and usually understand it as the correctness of an idea.

But where have we strayed to? We are questioning concerning technology, and we have arrived now at *alētheia*, at revealing. What has the essence of technology to do with revealing? The answer: everything. For every bringing-forth is grounded in revealing. Bringing-forth, indeed, gathers within itself the four modes of occasioning—causality—and rules them throughout. Within its domain belong end and means, belongs instrumentality.[11] Instrumentality is considered to be the fundamental characteristic of technology. If we inquire, step by step, into what technology, represented as means, actually is, then we shall arrive at revealing. The possibility of all productive manufacturing lies in revealing.

Technology is therefore no mere means. Technology is a way of revealing. If we give heed to this, then another whole realm for the essence of technology will open itself up to us. It is the realm of revealing, i.e., of truth.[12]

This prospect strikes us as strange. Indeed, it should do so, should do so as persistently as possible and with so much urgency that we will finally take seriously the simple question of what the name "technology" means. The word stems from the Greek. *Technikon* means that which belongs to *technē*. We must observe

11. Here and elsewhere "belongs within" translates the German *gehört in* with the accusative (literally, belongs into), an unusual usage that Heidegger often employs. The regular German construction is *gehört zu* (belongs to). With the use of "belongs into," Heidegger intends to suggest a relationship involving origin.

12. Heidegger here hyphenates the word *Wahrheit* (truth) so as to expose its stem, *wahr*. He points out elsewhere that words with this stem have a common derivation and underlying meaning (SR 165). Such words often show the connotations of attentive watchfulness and guarding that he there finds in their Greek cognates, *horaō*, *ōra*, e.g., *wahren* (to watch over and keep safe) and *bewahren* (to preserve). Hyphenating *Wahrheit* draws it overtly into this circle of meaning. It points to the fact that in truth, which is unconcealment (*Unverborgenheit*), a safekeeping carries itself out. *Wahrheit* thus offers here a very close parallel to its companion noun *Entbergung* (revealing; literally, harboring forth), built on *bergen* (to rescue, to harbor, to conceal). See n. 10, above. For a further discussion of words built around *wahr*, see T 42, n. 9.

two things with respect to the meaning of this word. One is that *technē* is the name not only for the activities and skills of the craftsman, but also for the arts of the mind and the fine arts. *Technē* belongs to bringing-forth, to *poiēsis*; it is something poietic.

The other point that we should observe with regard to *technē* is even more important. From earliest times until Plato the word *technē* is linked with the word *epistēmē*. Both words are names for knowing in the widest sense. They mean to be entirely at home in something, to understand and be expert in it. Such knowing provides an opening up. As an opening up it is a revealing. Aristotle, in a discussion of special importance (*Nicomachean Ethics*, Bk. VI, chaps. 3 and 4), distinguishes between *epistēmē* and *technē* and indeed with respect to what and how they reveal. *Technē* is a mode of *alētheuein*. It reveals whatever does not bring itself forth and does not yet lie here before us, whatever can look and turn out now one way and now another. Whoever builds a house or a ship or forges a sacrificial chalice reveals what is to be brought forth, according to the perspectives of the four modes of occasioning. This revealing gathers together in advance the aspect and the matter of ship or house, with a view to the finished thing envisioned as completed, and from this gathering determines the manner of its construction. Thus what is decisive in *technē* does not lie at all in making and manipulating nor in the using of means, but rather in the aforementioned revealing. It is as revealing, and not as manufacturing, that *technē* is a bringing-forth.

Thus the clue to what the word *technē* means and to how the Greeks defined it leads us into the same context that opened itself to us when we pursued the question of what instrumentality as such in truth might be.

Technology is a mode of revealing. Technology comes to presence [*West*] in the realm where revealing and unconcealment take place, where *alētheia*, truth, happens.

In opposition to this definition of the essential domain of technology, one can object that it indeed holds for Greek thought and that at best it might apply to the techniques of the handcraftsman, but that it simply does not fit modern machine-powered technology. And it is precisely the latter and

it alone that is the disturbing thing, that moves us to ask the question concerning technology per se. It is said that modern technology is something incomparably different from all earlier technologies because it is based on modern physics as an exact science. Meanwhile we have come to understand more clearly that the reverse holds true as well: Modern physics, as experimental, is dependent upon technical apparatus and upon progress in the building of apparatus. The establishing of this mutual relationship between technology and physics is correct. But it remains a merely historiographical establishing of facts and says nothing about that in which this mutual relationship is grounded. The decisive question still remains: Of what essence is modern technology that it happens to think of putting exact science to use?

What is modern technology? It too is a revealing. Only when we allow our attention to rest on this fundamental characteristic does that which is new in modern technology show itself to us.

And yet the revealing that holds sway throughout modern technology does not unfold into a bringing-forth in the sense of *poiēsis*. The revealing that rules in modern technology is a challenging [*Herausfordern*],[13] which puts to nature the unreasonable demand that it supply energy that can be extracted and stored as such. But does this not hold true for the old windmill as well? No. Its sails do indeed turn in the wind; they are left entirely to the wind's blowing. But the windmill does not unlock energy from the air currents in order to store it.

In contrast, a tract of land is challenged into the putting out of coal and ore. The earth now reveals itself as a coal mining district, the soil as a mineral deposit. The field that the peasant formerly cultivated and set in order [*bestellte*] appears differently than it did when to set in order still meant to take care of and

13. *Herausfordern* means to challenge, to call forth or summon to action, to demand positively, to provoke. It is composed of the verb *fordern* (to demand, to summon, to challenge) and the adverbial prefixes *her-* (hither) and *aus-* (out). The verb might be rendered very literally as "to demand out hither." The structural similarity between *herausfordern* and *her-vor-bringen* (to bring forth hither) is readily apparent. It serves of itself to point up the relation subsisting between the two modes of revealing of which the verbs speak—modes that, in the very distinctive ways peculiar to them, occasion a coming forth into unconcealment and presencing. See below, 29–30.

to maintain. The work of the peasant does not challenge the soil of the field. In the sowing of the grain it places the seed in the keeping of the forces of growth and watches over its increase. But meanwhile even the cultivation of the field has come under the grip of another kind of setting-in-order, which *sets* upon [*stellt*] nature.[14] It sets upon it in the sense of challenging it. Agriculture is now the mechanized food industry. Air is now set upon to yield nitrogen, the earth to yield ore, ore to yield uranium, for example; uranium is set upon to yield atomic energy, which can be released either for destruction or for peaceful use.

This setting-upon that challenges forth the energies of nature is an expediting [*Fördern*], and in two ways. It expedites in that it unlocks and exposes. Yet that expediting is always itself directed from the beginning toward furthering something else, i.e., toward driving on to the maximum yield at the minimum expense. The coal that has been hauled out in some mining district has not been supplied in order that it may simply be present somewhere or other. It is stockpiled; that is, it is on call, ready to deliver the sun's warmth that is stored in it. The sun's warmth is challenged forth for heat, which in turn is ordered to deliver steam whose pressure turns the wheels that keep a factory running.

14. The verb *stellen* (to place or set) has a wide variety of uses. It can mean to put in place, to order, to arrange, to furnish or supply, and, in a military context, to challenge or engage. Here Heidegger sees the connotations of *herausfordern* (to challenge, to call forth, to demand out hither) as fundamentally determinative of the meaning of *stellen*, and this remains true throughout his ensuing discussion. The translation of *stellen* with "to set upon" is intended to carry this meaning. The connotations of setting in place and of supplying that lie within the word *stellen* remain strongly present in Heidegger's repeated use of the verb hereafter, however, since the "setting-upon" of which it speaks is inherently a setting in place so as to supply. Where these latter meanings come decisively to the fore, *stellen* has been translated with "to set" or "to set up," or, rarely, with "to supply."

Stellen embraces the meanings of a whole family of verbs: *bestellen* (to order, command; to set in order), *vorstellen* (to represent), *sicherstellen* (to secure), *nachstellen* (to entrap), *verstellen* (to block or disguise), *herstellen* (to produce, to set here), *darstellen* (to present or exhibit), and so on. In these verbs the various nuances within *stellen* are reinforced and made specific. All these meanings are gathered together in Heidegger's unique use of the word that is pivotal for him, *Ge-stell* (Enframing). Cf. pp. 19 ff. See also the opening paragraph of "The Turning," pp. 36–37.

The hydroelectric plant is set into the current of the Rhine. It sets the Rhine to supplying its hydraulic pressure, which then sets the turbines turning. This turning sets those machines in motion whose thrust sets going the electric current for which the long-distance power station and its network of cables are set up to dispatch electricity.[15] In the context of the interlocking processes pertaining to the orderly disposition of electrical energy, even the Rhine itself appears as something at our command. The hydroelectric plant is not built into the Rhine River as was the old wooden bridge that joined bank with bank for hundreds of years. Rather the river is dammed up into the power plant. What the river is now, namely, a water power supplier, derives from out of the essence of the power station. In order that we may even remotely consider the monstrousness that reigns here, let us ponder for a moment the contrast that speaks out of the two titles, "The Rhine" as dammed up into the *power* works, and "The Rhine" as uttered out of the *art* work, in Hölderlin's hymn by that name. But, it will be replied, the Rhine is still a river in the landscape, is it not? Perhaps. But how? In no other way than as an object on call for inspection by a tour group ordered there by the vacation industry.

The revealing that rules throughout modern technology has the character of a setting-upon, in the sense of a challenging-forth. That challenging happens in that the energy concealed in nature is unlocked, what is unlocked is transformed, what is transformed is stored up, what is stored up is, in turn, distributed, and what is distributed is switched about ever anew. Unlocking, transforming, storing, distributing, and switching about are ways of revealing. But the revealing never simply comes to an end. Neither does it run off into the indeterminate. The revealing reveals to itself its own manifoldly interlocking paths, through regulating their course. This regulating itself is, for its part, everywhere secured. Regulating and securing even become the chief characteristics of the challenging revealing.

15. In these two sentences, in order to show something of the manner in which Heidegger gathers together a family of meanings, a series of *stellen* verbs—*stellen* (three times), *herstellen*, *bestellen*—have been translated with verbal expressions formed around "set." For the usual meanings of these verbs, see n. 14.

What kind of unconcealment is it, then, that is peculiar to that which comes to stand forth through this setting-upon that challenges? Everywhere everything is ordered to stand by, to be immediately at hand, indeed to stand there just so that it may be on call for a further ordering. Whatever is ordered about in this way has its own standing. We call it the standing-reserve [Bestand].[16] The word expresses here something more, and something more essential, than mere "stock." The name "standing-reserve" assumes the rank of an inclusive rubric. It designates nothing less than the way in which everything presences that is wrought upon by the challenging revealing. Whatever stands by in the sense of standing-reserve no longer stands over against us as object.

Yet an airliner that stands on the runway is surely an object. Certainly. We can represent the machine so. But then it conceals itself as to what and how it is. Revealed, it stands on the taxi strip only as standing-reserve, inasmuch as it is ordered to ensure the possibility of transportation. For this it must be in its whole structure and in every one of its constituent parts, on call for duty, i.e., ready for takeoff. (Here it would be appropriate to discuss Hegel's definition of the machine as an autonomous tool. When applied to the tools of the craftsman, his characterization is correct. Characterized in this way, however, the machine is not thought at all from out of the essence of technology within which it belongs. Seen in terms of the standing-reserve, the machine is completely unautonomous, for it has its standing only from the ordering of the orderable.)

The fact that now, wherever we try to point to modern technology as the challenging revealing, the words "setting-upon," "ordering," "standing-reserve," obtrude and accumulate in a dry, monotonous, and therefore oppressive way, has its basis in what is now coming to utterance.

16. *Bestand* ordinarily denotes a store or supply as "standing by." It carries the connotation of the verb *bestehen* with its dual meaning of to last and to undergo. Heidegger uses the word to characterize the manner in which everything commanded into place and ordered according to the challenging demand ruling in modern technology presences as revealed. He wishes to stress here not the permanency, but the orderability and substitutability of objects. *Bestand* contrasts with *Gegenstand* (object; that which stands over against). Objects indeed lose their character as objects when they are caught up in the "standing-reserve." Cf. Introduction, p. xxix.

Who accomplishes the challenging setting-upon through which what we call the real is revealed as standing-reserve? Obviously, man. To what extent is man capable of such a revealing? Man can indeed conceive, fashion, and carry through this or that in one way or another. But man does not have control over unconcealment itself, in which at any given time the real shows itself or withdraws. The fact that the real has been showing itself in the light of Ideas ever since the time of Plato, Plato did not bring about. The thinker only responded to what addressed itself to him.

Only to the extent that man for his part is already challenged to exploit the energies of nature can this ordering revealing happen. If man is challenged, ordered, to do this, then does not man himself belong even more originally than nature within the standing-reserve? The current talk about human resources, about the supply of patients for a clinic, gives evidence of this. The forester who, in the wood, measures the felled timber and to all appearances walks the same forest path in the same way as did his grandfather is today commanded by profit-making in the lumber industry, whether he knows it or not. He is made subordinate to the orderability of cellulose, which for its part is challenged forth by the need for paper, which is then delivered to newspapers and illustrated magazines. The latter, in their turn, set public opinion to swallowing what is printed, so that a set configuration of opinion becomes available on demand. Yet precisely because man is challenged more originally than are the energies of nature, i.e., into the process of ordering, he never is transformed into mere standing-reserve. Since man drives technology forward, he takes part in ordering as a way of revealing. But the unconcealment itself, within which ordering unfolds, is never a human handiwork, any more than is the realm through which man is already passing every time he as a subject relates to an object.

Where and how does this revealing happen if it is no mere handiwork of man? We need not look far. We need only apprehend in an unbiased way That which has already claimed man and has done so, so decisively that he can only be man at any given time as the one so claimed. Wherever man opens his eyes and ears, unlocks his heart, and gives himself over to meditating

and striving, shaping and working, entreating and thanking, he finds himself everywhere already brought into the unconcealed. The unconcealment of the unconcealed has already come to pass whenever it calls man forth into the modes of revealing allotted to him. When man, in his way, from within unconcealment reveals that which presences, he merely responds to the call of unconcealment even when he contradicts it. Thus when man, investigating, observing, ensnares nature as an area of his own conceiving, he has already been claimed by a way of revealing that challenges him to approach nature as an object of research, until even the object disappears into the objectlessness of standing-reserve.

Modern technology as an ordering revealing is, then, no merely human doing. Therefore we must take that challenging that sets upon man to order the real as standing-reserve in accordance with the way in which it shows itself. That challenging gathers man into ordering. This gathering concentrates man upon ordering the real as standing-reserve.

That which primordially unfolds the mountains into mountain ranges and courses through them in their folded togetherness is the gathering that we call "Gebirg" [mountain chain].

That original gathering from which unfold the ways in which we have feelings of one kind or another we name "Gemüt" [disposition].

We now name that challenging claim which gathers man thither to order the self-revealing as standing-reserve: "Ge-stell" [Enframing].[17]

We dare to use this word in a sense that has been thoroughly unfamiliar up to now.

17. The translation "Enframing" for Ge-stell is intended to suggest, through the use of the prefix "en-," something of the active meaning that Heidegger here gives to the German word. While following the discussion that now ensues, in which Enframing assumes a central role, the reader should be careful not to interpret the word as though it simply meant a framework of some sort. Instead he should constantly remember that Enframing is fundamentally a calling-forth. It is a "challenging claim," a demanding summons, that "gathers" so as to reveal. This claim enframes in that it assembles and orders. It puts into a framework or configuration everything that it summons forth, through an ordering for use that it is forever restructuring anew. Cf. Introduction, pp. xxix ff.

According to ordinary usage, the word *Gestell* [frame] means some kind of apparatus, e.g., a bookrack. *Gestell* is also the name for a skeleton. And the employment of the word *Ge-stell* [Enframing] that is now required of us seems equally eerie, not to speak of the arbitrariness with which words of a mature language are thus misused. Can anything be more strange? Surely not. Yet this strangeness is an old usage of thinking. And indeed thinkers accord with this usage precisely at the point where it is a matter of thinking that which is highest. We, late born, are no longer in a position to appreciate the significance of Plato's daring to use the word *eidos* for that which in everything and in each particular thing endures as present. For *eidos*, in the common speech, meant the outward aspect [*Ansicht*] that a visible thing offers to the physical eye. Plato exacts of this word, however, something utterly extraordinary: that it name what precisely is not and never will be perceivable with physical eyes. But even this is by no means the full extent of what is extraordinary here. For *idea* names not only the nonsensuous aspect of what is physically visible.[18] Aspect (*idea*) names and is, also, that which constitutes the essence in the audible, the tasteable, the tactile, in everything that is in any way accessible. Compared with the demands that Plato makes on language and thought in this and other instances, the use of the word *Gestell* as the name for the essence of modern technology, which we now venture here, is almost harmless. Even so, the usage now required remains something exacting and is open to misinterpretation.

Enframing means the gathering together of that setting-upon which sets upon man, i.e., challenges him forth, to reveal the real, in the mode of ordering, as standing-reserve. Enframing means that way of revealing which holds sway in the essence of modern technology and which is itself nothing technological. On the other hand, all those things that are so familiar to us and are standard parts of an assembly, such as rods, pistons, and chassis, belong to the technological. The assembly itself, however, together with the aforementioned stockparts, falls within

18. Where *idea* is italicized it is not the English word but a transliteration of the Greek.

the sphere of technological activity; and this activity always merely responds to the challenge of Enframing, but it never comprises Enframing itself or brings it about.

The word *stellen* [to set upon] in the name *Ge-stell* [Enframing] not only means challenging. At the same time it should preserve the suggestion of another *Stellen* from which it stems, namely, that producing and presenting [*Her- und Dar-stellen*] which, in the sense of *poiēsis*, lets what presences come forth into unconcealment. This producing that brings forth—e.g., the erecting of a statue in the temple precinct—and the challenging ordering now under consideration are indeed fundamentally different, and yet they remain related in their essence. Both are ways of revealing, of *alētheia*. In Enframing, that unconcealment comes to pass in conformity with which the work of modern technology reveals the real as standing-reserve. This work is therefore neither only a human activity nor a mere means within such activity. The merely instrumental, merely anthropological definition of technology is therefore in principle untenable. And it cannot be rounded out by being referred back to some metaphysical or religious explanation that undergirds it.

It remains true, nonetheless, that man in the technological age is, in a particularly striking way, challenged forth into revealing. That revealing concerns nature, above all, as the chief storehouse of the standing energy reserve. Accordingly, man's ordering attitude and behavior display themselves first in the rise of modern physics as an exact science. Modern science's way of representing pursues and entraps nature as a calculable coherence of forces. Modern physics is not experimental physics because it applies apparatus to the questioning of nature. Rather the reverse is true. Because physics, indeed already as pure theory, sets nature up to exhibit itself as a coherence of forces calculable in advance, it therefore orders its experiments precisely for the purpose of asking whether and how nature reports itself when set up in this way.

But after all, mathematical physics arose almost two centuries before technology. How, then, could it have already been set upon by modern technology and placed in its service? The facts testify to the contrary. Surely technology got under way only

when it could be supported by exact physical science. Reckoned chronologically, this is correct. Thought historically, it does not hit upon the truth.

The modern physical theory of nature prepares the way first not simply for technology but for the essence of modern technology. For already in physics the challenging gathering-together into ordering revealing holds sway. But in it that gathering does not yet come expressly to appearance. Modern physics is the herald of Enframing, a herald whose origin is still unknown. The essence of modern technology has for a long time been concealing itself, even where power machinery has been invented, where electrical technology is in full swing, and where atomic technology is well under way.

All coming to presence, not only modern technology, keeps itself everywhere concealed to the last.[19] Nevertheless, it remains, with respect to its holding sway, that which precedes all: the earliest. The Greek thinkers already knew of this when they said: That which is earlier with regard to the arising that holds sway becomes manifest to us men only later. That which is primally early shows itself only ultimately to men.[20] Therefore, in the realm of thinking, a painstaking effort to think through still more primally what was primally thought is not the absurd wish to revive what is past, but rather the sober readiness to be astounded before the coming of what is early.

Chronologically speaking, modern physical science begins in the seventeenth century. In contrast, machine-power technology develops only in the second half of the eighteenth century. But modern technology, which for chronological reckoning is the later, is, from the point of view of the essence holding sway within it, the historically earlier.

19. "Coming to presence" here translates the gerund *Wesende,* a verbal form that appears, in this volume, only in this essay. With the introduction into the discussion of "coming to presence" as an alternate translation of the noun *Wesen* (essence), subsequent to Heidegger's consideration of the meaning of essence below (pp. 30 ff.), occasionally the presence of *das Wesende* is regrettably but unavoidably obscured.

20. "That which is primally early" translates *die anfängliche Frühe.* For a discussion of that which "is to all present and absent beings . . . the earliest and most ancient at once"—i.e., *Ereignen, das Ereignis*—see "The Way to Language" in *On the Way to Language,* trans. Peter D. Hertz (New York: Harper & Row, 1971), p. 127.

If modern physics must resign itself ever increasingly to the fact that its realm of representation remains inscrutable and incapable of being visualized, this resignation is not dictated by any committee of researchers. It is challenged forth by the rule of Enframing, which demands that nature be orderable as standing-reserve. Hence physics, in all its retreating from the representation turned only toward objects that has alone been standard till recently, will never be able to renounce this one thing: that nature reports itself in some way or other that is identifiable through calculation and that it remains orderable as a system of information. This system is determined, then, out of a causality that has changed once again. Causality now displays neither the character of the occasioning that brings forth nor the nature of the *causa efficiens*, let alone that of the *causa formalis*. It seems as though causality is shrinking into a reporting—a reporting challenged forth—of standing-reserves that must be guaranteed either simultaneously or in sequence. To this shrinking would correspond the process of growing resignation that Heisenberg's lecture depicts in so impressive a manner.*

Because the essence of modern technology lies in Enframing, modern technology must employ exact physical science. Through its so doing, the deceptive illusion arises that modern technology is applied physical science. This illusion can maintain itself only so long as neither the essential origin of modern science nor indeed the essence of modern technology is adequately found out through questioning.

We are questioning concerning technology in order to bring to light our relationship to its essence. The essence of modern technology shows itself in what we call Enframing. But simply to point to this is still in no way to answer the question concerning technology, if to answer means to respond, in the sense of correspond, to the essence of what is being asked about.

Where do we find ourselves brought to, if now we think one step further regarding what Enframing itself actually is? It is nothing technological, nothing on the order of a machine. It is the way in which the real reveals itself as standing-reserve.

* W. Heisenberg, "Das Naturbild in der heutigen Physik," in *Die Künste im technischen Zeitalter* (Munich, 1954), pp. 43 ff.

Again we ask: Does this revealing happen somewhere beyond all human doing? No. But neither does it happen exclusively *in* man, or decisively *through* man.

Enframing is the gathering together that belongs to that setting-upon which sets upon man and puts him in position to reveal the real, in the mode of ordering, as standing-reserve. As the one who is challenged forth in this way, man stands within the essential realm of Enframing. He can never take up a relationship to it only subsequently. Thus the question as to how we are to arrive at a relationship to the essence of technology, asked in this way, always comes too late. But never too late comes the question as to whether we actually experience ourselves as the ones whose activities everywhere, public and private, are challenged forth by Enframing. Above all, never too late comes the question as to whether and how we actually admit ourselves into that wherein Enframing itself comes to presence.

The essence of modern technology starts man upon the way of that revealing through which the real everywhere, more or less distinctly, becomes standing-reserve. "To start upon a way" means "to send" in our ordinary language. We shall call that sending-that-gathers [*versammelde Schicken*] which first starts man upon a way of revealing, destining [*Geschick*].[21] It is from out of this destining that the essence of all history [*Geschichte*] is determined. History is neither simply the object of written chronicle nor simply the fulfillment of human activity. That activity first becomes history as something destined.* And it is only the destining into objectifying representation that makes the historical accessible as an object for historiography, i.e., for a science, and on this basis makes possible the current equating of the historical with that which is chronicled.

Enframing, as a challenging-forth into ordering, sends into a way of revealing. Enframing is an ordaining of destining, as is

21. For a further presentation of the meaning resident in *Geschick* and the related verb *schicken*, cf. T 38 ff., and Introduction, pp. xxviii ff.

* See *Vom Wesen der Wahrheit*, 1930; 1st ed., 1943, pp. 16 ff. [English translation, "On the Essence of Truth," in *Existence and Being*, ed. Werner Brock (Chicago: Regnery, 1949), pp. 308 ff.]

every way of revealing. Bringing-forth, *poiēsis*, is also a destining in this sense.

Always the unconcealment of that which is[22] goes upon a way of revealing. Always the destining of revealing holds complete sway over man. But that destining is never a fate that compels. For man becomes truly free only insofar as he belongs to the realm of destining and so becomes one who listens and hears [*Hörender*], and not one who is simply constrained to obey [*Höriger*].

The essence of freedom is *originally* not connected with the will or even with the causality of human willing.

Freedom governs the open in the sense of the cleared and lighted up, i.e., of the revealed.[23] It is to the happening of revealing, i.e., of truth, that freedom stands in the closest and most intimate kinship. All revealing belongs within a harboring and a concealing. But that which frees—the mystery—is concealed and always concealing itself. All revealing comes out of the open, goes into the open, and brings into the open. The freedom of the open consists neither in unfettered arbitrariness nor in the constraint of mere laws. Freedom is that which conceals in a way that opens to light, in whose clearing there shimmers that veil that covers what comes to presence of all truth and lets the veil appear as what veils. Freedom is the realm of the destining that at any given time starts a revealing upon its way.

The essence of modern technology lies in Enframing. Enframing belongs within the destining of revealing. These sentences express something different from the talk that we hear more frequently, to the effect that technology is the fate of our age, where "fate" means the inevitableness of an unalterable course.

But when we consider the essence of technology, then we experience Enframing as a destining of revealing. In this way we are already sojourning within the open space of destining, a destining that in no way confines us to a stultified compulsion to push on blindly with technology or, what comes to the same

22. *dessen was ist.* On the peculiar significance of *das was ist* (that which is), see T 44 n. 12.
23. "The open" here translates *das Freie*, cognate with *Freiheit*, freedom. Unfortunately the repetitive stress of the German phrasing cannot be reproduced in English, since the basic meaning of *Freie*—open air, open space —is scarcely heard in the English "free."

thing, to rebel helplessly against it and curse it as the work of the devil. Quite to the contrary, when we once open ourselves expressly to the *essence* of technology, we find ourselves unexpectedly taken into a freeing claim.

The essence of technology lies in Enframing. Its holding sway belongs within destining. Since destining at any given time starts man on a way of revealing, man, thus under way, is continually approaching the brink of the possibility of pursuing and pushing forward nothing but what is revealed in ordering, and of deriving all his standards on this basis. Through this the other possibility is blocked, that man might be admitted more and sooner and ever more primally to the essence of that which is unconcealed and to its unconcealment, in order that he might experience as his essence his needed belonging to revealing.

Placed between these possibilities, man is endangered from out of destining. The destining of revealing is as such, in every one of its modes, and therefore necessarily, *danger.*

In whatever way the destining of revealing may hold sway, the unconcealment in which everything that is shows itself at any given time harbors the danger that man may quail at the unconcealed and may misinterpret it. Thus where everything that presences exhibits itself in the light of a cause-effect coherence, even God can, for representational thinking, lose all that is exalted and holy, the mysteriousness of his distance. In the light of causality, God can sink to the level of a cause, of *causa efficiens.* He then becomes, even in theology, the god of the philosophers, namely, of those who define the unconcealed and the concealed in terms of the causality of making, without ever considering the essential origin of this causality.

In a similar way the unconcealment in accordance with which nature presents itself as a calculable complex of the effects of forces can indeed permit correct determinations; but precisely through these successes the danger can remain that in the midst of all that is correct the true will withdraw.

The destining of revealing is in itself not just any danger, but danger as such.

Yet when destining reigns in the mode of Enframing, it is the supreme danger. This danger attests itself to us in two ways. As soon as what is unconcealed no longer concerns man even as

object, but does so, rather, exclusively as standing-reserve, and man in the midst of objectlessness is nothing but the orderer of the standing-reserve, then he comes to the very brink of a precipitous fall; that is, he comes to the point where he himself will have to be taken as standing-reserve. Meanwhile man, precisely as the one so threatened, exalts himself to the posture of lord of the earth. In this way the impression comes to prevail that everything man encounters exists only insofar as it is his construct. This illusion gives rise in turn to one final delusion: It seems as though man everywhere and always encounters only himself. Heisenberg has with complete correctness pointed out that the real must present itself to contemporary man in this way.* *In truth, however, precisely nowhere does man today any longer encounter himself, i.e., his essence.* Man stands so decisively in attendance on the challenging-forth of Enframing that he does not apprehend Enframing as a claim, that he fails to see himself as the one spoken to, and hence also fails in every way to hear in what respect he ek-sists, from out of his essence, in the realm of an exhortation or address, and thus *can never* encounter only himself.

But Enframing does not simply endanger man in his relationship to himself and to everything that is. As a destining, it banishes man into that kind of revealing which is an ordering. Where this ordering holds sway, it drives out every other possibility of revealing. Above all, Enframing conceals that revealing which, in the sense of *poiēsis*, lets what presences come forth into appearance. As compared with that other revealing, the setting-upon that challenges forth thrusts man into a relation to that which is, that is at once antithetical and rigorously ordered. Where Enframing holds sway, regulating and securing of the standing-reserve mark all revealing. They no longer even let their own fundamental characteristic appear, namely, this revealing as such.

Thus the challenging Enframing not only conceals a former way of revealing, bringing-forth, but it conceals revealing itself and with it That wherein unconcealment, i.e., truth, comes to pass.

* "Das Naturbild," pp. 60 ff.

Enframing blocks the shining-forth and holding-sway of truth. The destining that sends into ordering is consequently the extreme danger. What is dangerous is not technology. There is no demonry of technology, but rather there is the mystery of its essence. The essence of technology, as a destining of revealing, is the danger. The transformed meaning of the word "Enframing" will perhaps become somewhat more familiar to us now if we think Enframing in the sense of destining and danger.

The threat to man does not come in the first instance from the potentially lethal machines and apparatus of technology. The actual threat has already affected man in his essence. The rule of Enframing threatens man with the possibility that it could be denied to him to enter into a more original revealing and hence to experience the call of a more primal truth.

Thus, where Enframing reigns, there is *danger* in the highest sense.

> *But where danger is, grows*
> *The saving power also.*

Let us think carefully about these words of Hölderlin. What does it mean "to save"? Usually we think that it means only to seize hold of a thing threatened by ruin, in order to secure it in its former continuance. But the verb "to save" says more. "To save" is to fetch something home into its essence, in order to bring the essence for the first time into its genuine appearing. If the essence of technology, Enframing, is the extreme danger, and if there is truth in Hölderlin's words, then the rule of Enframing cannot exhaust itself solely in blocking all lighting-up of every revealing, all appearing of truth. Rather, precisely the essence of technology must harbor in itself the growth of the saving power. But in that case, might not an adequate look into what Enframing is as a destining of revealing bring into appearance the saving power in its arising?

In what respect does the saving power grow there also where the danger is? Where something grows, there it takes root, from thence it thrives. Both happen concealedly and quietly and in their own time. But according to the words of the poet we have no right whatsoever to expect that there where the danger is we

should be able to lay hold of the saving power immediately and without preparation. Therefore we must consider now, in advance, in what respect the saving power does most profoundly take root and thence thrive even in that wherein the extreme danger lies, in the holding sway of Enframing. In order to consider this, it is necessary, as a last step upon our way, to look with yet clearer eyes into the danger. Accordingly, we must once more question concerning technology. For we have said that in technology's essence roots and thrives the saving power.

But how shall we behold the saving power in the essence of technology so long as we do not consider in what sense of "essence" it is that Enframing is actually the essence of technology?

Thus far we have understood "essence" in its current meaning. In the academic language of philosophy, "essence" means *what* something is; in Latin, *quid. Quidditas*, whatness, provides the answer to the question concerning essence. For example, what pertains to all kinds of trees—oaks, beeches, birches, firs—is the same "treeness." Under this inclusive genus—the "universal"— fall all real and possible trees. Is then the essence of technology, Enframing, the common genus for everything technological? If that were the case then the steam turbine, the radio transmitter, and the cyclotron would each be an Enframing. But the word "Enframing" does not mean here a tool or any kind of apparatus. Still less does it mean the general concept of such resources. The machines and apparatus are no more cases and kinds of Enframing than are the man at the switchboard and the engineer in the drafting room. Each of these in its own way indeed belongs as stockpart, available resource, or executer, within Enframing; but Enframing is never the essence of technology in the sense of a genus. Enframing is a way of revealing having the character of destining, namely, the way that challenges forth. The revealing that brings forth (*poiēsis*) is also a way that has the character of destining. But these ways are not kinds that, arrayed beside one another, fall under the concept of revealing. Revealing is that destining which, ever suddenly and inexplicably to all thinking, apportions itself into the revealing that brings forth and that also challenges, and which allots itself to man. The challenging reveal-

ing has its origin as a destining in bringing-forth. But at the same time Enframing, in a way characteristic of a destining, blocks *poiēsis*.

Thus Enframing, as a destining of revealing, is indeed the essence of technology, but never in the sense of genus and *essentia*. If we pay heed to this, something astounding strikes us: It is technology itself that makes the demand on us to think in another way what is usually understood by "essence." But in what way?

If we speak of the "essence of a house" and the "essence of a state," we do not mean a generic type; rather we mean the ways in which house and state hold sway, administer themselves, develop and decay—the way in which they "essence" [*Wesen*]. Johann Peter Hebel in a poem, "Ghost on Kanderer Street," for which Goethe had a special fondness, uses the old word *die Weserei*. It means the city hall inasmuch as there the life of the community gathers and village existence is constantly in play, i.e., comes to presence. It is from the verb *wesen* that the noun is derived. *Wesen* understood as a verb is the same as *währen* [to last or endure], not only in terms of meaning, but also in terms of the phonetic formation of the word. Socrates and Plato already think the essence of something as what essences, what comes to presence, in the sense of what endures. But they think what endures as what remains permanently [*das Fortwährende*] (*aei on*). And they find what endures permanently in what, as that which remains, tenaciously persists throughout all that happens. That which remains they discover, in turn, in the aspect [*Aussehen*] (*eidos, idea*), for example, the Idea "house."

The Idea "house" displays what anything is that is fashioned as a house. Particular, real, and possible houses, in contrast, are changing and transitory derivatives of the Idea and thus belong to what does not endure.

But it can never in any way be established that enduring is based solely on what Plato thinks as *idea* and Aristotle thinks as *to ti ēn einai* (that which any particular thing has always been), or what metaphysics in its most varied interpretations thinks as *essentia*.

All essencing endures. But is enduring only permanent enduring? Does the essence of technology endure in the sense of

the permanent enduring of an Idea that hovers over everything technological, thus making it seem that by technology we mean some mythological abstraction? The way in which technology essences lets itself be seen only from out of that permanent enduring in which Enframing comes to pass as a destining of revealing. Goethe once uses the mysterious word *fortgewähren* [to grant permanently] in place of *fortwähren* [to endure permanently].* He hears *währen* [to endure] and *gewähren* [to grant] here in one unarticulated accord.[24] And if we now ponder more carefully than we did before what it is that actually endures and perhaps alone endures, we may venture to say: *Only what is granted endures. That which endures primally out of the earliest beginning is what grants.*[25]

As the essencing of technology, Enframing is that which endures. Does Enframing hold sway at all in the sense of granting? No doubt the question seems a horrendous blunder. For according to everything that has been said, Enframing is, rather, a destining that gathers together into the revealing that challenges forth. Challenging is anything but a granting. So it seems, so long as we do not notice that the challenging-forth into the ordering of the real as standing-reserve still remains a destining that starts man upon a way of revealing. As this destining, the coming to presence of technology gives man entry into That which, of himself, he can neither invent nor in any way make. For there is no such thing as a man who, solely of himself, is only man.

But if this destining, Enframing, is the extreme danger, not only for man's coming to presence, but for all revealing as such, should this destining still be called a granting? Yes, most emphat-

* "Die Wahlverwandtschaften" [Congeniality], pt. II, chap. 10, in the novelette *Die wunderlichen Nachbarskinder* [The strange neighbor's children].

24. The verb *gewähren* is closely allied to the verbs *währen* (to endure) and *wahren* (to watch over, to keep safe, to preserve). *Gewähren* ordinarily means to be surety for, to warrant, to vouchsafe, to grant. In the discussion that follows, the verb will be translated simply with "to grant." But the reader should keep in mind also the connotations of safeguarding and guaranteeing that are present in it as well.

25. *Nur das Gewährte währt. Das anfänglich aus der Frühe Währende ist das Gewährende.* A literal translation of the second sentence would be, "That which endures primally from out of the early. . . ." On the meaning of "the early," see n. 20 above.

ically, if in this destining the saving power is said to grow. Every destining of revealing comes to pass from out of a granting and as such a granting. For it is granting that first conveys to man that share in revealing which the coming-to-pass of revealing needs.[26] As the one so needed and used, man is given to belong to the coming-to-pass of truth. The granting that sends in one way or another into revealing is as such the saving power. For the saving power lets man see and enter into the highest dignity of his essence. This dignity lies in keeping watch over the unconcealment—and with it, from the first, the concealment—of all coming to presence on this earth. It is precisely in Enframing, which threatens to sweep man away into ordering as the supposed single way of revealing, and so thrusts man into the danger of the surrender of his free essence—it is precisely in this extreme danger that the innermost indestructible belongingness of man within granting may come to light, provided that we, for our part, begin to pay heed to the coming to presence of technology.

Thus the coming to presence of technology harbors in itself what we least suspect, the possible arising of the saving power.

Everything, then, depends upon this: that we ponder this arising and that, recollecting, we watch over it. How can this happen? Above all through our catching sight of what comes to presence in technology, instead of merely staring at the technological. So long as we represent technology as an instrument, we remain held fast in the will to master it. We press on past the essence of technology.

When, however, we ask how the instrumental comes to presence as a kind of causality, then we experience this coming to presence as the destining of a revealing.

When we consider, finally, that the coming to presence of the essence of technology comes to pass in the granting that needs and uses man so that he may share in revealing, then the following becomes clear:

26. Here and subsequently in this essay, "coming-to-pass" translates the noun *Ereignis*. Elsewhere, in "The Turning," this word, in accordance with the deeper meaning that Heidegger there finds for it, will be translated with "disclosing that brings into its own." See T 45; see also Introduction, pp. xxxvi–xxxvii.

The essence of technology is in a lofty sense ambiguous. Such ambiguity points to the mystery of all revealing, i.e., of truth.

On the one hand, Enframing challenges forth into the frenziedness of ordering that blocks every view into the coming-to-pass of revealing and so radically endangers the relation to the essence of truth.

On the other hand, Enframing comes to pass for its part in the granting that lets man endure—as yet unexperienced, but perhaps more experienced in the future—that he may be the one who is needed and used for the safekeeping of the coming to presence of truth.[27] Thus does the arising of the saving power appear.

The irresistibility of ordering and the restraint of the saving power draw past each other like the paths of two stars in the course of the heavens. But precisely this, their passing by, is the hidden side of their nearness.

When we look into the ambiguous essence of technology, we behold the constellation, the stellar course of the mystery.

The question concerning technology is the question concerning the constellation in which revealing and concealing, in which the coming to presence of truth, comes to pass.

But what help is it to us to look into the constellation of truth? We look into the danger and see the growth of the saving power.

Through this we are not yet saved. But we are thereupon summoned to hope in the growing light of the saving power. How can this happen? Here and now and in little things, that we may foster the saving power in its increase. This includes holding always before our eyes the extreme danger.

The coming to presence of technology threatens revealing, threatens it with the possibility that all revealing will be consumed in ordering and that everything will present itself only in the unconcealedness of standing-reserve. Human activity can never directly counter this danger. Human achievement alone can never banish it. But human reflection can ponder the fact that

27. "Safekeeping" translates the noun *Wahrnis*, which is unique to Heidegger. *Wahrnis* is closely related to the verb *wahren* (to watch over, to keep safe, to preserve), integrally related to *Wahrheit* (truth), and closely akin to *währen* (to endure) and *gewähren* (to be surety for, to grant). On the meaning of *Wahrnis*, see T 42, n. 9 and n. 12 above.

all saving power must be of a higher essence than what is endangered, though at the same time kindred to it.

But might there not perhaps be a more primally granted revealing that could bring the saving power into its first shining forth in the midst of the danger, a revealing that in the technological age rather conceals than shows itself?

There was a time when it was not technology alone that bore the name *technē*. Once that revealing that brings forth truth into the splendor of radiant appearing also was called *technē*.

Once there was a time when the bringing-forth of the true into the beautiful was called *technē*. And the *poiēsis* of the fine arts also was called *technē*.

In Greece, at the outset of the destining of the West, the arts soared to the supreme height of the revealing granted them. They brought the presence [*Gegenwart*] of the gods, brought the dialogue of divine and human destinings, to radiance. And art was simply called *technē*. It was a single, manifold revealing. It was pious, *promos*, i.e., yielding to the holding-sway and the safekeeping of truth.

The arts were not derived from the artistic. Art works were not enjoyed aesthetically. Art was not a sector of cultural activity.

What, then, was art—perhaps only for that brief but magnificent time? Why did art bear the modest name *technē*? Because it was a revealing that brought forth and hither, and therefore belonged within *poiēsis*. It was finally that revealing which holds complete sway in all the fine arts, in poetry, and in everything poetical that obtained *poiēsis* as its proper name.

The same poet from whom we heard the words

> But where danger is, grows
> The saving power also.

says to us:

> . . . poetically dwells man upon this earth.

The poetical brings the true into the splendor of what Plato in the *Phaedrus* calls *to ekphanestaton*, that which shines forth most purely. The poetical thoroughly pervades every art, every revealing of coming to presence into the beautiful.

Could it be that the fine arts are called to poetic revealing? Could it be that revealing lays claim to the arts most primally, so that they for their part may expressly foster the growth of the saving power, may awaken and found anew our look into that which grants and our trust in it?

Whether art may be granted this highest possibility of its essence in the midst of the extreme danger, no one can tell. Yet we can be astounded. Before what? Before this other possibility: that the frenziedness of technology may entrench itself everywhere to such an extent that someday, throughout everything technological, the essence of technology may come to presence in the coming-to-pass of truth.

Because the essence of technology is nothing technological, essential reflection upon technology and decisive confrontation with it must happen in a realm that is, on the one hand, akin to the essence of technology and, on the other, fundamentally different from it.

Such a realm is art. But certainly only if reflection on art, for its part, does not shut its eyes to the constellation of truth after which we are *questioning*.

Thus questioning, we bear witness to the crisis that in our sheer preoccupation with technology we do not yet experience the coming to presence of technology, that in our sheer aesthetic-mindedness we no longer guard and preserve the coming to presence of art. Yet the more questioningly we ponder the essence of technology, the more mysterious the essence of art becomes.

The closer we come to the danger, the more brightly do the ways into the saving power begin to shine and the more questioning we become. For questioning is the piety of thought.

The Turning

The essence[1] of Enframing is that setting-upon gathered into itself which entraps the truth of its own coming to presence with oblivion.[2] This entrapping disguises itself, in that it develops

1. Throughout this essay the noun *Wesen* will sometimes be given its traditional translation "essence," but more often it will be translated with "coming to presence." For Heidegger the essence of anything is its "enduring as presence." As such, it is the manner in which anything in its enduring comports itself effectually as what it is, i.e., the manner in which it "holds sway" through time (see QT 30; 3, n. 1). In this essay the *Wesen* of that enframing summons—"Enframing," *das Ge-stell*—which governs the modern age is the "challenging setting-upon" (*Stellen*) that sets everything in place as supply, ruling in modern technology (cf. QT 15, n. 14; 19, n. 17); the *Wesen* of modern technology is Enframing itself; the *Wesen* of Being is the manner in which Being endures, at any given time, as the Being of whatever is (cf. p. 38); the *Wesen* of man is that dwelling in openness, accomplished through language and thinking, wherein Being can be and is preserved and set free into presence (cf. pp. 39–42 and "Time and Being" in *On Time and Being*, trans. Joan Stambaugh [New York: Harper & Row, 1972], p. 12).

2. *Vergessenheit* (oblivion) is not to be confused with the propensity to forget things or with a lapse of memory. In this essay, as for Heidegger generally, *Vergessenheit* is to be understood in the positive sense of the Greek *lēthē*. It is that concealedness which is the source and foundation of all unconcealedness or truth (*alētheia*). There can be no unveiling unless there is concealment from whence it comes. The words of Heraclitus, *physis kryptesthai philei*—ordinarily translated "nature loves to hide"—would be rendered by Heidegger approximately as "concealedness is the very heart of coming into appearance" (from the transcript of the "Séminaire tenu au Thor en septembre 1969 par le Professeur Martin Heidegger," p. 21).

into the setting in order of everything that presences as standing-reserve, establishes itself in the standing-reserve, and rules as the standing-reserve.

Enframing comes to presence as the danger. But does the danger therewith announce itself *as* the danger? No. To be sure, men are at all times and in all places exceedingly oppressed by dangers and exigencies. But *the* danger, namely, Being itself endangering itself in the truth of its coming to presence, remains veiled and disguised. This disguising is what is most dangerous in the danger. In keeping with this disguising of the danger through the ordering belonging to Enframing, it seems time and time again as though technology were a means in the hands of man. But, in truth, it is the coming to presence of man that is now being ordered forth to lend a hand to the coming to presence of technology.

Does this mean that man, for better or worse, is helplessly delivered over to technology? No, it means the direct opposite; and not only that, but essentially it means something more than the opposite, because it means something different.

If Enframing is a destining of the coming to presence of Being itself, then we may venture to suppose that Enframing, as one among Being's modes of coming to presence, changes. For what gives destining its character as destining is that it takes place so as suitably to adapt itself to the ordaining that is ever one.[3] To take place so as to adapt means to set out in order to adjust fittingly to the directing already made apparent—for which another destining, yet veiled, is waiting. That which has the character of destining moves, in itself, at any given time, toward a special moment that sends it into another destining, in which, however, it is not simply submerged and lost. We are still too

3. "Destining" translates *Geschick*, which ordinarily means skill, aptitude, fitness, as well as fate or destiny, and is here regularly rendered by "destining." The expressions "ordaining" and "takes place so as suitably to adapt itself" render words closely allied to *Geschick*. "Ordaining" translates *Schickung*, meaning providential decree, dispensation. "To take place so as suitably to adapt" translates the verb *sich schicken*, which means to come to pass or happen, to suit or be fit, to accommodate oneself, to agree with, to match or blend. In this essay, where Heidegger's central concern is with turning about, a changing of direction, the connotations of aptness, fitness, and self-adapting brought forward for *Geschick* in this passage should always be kept in mind for the word "destining." Cf. QT 24.

inexperienced and thoughtless to think the essence of the his-
torical from out of destining and ordaining and taking place so
as to adapt. We are still too easily inclined, out of habit, to
conceive that which has the character of destining in terms of
happening, and to represent the latter as an expiration, a passing
away, of events that have been established historiographically.
We locate history in the realm of happening, instead of thinking
history in accordance with its essential origin from out of des-
tining. But destining is essentially destining of Being, indeed
in such a way that Being itself takes place so as to adapt itself,
and ever comes to presence as a destining and, accordingly,
changes in the manner of a destining. If a change in Being—
i.e., now, in the coming to presence of Enframing—comes to
pass, then this in no way means that technology, whose essence
lies in Enframing, will be done away with.[4] Technology will not
be struck down; and it most certainly will not be destroyed.

If the essence, the coming to presence, of technology, Enfram-
ing as the danger within Being, is Being itself, then technology
will never allow itself to be mastered, either positively or nega-
tively, by a human doing founded merely on itself. Technology,
whose essence is Being itself, will never allow itself to be over-
come by men. That would mean, after all, that man was the
master of Being.

Nevertheless, because Being, as the essence of technology, has
adapted itself into Enframing, and because man's coming to
presence belongs to the coming to presence of Being—inasmuch
as Being's coming to presence needs the coming to presence of
man, in order to remain *kept safe* as Being in keeping with its
own coming to presence in the midst of whatever is, and thus

4. The phrase "comes to pass" renders the German verb *sich ereignet*
(from *sich ereignen*, to happen or take place). The noun *Ereignis* usually
means, correspondingly, event. Later in this essay (p. 45), Heidegger points
to the fact that *Ereignis*, and with it necessarily *sich ereignen*, embodies the
meanings of the two verbs *eignen* (to be one's own, to suit, to belong to),
and the archaic *eräugnen* (to bring before the eyes, to bring to sight). He
says: *Ereignis ist eignende Eräugnis* ("Disclosing coming-to-pass is bring-
ing-to-sight that brings into its own") (p. 45). Although the introduction of
this fullness of meaning for *sich ereignen* and *Ereignis* has been reserved
in the translation for the point at which Heidegger's definitive statement is
made, that meaning clearly informs the argument of the essay throughout
and should therefore be borne in mind.

as Being to endure as present—for 'this reason the coming to presence of technology cannot be led into the change of its destining without the cooperation of the coming to presence of man. Through this cooperation, however, technology will not be overcome [*überwunden*] by men. On the contrary, the coming to presence of technology will be surmounted [*verwunden*] in a way that restores it into its yet concealed truth. This restoring surmounting is similar to what happens when, in the human realm, one gets over grief or pain. But the surmounting of a destining of Being—here and now, the surmounting of Enframing—each time comes to pass out of the arrival of another destining, a destining that does not allow itself either to be logically and historiographically predicted or to be metaphysically construed as a sequence belonging to a process of history. For never does the historical—let alone happening itself as represented historiographically—determine destining; but rather happening, together with the representation of the constancy assigned to it, is already in each instance that which, belonging to a destining of Being, has the character of destining.

Man is indeed needed and used for the restorative surmounting of the essence of technology. But man is used here in his essence that *corresponds* to that surmounting. In keeping with this, man's essence must first open itself to the essence of technology. This opening is, in terms of that coming-to-pass which discloses, something quite different from the event of man's affirming technology and its means and promoting them. However, in order that man in his essence may become attentive to the essence of technology, and in order that there may be founded an essential relationship between technology and man in respect to their essence, modern man must first and above all find his way back into the full breadth of the space proper to his essence. That essential space of man's essential being receives the dimension that unites it to something beyond itself solely from out of the conjoining relation [*Ver-hältnis*] that is the way in which the safekeeping of Being itself is given to belong to the essence of man as the one who is needed and used by Being. Unless man first establishes himself beforehand in the space proper to his essence and there takes up his dwelling, he will not be capable of anything essential within the destining

now holding sway. In pondering this let us pay heed to a word of Meister Eckhart, as we think it in keeping with what is most fundamental to it. It reads: "Those who are not of a great essence, whatever work they perform, nothing comes of it"[5] (*Reden der Unterscheidung*, No. 4).

It is toward the great essence of man that we are thinking, inasmuch as man's essence belongs to the essence of Being and is needed by Being to keep safe the coming to presence of Being into its truth.

Therefore, what is necessary above all is this: that beforehand we ponder the *essence* of Being as that which is worthy of thinking; that beforehand, in thinking this, we experience to what extent we are called upon first to trace a path for such experiencing and to prepare that path as a way into that which till now has been impassable.

All this we can do only if, *before* considering the question that is seemingly always the most immediate one and the only urgent one, What shall we do? we ponder this: *How must we think?* For thinking is genuine activity, genuine taking a hand, if to take a hand means to lend a hand to the essence, the coming to presence, of Being. This means: to prepare (build) for the coming to presence of Being that abode in the midst of whatever is[6] into which Being brings itself and its essence to utterance in language. Language first gives to every purposeful deliberation its ways and its byways. Without language, there would be lacking to every doing every dimension in which it could bestir

5. *Die nitt von grossem wesen sind, was werk die wirken, da wirt nit us.*
6. *inmitten des Seienden.* "Whatever is" here translates *Seienden*, the present participle of the German verb *sein* (to be) used as a noun. The necessity in English of translating *Sein*, when it appears as a noun, with "Being" precludes the possibility of the use of the most obvious translation, "being," for *Seiendes*. A phrase such as the "Being of being" or "Being in the midst of being" would clearly present unacceptable difficulties. Heidegger does not intend *das Seiende* to refer primarily to any mere aggregate of entities or beings, let alone to a particular being. The word connotes for him, first of all, the intricately interrelated entirety of all that *is*, in whose "is" Being is made manifest. The verbal force of the participle is always significantly present. In these essays, the translation of *das Seiende* will vary according to the demands of particular contexts. The translations "what is," "whatever is," "that which is," "what is in being," "whatever is in being," and "that which is in being" will ordinarily be used.

itself and be effective. In view of this, language is never pri-
marily the expression of thinking, feeling, and willing. Language
is the primal dimension within which man's essence is first able
to correspond at all to Being and its claim, and, in correspond-
ing, to belong to Being. *This primal corresponding*, expressly
carried out, *is thinking*. Through thinking, we first learn to dwell
in the realm in which there comes to pass the restorative sur-
mounting of the destining of Being, the surmounting of En-
framing.

The coming to presence of Enframing is the danger. As the
danger, Being turns about into the oblivion of its coming to
presence, turns away from this coming to presence, and in that
way simultaneously turns counter to the truth of its coming to
presence. In the danger there holds sway this turning about not
yet thought on. In the coming to presence of the danger there
conceals itself, therefore, the possibility of a turning in which
the oblivion belonging to the coming to presence of Being will
so turn itself that, with *this* turning, the truth of the coming to
presence of Being will expressly turn in—turn homeward—into
whatever is.[7]

Yet probably *this* turning—the turning of the oblivion of
Being into the safekeeping belonging to the coming to presence
of Being—will finally come to pass only when the danger, which
is in its concealed essence ever susceptible of turning, first comes
expressly to light as the danger that it is. Perhaps we stand
already in the shadow cast ahead by the advent of *this* turning.
When and how it will come to pass after the manner of a des-
tining no one knows. Nor is it necessary that we know. A knowl-

7. "Will turn in—turn homeward—" translates *einkehrt*. The verb
einkehren means to turn in, to enter, to put up at an inn, to alight, to stay.
The related noun *Einkehr*, translated in this essay as "in-turning," means
putting up at an inn; an inn or lodging. *Einkehren* and *Einkehr* speak of a
thorough being at home that yet partakes of the transiency belonging to
the ongoing. Both words suggest the *Heimkehr* (homecoming) important
in Heidegger's earlier Hölderlin essays. The allusion to a transient abiding
made here in these words leads toward Heidegger's culminating portrayal
of the turning within Being as a self-clearing, i.e., a self-opening-up, as
which and into which Being's own self-lighting that is a self-manifesting
entering brings itself to pass. Cf. pp. 44–45, where we find, in immediate
conjunction with *Einkehr*, the introduction of the nouns *Einblick* (entering,
flashing glance, insight) and *Einblitz* (in-flashing).

edge of this kind would even be most ruinous for man, because his essence is to be the one who waits, the one who attends upon the coming to presence of Being in that in thinking he guards it. Only when man, as the shepherd of Being, attends upon the truth of Being can he expect an arrival of a destining of Being and not sink to the level of a mere wanting to know.

But what happens there where the danger comes to pass as the danger and is thus for the first time unconcealedly danger?

That we may hear the answer to this question, let us give heed to the beckoning sign that is preserved in some words of Hölderlin. At the beginning of the later version of his Hymn "Patmos," the poet says:

> But where danger is, grows
> The saving power also.*

If now we think these words still more essentially than the poet sang them, if we follow them in thought as far as they go, they say: Where the danger is as the danger, there the saving power is already thriving also. The latter does not appear incidentally. The saving power is not secondary to the danger. The selfsame danger is, when it is *as* the danger, the saving power. The danger is the saving power, inasmuch as it brings the saving power out of its—the danger's—concealed essence that is ever susceptible of turning. What does "to save" mean? It means to loose, to emancipate, to free, to spare and husband, to harbor protectingly, to take under one's care, to keep safe. Lessing still uses the word "saving" emphatically, in the sense of vindication, i.e., to put something back into what is proper and right, into the essential,[8] and to keep it safe therein. That which genuinely saves is that which keeps safe, safekeeping.[9]

* Von Hellingrath, ed., IV, 227.

8. *in das Rechte, wesenhafte zurückstellen.*

9. The preceding three sentences make plain with peculiar force the meaning that Heidegger intends for the verb *wahren* (to keep safe) and the noun *Wahrnis* (safekeeping). His equating here of these two words with *das Rettende* (the saving-power) draws into them all the connotations of freeing and safeguarding that he has just established for the latter. *Wahren*, ordinarily understood as to watch over, to keep safe, to preserve—and with it *Wahrnis*—clearly carries, simultaneously, connotations of freeing, i.e., of allowing to be manifest. The same connotations are resident in all the

But where is the danger? What is the place for it? Inasmuch as the danger is Being itself, it is both nowhere and everywhere. It *has* no place as something other than itself. It is itself the placeless dwelling place of all presencing. The danger is the epoch of Being coming to presence as Enframing.[10]

When the danger *is* as the danger, then its coming to presence expressly comes to pass. But the danger is the entrapping that is the way in which Being itself, in the mode of Enframing, pursues with oblivion the safekeeping belonging to Being. In the entrapping, what comes to presence is this, that Being dismisses and puts away its truth into oblivion in such a way that Being denies its own coming to presence. When, accordingly, the danger is as the danger, then the entrapping that is the way Being itself entraps its truth with oblivion comes expressly to pass. When this *entrapping-with-oblivion* does come expressly to pass, then oblivion as such turns in and abides. Thus rescued through this abiding from falling away out of remembrance, it is no longer oblivion. With such in-turning, the oblivion relating to Being's safekeeping is no longer the oblivion of Being; but rather, turning in thus, it turns about into the safekeeping of Being. When the danger is as the danger, with the turning about of oblivion, the safekeeping of Being comes to pass; world comes to pass.* That world comes to pass as world, that the thing things, this is the distant advent of the coming to presence of Being itself.

The self-denying of the truth of Being, which entraps itself with oblivion, harbors the favor as yet ungranted, that this self-entrapping will turn about; that, in such turning, oblivion will turn and become the safekeeping belonging to the coming to

words built on *wahr*. They should be heard in *Wahrheit* (truth), which, in the discussion now in progress, is often used—sometimes all but interchangeably—with *Wahrnis*. For the common derivation of *wahren* and *Wahrheit*, and hence of other words built on the stem *wahr*, and for the fundamental meaning therein, cf. SR 164–165.

10. Heidegger never intends "epoch" simply in the sense of "era" or "age." "Epoch" always carries for him the meaning of the Greek *epoche*, i.e., withholding-to-self (*Ansichhalten*). Cf. "Time and Being," *On Time and Being*, p. 9. Here, then, the meaning is that the danger is the self-withholding of Being enduring as present in the mode of Enframing.

* Cf. "The Thing," in *Poetry, Language, Thought*, trans. Albert Hofstadter (New York: Harper & Row, 1971), pp. 165 ff.

presence of Being, instead of allowing that coming to presence to fall into disguise. In the coming to presence of the danger there comes to presence and dwells a favor, namely, the favor of the turning about of the oblivion of Being into the truth of Being. In the coming to presence of the danger, where it *is* as the danger, is the turning about into the safekeeping, is this safekeeping itself, is the saving power of Being.

When the turning comes to pass in the danger, this can happen only without mediation. For Being has no equal whatever. It is not brought about by anything else nor does it itself bring anything about. Being never at any time runs its course within a cause-effect coherence. Nothing that effects, as Being, precedes the mode in which it—Being itself—takes place so as to adapt itself; and no effect, as Being, follows after. Sheerly, out of its own essence of concealedness, Being brings itself to pass into its epoch. Therefore we must pay heed:

The turning of the danger comes to pass suddenly. In this turning, the clearing belonging to the essence of Being suddenly clears itself and lights up. This sudden self-lighting is the lightning-flash. It brings itself into its own brightness, which it itself both brings along and brings in. When, in the turning of the danger, the truth of Being flashes, the essence of Being clears and lights itself up. Then the truth of the essence, the coming to presence, of Being turns and enters in.

Toward where does in-turning bring itself to pass? Toward nowhere except into Being itself, which is as yet coming to presence out of the oblivion of its truth. But this same Being comes to presence as the coming to presence of technology. The coming to presence of technology is Enframing. In-turning, as the bringing to pass of the turning about of oblivion, turns in into that which now is the epoch of Being. That which genuinely is,[11] is in no way this or that particular being. What genuinely is, i.e., what expressly dwells and endures as present in the "is," is uniquely Being. Only Being "is," only in Being and as Being does that which the "is" names bring itself to pass; that which is, is Being from out of its essence.[12]

11. *Das was eigentlich ist.*
12. "That which is" here translates *das was ist.* In the discussion that begins at this point, Heidegger is clearly employing a usage that must force

"To flash [*blitzen*], in terms both of its derivation and of what it designates, is "to glance" [*blicken*]. In the flashing glance and as that glance, the essence, the coming to presence, of Being enters into its own emitting of light. Moving through the element of its own shining, the flashing glance retrieves that which it catches sight of and brings it back into the brightness of its own looking. And yet that glancing, in its giving of light, simultaneously keeps safe the concealed darkness of its origin as the unlighted. The in-turning [*Einkehr*] that is the lightning-flash of the truth of Being is the entering, flashing glance—insight [*Einblick*]. We have thought the truth of Being in the worlding of world as the mirror play of the fourfold of sky and earth, mortals and divinities.* When oblivion turns about, when world as the safekeeping of the coming to presence of Being turns in, then there comes to pass the in-flashing [*Einblitz*] of world into the injurious neglect of the thing.[13] That neglect comes to pass in the mode of the rule of Enframing. In-flashing of world into Enframing is in-flashing of the truth of Being into truthless Being. In-flashing is the disclosing coming-to-pass within Being itself. Disclosing coming-to-pass [*Ereignis*] is bringing to sight that brings into its own [*eignende Eräugnis*].

any German reader to think afresh; by specifically distinguishing *das was ist* from any use of the present participle *Seiendes* for "this or that particular being," he can set forth a distinction apparent in the words themselves. For the English-speaking reader of this volume, however, a different and more difficult problem remains. Since *das Seiende* is very often translated in these essays with "what is," "whatever is," and "that which is," confusion could easily result in the present context. Only in the discussion now underway, in two related passages in QT (pp. 25, 27), and in one other instance (WN 97) will "that which is" translate forms of *das was ist; das Seiende* will be translated variously as "what is," "what is in being," and "that which is in being."

* Cf. *Poetry, Language, Thought,* 165ff.

13. "Injurious neglect" translates *Verwahrlosung.* Doubtless we should hear in *Verwahrlosung*—a noun built on the verb *verwahren* (to keep, guard, secure, protect) with the negating prefix *los-* —connotations that go beyond its ordinary meaning of neglect and injury caused by neglect, and that accord with those of manifesting that Heidegger finds resident in the stem *wahr* (cf. p. 42, n. 9). In this and in the following sentence in the text, the reader should be reminded of the character of Enframing as that "setting-upon that challenges forth" which sets everything in place as supply, which orders everything as standing-reserve and hence keeps nothing safe, i.e., leaves nothing free to be as it genuinely is.

Insight into that which is—this designation now names the disclosing that brings into its own that is the coming-to-pass of the turning within Being, of the turning of the denial of Being's coming to presence into the disclosing coming-to-pass of Being's safekeeping. Insight into that which is, is itself the disclosing that brings into its own, as which the truth of Being relates itself and stands in relation to truthless Being. Insight into that which is—this names the constellation in the essence of Being. This constellation is the dimension in which Being comes to presence as the danger.

From the first and almost to the last it has seemed as though "insight into that which is" means only a glance such as we men throw out from ourselves into what is. We ordinarily take "that which is" to be whatever is in being. For the "is" is asserted of what is in being. But now everything has turned about. Insight does not name any discerning examination [*Einsicht*] into what is in being that we conduct for ourselves; insight [*Einblick*] as in-flashing [*Einblitz*] is the disclosing coming-to-pass of the constellation of the turning within the coming to presence of Being itself, and that within the epoch of Enframing. That which is, is in no way that which is in being. For the "it is" and the "is" are accorded to what is in being only inasmuch as what is in being is appealed to in respect to its Being. In the "is," "Being" is uttered: that which "is," in the sense that it constitutes the Being of what is in being, is Being.[14]

The ordering belonging to Enframing sets itself above the thing, leaves it, as thing, unsafeguarded, truthless.[15] In this way Enframing disguises the nearness of world that nears in the thing. Enframing disguises even this, its disguising, just as the forgetting of something forgets itself and is drawn away in the wake of forgetful oblivion. The coming-to-pass of oblivion not only lets fall from remembrance into concealment; but that falling itself falls simultaneously from remembrance into concealment, which itself also falls away in that falling.

14. On the relation between *das Sein* (Being) and *das Seiende* (what is) see "The Onto-theo-logical Constitution of Metaphysics," in *Identity and Difference*, trans. Joan Stambaugh (New York: Harper & Row, 1969), pp. 64, 132.

15. *ungewahrt, wahrlos.*

And yet—in all the disguising belonging to Enframing, the bright open-space of world lights up, the truth of Being flashes. At the instant, that is, when Enframing lights up, in its coming to presence, as the danger, i.e., as the saving-power. In Enframing, moreover, as a destining of the coming to presence of Being, there comes to presence a light from the flashing of Being. Enframing is, though veiled, still glance, and no blind destiny in the sense of a completely ordained fate.

Insight into that which is—thus do we name the sudden flash of the truth of Being into truthless Being.

When insight comes disclosingly to pass, then men are the ones who are struck in their essence by the flashing of Being. In insight, men are the ones who are caught sight of.

Only when man, in the disclosing coming-to-pass of the insight by which he himself is beheld, renounces human self-will and projects himself toward that insight, away from himself, does he correspond in his essence to the claim of that insight. In thus corresponding man is gathered into his own [ge-eignet],[16] that he, within the safeguarded element of world, may, as the mortal, look out toward the divine.

Otherwise not; for the god also is—when he is—a being and stands as a being within Being and its coming to presence, which brings itself disclosingly to pass out of the worlding of world.[17]

16. The translation "gathered into his own" for ge-eignet takes cognizance of the prefix ge-, which Heidegger has separated from the verb eignen (to be one's own). Heidegger repeatedly stresses the force of ge- as meaning "gathering." Cf. e.g., QT 19. Here the suggestion of gathering points to man's belonging within the wholly mutual interrelating of the fourfold of sky and earth, divinities and mortals. The ensuing allusions to "the divine" and "the god" bespeak the same context of thought (cf. "The Thing," Poetry, Language, Thought, pp. 178 ff.). Ge-eignet speaks specifically of that bringing into its own which is the disclosing coming-to-pass (Ereignis) of the "insight into that which is" that is the in-flashing of Being into its own enduring as presence—the in-flashing that brings to pass, in Being's manifesting of itself to itself, the worlding of world and the thinging of the thing.

17. "The god" of whom Heidegger speaks is not the god of the metaphysical-theological tradition of Christendom. Heidegger characteristically thinks of a dimension of the divine that the divinities make manifest—as among the Greeks, or for the Hebrew prophets, or in the preaching of Jesus—and toward which they beckon man. He can speak of the modern age as "the time of the gods that have fled and of the god that is coming" ("Remembrance of the Poet," Tr. Douglas Scott, in Existence and Being,

Only when insight brings itself disclosingly to pass, only when the coming to presence of technology lights up as Enframing, do we discern how, in the ordering of the standing-reserve, the truth of Being remains denied as world. Only then do we notice that all mere willing and doing in the mode of ordering steadfastly persists in injurious neglect. In this same way all mere organizing of the world conceived and represented historiographically in terms of universality remains truthless and without foundation. All mere chasing after the future so as to work out a picture of it through calculation in order to extend what is present and half-thought into what, now veiled, is yet to come, itself still moves within the prevailing attitude belonging to technological, calculating representation. All attempts to reckon existing reality morphologically, psychologically, in terms of decline and loss, in terms of fate, catastrophe, and destruction, are merely technological behavior. That behavior operates through the device of the enumerating of symptoms whose standing-reserve can be increased to infinity and always varied anew. Such analyses of the "situation" do not notice that they are working only according to the meaning and manner of technological dissecting, and that they thus furnish to the technological consciousness the historiographical-technological presentation of happening commensurate with that consciousness. But no historiographical representation of history as happening ever brings us into the proper relation to destining, let alone into the essential origin of destining in the disclosing coming-to-pass of the truth of Being that brings everything into its own.

All that is merely technological never arrives at the essence of technology. It cannot even once recognize its outer precincts.

Therefore, as we seek to give utterance to insight into that which is, we do not describe the situation of our time. It is the constellation of Being that is uttering itself to us.

But we do not yet hear, we whose hearing and seeing are perishing through radio and film under the rule of technology. The

introd. and analysis by Werner Brock [Chicago: Regnery, 1949], p. 288), and can anticipate a time when, through the fulfillment of the essence of that age, Being will make itself accessible to genuine questioning, and "ample space" will therewith be opened "for the decision as to whether Being will once again become capable of a god" (AWP 153).

constellation of Being is the denial of world, in the form of injurious neglect of the thing. Denial is not nothing; it is the highest mystery of Being within the rule of Enframing.

Whether the god lives or remains dead is not decided by the religiosity of men and even less by the theological aspirations of philosophy and natural science. Whether or not God is God comes disclosingly to pass from out of and within the constellation of Being.

So long as we do not, through thinking, experience what is, we can never belong to what will be.

Will insight into that which is bring itself disclosingly to pass?

Will we, as the ones caught sight of, be so brought home into the essential glance of Being that we will no longer elude it? Will we arrive thereby within the essence of the nearness that, in thinging the thing, brings world near? Will we dwell as those at home in nearness, so that we will belong primally within the fourfold of sky and earth, mortals and divinities?

Will insight into that which is bring itself disclosingly to pass? Will we correspond to that insight, through a looking that looks into the essence of technology and becomes aware of Being itself within it?

Will we see the lightning-flash of Being in the essence of technology? The flash that comes out of stillness, as stillness itself? Stillness stills. What does it still? It stills Being into the coming to presence of world.

May world in its worlding be the nearest of all nearing that nears, as it brings the truth of Being near to man's essence, and so gives man to belong to the disclosing bringing-to-pass that is a bringing into its own.

Part II

✠ ✠

The Word of Nietzsche: "God Is Dead"

The following exposition attempts to point the way toward the place from which it may be possible someday to ask the question concerning the essence of nihilism.[1] The exposition stems from a thinking that is for once just beginning to gain some clarity concerning Nietzsche's fundamental position within the history of Western metaphysics. This pointing of the way will clarify a stage in Western metaphysics that is probably its final stage; for inasmuch as through Nietzsche metaphysics has in a certain sense divested itself of its own essential possibility, other possibilities of metaphysics can no longer appear. Through the overturning of metaphysics accomplished by Nietzsche,[2] there remains for metaphysics nothing but a turning aside into its own inessentiality and disarray. The suprasensory is transformed

1. "Essence" will be the translation of the noun *Wesen* throughout this essay. The reader should continually keep in mind that the "essence" of metaphysics or of nihilism, of the will to power or of value or of truth, always means fundamentally for Heidegger the manner in which each, in its ongoing presence, "holds sway" and prevails as whatever it is. See QT 3, n. 1, 30.

2. Throughout this essay the word "overturning" (*Umkehrung*) is used in the sense of an upsetting or a turning upside down, never in the sense of an overcoming or conquest (*Überwindung*).

into an unstable product of the sensory. And with such a debasement of its antithesis, the sensory denies its own essence. The deposing of the suprasensory does away with the merely sensory and thus with the difference between the two. The deposing of the suprasensory culminates in a "neither-nor" in relation to the distinction between the sensory (*aesthēton*) and the nonsensory (*noēton*). It culminates in meaninglessness. It remains, nevertheless, the unthought and invincible presupposition of its own blind attempts to extricate itself from meaninglessness through a mere assigning of sense and meaning.

In what follows, metaphysics is thought as the truth of what *is* as such in its entirety, and not as the doctrine of any particular thinker. Each thinker has at any given time his fundamental philosophical position within metaphysics. Therefore a particular metaphysics can be called by his name. However, according to what is here thought as the essence of metaphysics, that does not mean in any way that metaphysics at any given time is the accomplishment and possession of the thinker as a personality within the public framework of creative cultural activity. In every phase of metaphysics there has been visible at any particular time a portion of a way that the destining of Being prepares as a path for itself over and beyond whatever is, in sudden epochs of truth.[3] Nietzsche himself interprets the course of Western history metaphysically, and indeed as the rise and development of nihilism. The thinking through of Nietzsche's metaphysics becomes a reflection on the situation and place of contemporary man, whose destiny is still but little experienced with respect to its truth. Every reflection of such a kind, however, if it is not simply an empty, repetitious reporting, remains out beyond what usually passes for reflection.[4] Its going beyond is not merely a surmounting and is not at all a surpassing; moreover, it is not an immediate overcoming. The fact that we are reflecting on Nietzsche's metaphysics does not mean that, in addition to considering his ethics and his epistemology and his aesthetics, we are also and above all taking note of his metaphysics; rather it means simply that we are trying to take

3. On the meaning of "epoch," see T 43, n. 10.
4. *Besinnung.* On the meaning of this word, see SR 155 n. 1.

Nietzsche seriously as a thinker. But also, to think means this
for Nietzsche: to represent what is as what is. Any metaphysical
thinking is onto-logy or it is nothing at all.[5]

For the reflection we are attempting here, it is a question of
preparing for a simple and inconspicuous step in thought. What
matters to preparatory thinking is to light up that space within
which Being itself might again be able to take man, with respect
to his essence, into a primal relationship. To be preparatory is
the essence of such thinking.

That thinking, which is essential and which is therefore every-
where and in every respect preparatory, proceeds in an unpre-
tentious way. Here all sharing in thinking, clumsy and groping
though it may be, is an essential help. Sharing in thinking proves
to be an unobtrusive sowing—a sowing that cannot be authen-
ticated through the prestige or utility attaching to it—by sowers
who may perhaps never see blade and fruit and may never know
a harvest. They serve the sowing, and even before that they
serve its preparation.

Before the sowing comes the plowing. It is a matter of making
the field capable of cultivation, the field that through the un-
avoidable predominance of the land of metaphysics has had to
remain in the unknown. It is a matter first of having a presenti-
ment of, then of finding, and then of cultivating, that field. It
is a matter of taking a first walk to that field. Many are the ways,
still unknown, that lead there. Yet always to each thinker there
is assigned but one way, his own, upon whose traces he must
again and again go back and forth that finally he may hold
to it as the one that is his own—although it never belongs to
him—and may tell what can be experienced on that one way.

Perhaps the title *Being and Time* is a road marker belonging

5. The word "onto-logy" is built from the Greek present participle *ontos*
(being). *Ontos* is paralleled by Heidegger's use of the German present
participle *das Seiende* employed as a noun, literally, being, i.e., what is,
what has or is in being. The meaning of "what is" can extend from "a
being" to the most inclusive encompassing of whatever is as such, in its
entirety. For Heidegger connotations of inclusiveness regularly predominate.
Das Seiende stands always in reciprocal and mutually determinative rela-
tion to *das Sein*, the German infinitive translated "Being." On this relation,
see "The Onto-theo-logical Constitution of Metaphysics," in *Identity and
Difference*, trans. Joan Stambaugh (New York: Harper & Row, 1969), pp.
64, 132.

to such a way. In accordance with the essential interwovenness of metaphysics with the sciences, which are counted among metaphysics' own offspring—an interwovenness demanded by metaphysics itself and forever sought anew—preparatory thinking must move from time to time in the sphere of the sciences; for the sciences, in manifold ways, always claim to give the fundamental form of knowing and of the knowable, in advance, whether deliberately or through the kind of currency and effectiveness that they themselves possess. The more unequivocally the sciences press on toward their predetermined technological essence and its distinctive character, the more decisively does the question concerning the possibility of knowledge laid claim to in technology clarify itself—the question concerning the kind and limits of that possibility and concerning its title to rightness.

An education in thinking in the midst of the sciences is part of preparatory thinking and its fulfillment. To find the suitable form for this, so that such education in thinking does not fall victim to a confusion with research and erudition, is the hard thing. This objective is in danger, then, above all when thinking is simultaneously and continually under the obligation of first finding its own abode. To think in the midst of the sciences means to pass near them without disdaining them.

We do not know what possibilities the destining of Western history holds in store for our people and the West. Moreover, the external shaping and ordering of those possibilities is not primarily what is needed. It is important only that learners in thinking should share in learning and, at the same time, sharing in teaching after their manner, should remain on the way and be there at the right moment.

The following exposition confines itself in its aim and scope to the sphere of the one experience from out of which *Being and Time* is thought. That thinking is concerned unceasingly with one single happening: In the history of Western thinking, indeed continually from the beginning, what is, is thought in reference to Being; yet the truth of Being remains unthought, and not only is that truth denied to thinking as a possible experience, but Western thinking itself, and indeed in the form of metaphysics, expressly, but nevertheless unknowingly, veils the happening of that denial.

Preparatory thinking therefore maintains itself necessarily within the realm of historical reflection. For this thinking, history is not the succession of eras, but a unique nearness of the Same[6] that, in incalculable modes of destining and out of changing immediacy, approaches and concerns thinking.

What is important to us now is the reflection pertaining to Nietzsche's metaphysics. Nietzsche's thinking sees itself as belonging under the heading "nihilism." That is the name for a historical movement, recognized by Nietzsche, already ruling throughout preceding centuries, and now determining this century. Nietzsche sums up his interpretation of it in the brief statement: "God is dead."

One could suppose that the pronouncement "God is dead" expresses an opinion of Nietzsche the atheist and is accordingly only a personal attitude, and therefore one-sided, and for that reason also easily refutable through the observation that today everywhere many men seek out the houses of God and endure hardships out of a trust in God as defined by Christianity. But the question remains whether the aforesaid word of Nietzsche is merely an extravagant view of a thinker about whom the correct assertion is readily at hand: he finally went mad. And it remains to ask whether Nietzsche does not rather pronounce here the word that always, within the metaphysically determined history of the West, is already being spoken by implication. Before taking any position too hastily, we must first try to think this pronouncement, "God is dead," in the way in which it is

6. For Heidegger the "Same" is a unity that—far from being abstract and simple—is rather a *together* that involves a reciprocal relation of belonging. That unity of belonging *together* springs out of the disclosing *bringing-into-its-own* (*Ereignis*) that is the unique bringing-to-pass that takes place within Being itself (cf. T 45 ff.). It holds sway in the primal relatings of Being and what is, and of Being and man. Thus the Same is that very difference, that separating-between (*Unter-Schied*), out of which Being and what is endure as present in their differentiating, which is an indissoluble relating. And again, "thinking and Being belong together into the Same and from out of the Same." (See "The Principle of Identity," in *Identity and Difference*, pp. 27 ff., 90 ff.) Thus the Same of which Heidegger here speaks is the Same in the sense of the belonging *together* that rules in the modes of the destining of the Being of what is, and that concerns a thinking that apprehends that Being as determined out of that unity which gives distinctiveness while uniting. (See "The Onto-theo-logical Constitution of Metaphysics," in *Identity and Difference*, pp. 64 ff., 133 ff.)

intended. To that end, therefore, we would do well to put aside all premature opinions that immediately obtrude for us at this dreadful word.

The following reflections attempt to elucidate Nietzsche's pronouncement in a few essential respects. Once again let it be emphasized: The word of Nietzsche speaks of the destining of two millennia of Western history. We ourselves, unprepared as we are, all of us together, must not suppose that through a lecture on the word of Nietzsche we can alter this destining or even simply learn to know it adequately. Even so, this one thing is now necessary: that out of reflection we receive instruction, and that on the way of instruction we learn to reflect.

Every exposition must of course not only draw upon the substance of the text; it must also, without presuming, imperceptibly give to the text something out of its own substance. This part that is added is what the layman, judging on the basis of what he holds to be the content of the text, constantly perceives as a meaning read in, and with the right that he claims for himself criticizes as an arbitrary imposition. Still, while a right elucidation never understands the text better than the author understood it, it does surely understand it differently. Yet this difference must be of such a kind as to touch upon the Same toward which the elucidated text is thinking.

Nietzsche spoke the word "God is dead" for the first time in the third book of his work *The Gay Science*, which appeared in the year 1882. With that work begins Nietzsche's way toward the development of his fundamental metaphysical position. Between it and his vain efforts at shaping his proposed masterpiece lies the publication of *Thus Spoke Zarathustra*. The proposed masterpiece was never completed. Tentatively it was to bear the title "The Will to Power" and to receive the subtitle "Attempt at a Revaluation of All Values."

The strange notion of the death of a god and the dying of the gods was already familiar to the younger Nietzsche. In a note from the time of the completion of his first work, *The Birth of Tragedy*, Nietzsche writes (1870): "I believe in the ancient German saying: 'All gods must die.'" The young Hegel, at the end of his treatise *Faith and Knowledge* (1802), names the "feeling on which rests the religion of the modern period—the feeling

God himself is dead. . . . " Hegel's pronouncement carries a thought different from that contained in the word of Nietzsche. Still, there exists between the two an essential connection that conceals itself in the essence of all metaphysics. The word of Pascal, taken from Plutarch, *"Le grand Pan est mort"* ["Great Pan is dead"] (*Pensées*, 694), belongs within the same realm, even if for contrary reasons.

Let us listen, to begin with, to the full text of section no. 125, from the work *The Gay Science*. The piece is entitled "The Madman" and runs:

The Madman. Have you not heard of that madman who lit a lantern in the bright morning hours, ran to the market place, and cried incessantly, "I seek God! I seek God!" As many of those who do not believe in God were standing around just then, he provoked much laughter. Why, did he get lost? said one. Did he lose his way like a child? said another. Or is he hiding? Is he afraid of us? Has he gone on a voyage? or emigrated? Thus they yelled and laughed. The madman jumped into their midst and pierced them with his glances.

"Whither is God" he cried. "I shall tell you. *We have killed him—* you and I. All of us are his murderers. But how have we done this? How were we able to drink up the sea? Who gave us the sponge to wipe away the entire horizon? What did we do when we unchained this earth from its sun? Whither is it moving now? Whither are we moving now? Away from all suns? Are we not plunging continually? Backward, sideward, forward, in all directions? Is there any up or down left? Are we not straying as through an infinite nothing? Do we not feel the breath of empty space? Has it not become colder? Is not night and more night coming on all the while? Must not lanterns be lit in the morning? Do we not hear anything yet of the noise of the gravediggers who are burying God? Do we not smell anything yet of God's decomposition? Gods too decompose. God is dead. God remains dead. And we have killed him. How shall we, the murderers of all murderers, comfort ourselves? What was holiest and most powerful of all that the world has yet owned has bled to death under our knives. Who will wipe this blood off us? What water is there for us to clean ourselves? What festivals of atonement, what sacred games shall we have to invent? Is not the greatness of this deed too great for us? Must not we ourselves become gods simply to seem worthy of it? There has never been a greater

deed; and whoever will be born after us—for the sake of this deed he will be part of a higher history than all history hitherto."

Here the madman fell silent and looked again at his listeners; and they too were silent and stared at him in astonishment. At last he threw his lantern on the ground, and it broke and went out. "I come too early," he said then; "my time has not come yet. This tremendous event is still on its way, still wandering—it has not yet reached the ears of man. Lightning and thunder require time, the light of the stars requires time, deeds require time even after they are done, before they can be seen and heard. This deed is still more distant from them than the most distant stars—*and yet they have done it themselves.*"

It has been related further that on that same day the madman entered divers churches and there sang his *requiem aeternam deo.* Led out and called to account, he is said to have replied each time, "What are these churches now if they are not the tombs and sepulchers of God?"[7]

Four years later (1886) Nietzsche added to the four books of *The Gay Science* a fifth, which is entitled "We Fearless Ones." Over the first section in that book (Aphorism 343) is inscribed "The Meaning of Our Cheerfulness." The piece begins, "The greatest recent event—that 'God is dead,' that the belief in the Christian god has become unbelievable—is already beginning to cast its first shadows over Europe."

From this sentence it is clear that Nietzsche's pronouncement

7. The translation of this passage is from Walter Kaufmann's *The Portable Nietzsche* (New York: Viking, 1968), pp. 95–96. The quotations from Nietzsche in this essay are regularly taken from Kaufmann or Kaufmann-Hollingdale translations when these are available. In some instances quotations have been revised, usually only slightly, where the context of Heidegger's thinking makes changes necessary so as to bring out the meaning that Heidegger sees in Nietzsche's words. The following is a list of passages where alterations in translation have been made; page numbers in parentheses refer to pages in this volume. From *The Will to Power*, trans. Walter Kaufmann and R. J. Hollingdale (New York: Random House, 1968): Aph 2 (p. 66), Aph. 1021 (p. 69), Aph. 28 (p. 69), Aph. 14 (p. 70), Aph. 715 (p. 71), Aph. 556 (p. 73), Aph. 715 (p. 74), Aph. 14 (p. 74), Aph. 675 (p. 77–78), Aph. 853 (p. 85). From *On the Genealogy of Morals*, trans. Walter Kaufmann (New York: Random House, 1967): Third Essay, Section I (p. 79). From *Beyond Good and Evil*, trans. Walter Kaufmann (New York: Random House, 1967): Aph. 23 (p. 79). From *Thus Spoke Zarathustra*, in *The Portable Nietzsche*; Close, Part I (p. 111). In all quotations, italics are Nietzsche's unless otherwise indicated.

concerning the death of God means the Christian god. But it is no less certain, and it is to be considered in advance, that the terms "God" and "Christian god" in Nietzsche's thinking are used to designate the suprasensory world in general. God is the name for the realm of Ideas and ideals. This realm of the suprasensory has been considered since Plato, or more strictly speaking, since the late Greek and Christian interpretation of Platonic philosophy, to be the true and genuinely real world. In contrast to it the sensory world is only the world down here, the changeable, and therefore the merely apparent, unreal world. The world down here is the vale of tears in contrast to the mountain of everlasting bliss in the beyond. If, as still happens in Kant, we name the sensory world the physical in the broader sense, then the suprasensory world is the metaphysical world.

The pronouncement "God is dead" means: The suprasensory world is without effective power. It bestows no life. Metaphysics, i.e., for Nietzsche Western philosophy understood as Platonism, is at an end. Nietzsche understands his own philosophy as the countermovement to metaphysics, and that means for him a movement in opposition to Platonism.

Nevertheless, as a mere countermovement it necessarily remains, as does everything "anti," held fast in the essence of that over against which it moves. Nietzsche's countermovement against metaphysics is, as the mere turning upside down of metaphysics, an inextricable entanglement in metaphysics, in such a way, indeed, that metaphysics is cut off from its essence and, as metaphysics, is never able to think its own essence. Therefore, what actually happens in metaphysics and as metaphysics itself remains hidden by metaphysics and for metaphysics.

If God as the suprasensory ground and goal of all reality is dead, if the suprasensory world of the Ideas has suffered the loss of its obligatory and above all its vitalizing and upbuilding power, then nothing more remains to which man can cling and by which he can orient himself. That is why in the passage just cited there stands this question: "Are we not straying as through an infinite nothing?" The pronouncement "God is dead" contains the confirmation that this Nothing is spreading out. "Nothing" means here: absence of a suprasensory, obligatory

world. Nihilism, "the most uncanny of all guests," is standing at the door.

The attempt to elucidate Nietzsche's word "God is dead" has the same significance as does the task of setting forth what Nietzsche understands by "nihilism" and of thus showing how Nietzsche himself stands in relation to nihilism. Yet, because this name is often used only as a catchword and slogan and frequently also as an invective intended to prejudice, it is necessary to know what it means. Not everyone who appeals to his Christian faith or to some metaphysical conviction or other stands on that account definitely outside nihilism. Conversely also, however, not everyone who troubles himself with thoughts about Nothing and its essence is a nihilist.

This name is readily used in such a tone as would indicate that the mere designation "nihilist," without one's even thinking to oneself anything specific in the word, already suffices to provide proof that a reflection on Nothing inevitably leads to a plunge into Nothing and means the establishment of the dictatorship of Nothing.

Actually, we should be asking whether the name "nihilism," thought strictly in the sense of Nietzsche's philosophy, has only a nihilistic, i.e., a negative, meaning, one that floats off into the void of nothingness. Given the vague and arbitrary use of the word "nihilism," it is surely necessary, before a thorough discussion of what Nietzsche himself says about nihilism, to gain the right perspective from which we may first begin to question concerning nihilism.

Nihilism is a historical movement, and not just any view or doctrine advocated by someone or other. Nihilism moves history after the manner of a fundamental ongoing event that is scarcely recognized in the destining of the Western peoples. Hence nihilism is also not simply one historical phenomenon among others— not simply one intellectual current that, along with others, with Christendom, with humanism, and with the Enlightenment— also comes to the fore within Western history.

Nihilism, thought in its essence, is, rather, the fundamental movement of the history of the West. It shows such great profundity that its unfolding can have nothing but world catastrophes as its consequence. Nihilism is the world-historical move-

ment of the peoples of the earth who have been drawn into the power realm of the modern age. Hence it is not only a phenomenon of the present age, nor is it primarily the product of the nineteenth century, in which to be sure a perspicacious eye for nihilism awoke and the name also became current. No more is nihilism the exclusive product of particular nations whose thinkers and writers speak expressly of it. Those who fancy themselves free of nihilism perhaps push forward its development most fundamentally. It belongs to the uncanniness of this uncanny guest that it cannot name its own origin.

Nihilism also does not rule primarily where the Christian god is disavowed or where Christianity is combated; nor does it rule exclusively where common atheism is preached in a secular setting. So long as we confine ourselves to looking only at this unbelief turned aside from Christianity, and at the forms in which it appears, our gaze remains fixed merely on the external and paltry façades of nihilism. The speech of the madman says specifically that the word "God is dead" has nothing in common with the opinions of those who are merely standing about and talking confusedly, who "do not believe in God." For those who are merely believers in that way, nihilism has not yet asserted itself at all as the destining of their own history.

So long as we understand the word "God is dead" only as a formula of unbelief, we are thinking it theologically in the manner of apologetics, and we are renouncing all claims to what matters to Nietzsche, i.e., to the reflection that ponders what has already happened regarding the truth of the suprasensory world and regarding its relation to man's essence.

Hence, also, nihilism in Nietzsche's sense in no way coincides with the situation conceived merely negatively, that the Christian god of biblical revelation can no longer be believed in, just as Nietzsche does not consider the Christian life that existed once for a short time before the writing down of the Gospels and before the missionary propaganda of Paul to belong to Christendom. Christendom for Nietzsche is the historical, world-political phenomenon of the Church and its claim to power within the shaping of Western humanity and its modern culture. Christendom in this sense and the Christianity of New Testament faith are not the same. Even a non-Christian life can affirm

Christendom and use it as a means of power, just as, conversely, a Christian life does not necessarily require Christendom. Therefore, a confrontation with Christendom is absolutely not in any way an attack against what is Christian, any more than a critique of theology is necessarily a critique of faith, whose interpretation theology is said to be. We move in the flatlands of the conflicts between world views so long as we disregard these essential distinctions.

In the word "God is dead" the name "God," thought essentially, stands for the suprasensory world of those ideals which contain the goal that exists beyond earthly life for that life and that, accordingly, determines life from above, and also in a certain way, from without. But now when unalloyed faith in God, as determined through the Church, dwindles away, when in particular the doctrine of faith, theology, in its role of serving as the normative explanation of that which is as a whole, is curtailed and thrust aside, then the fundamental structuring, in keeping with which the fixing of goals, extending into the suprasensory, rules sensory, earthly life, is in no way thereby shattered as well.

Into the position of the vanished authority of God and of the teaching office of the Church steps the authority of conscience, obtrudes the authority of reason. Against these the social instinct rises up. The flight from the world into the suprasensory is replaced by historical progress. The otherworldly goal of everlasting bliss is transformed into the earthly happiness of the greatest number. The careful maintenance of the cult of religion is relaxed through enthusiasm for the creating of a culture or the spreading of civilization. Creativity, previously the unique property of the biblical god, becomes the distinctive mark of human activity. Human creativity finally passes over into business enterprise.

Accordingly, that which must take the place of the suprasensory world will be variations on the Christian-ecclesiastical and theological interpretation of the world, which took over its schema of the *ordo* of the hierarchy of beings from the Jewish-Hellenistic world, and whose fundamental structure was established and given its ground through Plato at the beginning of Western metaphysics.

The realm for the essence and the coming-to-pass of nihilism is metaphysics itself—provided always that we do not mean by this name a doctrine, let alone only one particular discipline of philosophy, but that we think rather on the fundamental structuring of that which is, as a whole, insofar as that whole is differentiated into a sensory and a suprasensory world and the former is supported and determined by the latter. Metaphysics is history's open space wherein it becomes a destining that the suprasensory world, the Ideas, God, the moral law, the authority of reason, progress, the happiness of the greatest number, culture, civilization, suffer the loss of their constructive force and become void. We name this decay in the essence of the suprasensory its disessentializing [*Verwesung*].[8] Unbelief in the sense of a falling away from the Christian doctrine of faith is, therefore, never the essence and the ground, but always only a consequence, of nihilism; for it could be that Christendom itself represents one consequence and bodying-forth of nihilism.

From here we are able also to recognize the last aberration to which we remain exposed in comprehending and supposedly combating nihilism. Because we do not experience nihilism as a historical movement that has already long endured, the ground of whose essence lies in metaphysics, we succumb to the ruinous passion for holding phenomena that are already and simply consequences of nihilism for the latter itself, or we set forth the consequences and effects as the causes of nihilism. In our thoughtless accommodation to this way of representing matters, we have for decades now accustomed ourselves to cite the dominance of technology or the revolt of the masses as the cause of the historical condition of the age, and we tirelessly dissect the intellectual situation of the time in keeping with such views. But every analysis of man and his position in the midst of what is, however enlightened and ingenious it may be, remains

8. The noun *Verwesung* in ordinary usage means decomposition, and the corresponding verb *verwesen* means to perish or decay. Heidegger here uses *Verwesung* in a quite literal sense, to refer to that ongoing event of the deposing of the suprasensory world in which the suprasensory loses its essence. As this event takes place, culminating in Nietzsche's decisive work of the overturning of metaphysics, metaphysics, as the truth of what is as such, becomes the very reverse of itself and enters into its own nonenduring.

thoughtless, and engenders only the semblance of reflection so long as it fails to think on the place of habitation proper to man's essence and to experience that place in the truth of Being.

So long as we merely take the appearances of nihilism for nihilism itself, our taking of a position in relation to nihilism remains superficial. It is not one whit less futile when, out of dissatisfaction with the world situation, or out of half-avowed despair or moral indignation, or a believer's self-righteous superiority, it assumes a certain defensive vehemence.

In contrast to this, it is important above all that we reflect. Therefore, let us now ask Nietzsche himself what he understands by nihilism, and let us leave it open at first whether with this understanding Nietzsche after all touches on or can touch nihilism's essence.

In a note from the year 1887 Nietzsche poses the question, "What does nihilism mean?" (*Will to Power*, Aph. 2). He answers: "*That the highest values are devaluing themselves.*"

This answer is underlined and is furnished with the explanatory amplification: "The aim is lacking; 'Why?' finds no answer."

According to this note Nietzsche understands nihilism as an ongoing historical event. He interprets that event as the devaluing of the highest values up to now. God, the suprasensory world as the world that truly is and determines all, ideals and Ideas, the purposes and grounds that determine and support everything that is and human life in particular—all this is here represented as meaning the highest values. In conformity with the opinion that is even now still current, we understand by this the true, the good, and the beautiful; the true, i.e., that which really is; the good, i.e., that upon which everything everywhere depends; the beautiful, i.e., the order and unity of that which is in its entirety. And yet the highest values are already devaluing themselves through the emerging of the insight that the ideal world is not and is never to be realized within the real world. The obligatory character of the highest values begins to totter. The question arises: Of what avail are these highest values if they do not simultaneously render secure the warrant and the ways and means for a realization of the goals posited in them?

If, however, we were to insist on understanding Nietzsche's definition of the essence of nihilism in so many words as the

becoming valueless of the highest values, then we would have that conception of the essence of nihilism that has meanwhile become current and whose currency is undoubtedly strengthened through its being labeled "nihilism": to wit, that the devaluing of the highest values obviously means decay and ruin. Yet for Nietzsche nihilism is not in any way simply a phenomenon of decay; rather nihilism is, as the fundamental event of Western history, simultaneously and above all the intrinsic law of that history. For that reason, in his observations about nihilism Nietzsche gives scant attention to depicting historiographically the ongoing movement of the event of the devaluing of the highest values and to discovering definitively from this, through calculation, the downfall of the West; rather Nietzsche thinks nihilism as the "inner logic" of Western history.

With this, Nietzsche recognizes that despite the devaluing for the world of the highest values hitherto, the world itself remains; and he recognizes that, above all, the world, become value-less, presses inevitably on toward a new positing of values. After the former values have become untenable, the new positing of values changes, in respect to those former values, into a "revaluing of all values." The no to the values hitherto comes out of a yes to the new positing of values. Because in this yes, according to Nietzsche's view, there is no accommodation to or compromise with the former values, the absolute no belongs within this yes to the new value-positing. In order to secure the unconditionality of the new yes against falling back toward the previous values, i.e., in order to provide a foundation for the new positing of values as a countermovement, Nietzsche even designates the new positing of values as "nihilism," namely, as that nihilism through which the devaluing to a new positing of values that is alone definitive completes and consummates itself. This definitive phase of nihilism Nietzsche calls "completed," i.e., classical, nihilism. Nietzsche understands by nihilism the devaluing of the highest values up to now. But at the same time he takes an affirmative stand toward nihilism in the sense of a "revaluing of all previous values." Hence the name "nihilism" remains ambiguous, and seen in terms of its two extremes, always has first of all a double meaning, inasmuch as, on the one hand, it designates the mere devaluing of the highest values up to now,

but on the other hand it also means at the same time the unconditional countermovement to devaluing. Pessimism, which Nietzsche sees as the prefiguration of nihilism, is already twofold also, in the same sense. According to Schopenhauer, pessimism is the belief that in this worst of worlds life is not worth being lived and affirmed. According to this doctrine, life, and that means at the same time all existence as such, is to be denied. This pessimism is, according to Nietzsche, the "pessimism of weakness." It sees everywhere only gloom, finds in everything a ground for failure, and claims to know how everything will turn out, in the sense of a thoroughgoing disaster. Over against this, the pessimism of strength as strength is under no illusion, perceives what is dangerous, wants no covering up and glossing over. It sees to the heart of the ominousness of mere impatient waiting for the return of what has been heretofore. It penetrates analytically into phenomena and demands consciousness of the conditions and forces that, despite everything, guarantee mastery over the historical situation.

A more essential reflection could show how in what Nietzsche calls the pessimism of strength there is accomplished the rising up of modern humanity into the unconditional dominion of subjectivity within the subjectness of what is.[9] Through pessimism

9. "Subjectness" translates *Subjektität*, a word formed by Heidegger to refer to a mode of Being's coming to presence in its reciprocal interrelation with what is, namely, that mode wherein Being manifests itself in respect to what is, appearing as subject, as *subiectum*, as *hypokeimenon* (that which lies before). As such, subjectness has ruled from ancient times, while yet it has changed with the change in the destining of Being that took place at the beginning of the modern age and has reached consummation, through Nietzsche's metaphysics, in the subjectness of the will to power. In like manner, throughout Western history what is has been appearing as subject, though with a transformation corresponding to that change in the destining of Being. What is appeared as the *hypokeimenon* for the Greeks. Subsequently, the character of the *hypokeimenon* was transformed into the self-conscious, self-assertive subject, which, in its subjectivity, holds sway in our age. Heidegger writes elsewhere that the name "subjectness" "*should emphasize the fact that Being is determined in terms of the* subiectum, *but not necessarily by an ego.*" Subjectness "names the unified history of Being, beginning with the essential character of Being as *idea* up to the completion of the modern essence of Being as the will to power." (*The End of Philosophy*, trans. Joan Stambaugh [New York: Harper & Row, 1973], pp. 46, 48. Professor Stambaugh translates *Subjektität* as "subiectity.") Later in this essay (pp. 79 ff.), Heidegger will take up the discussion adumbrated in this sentence and this word.

in its twofold form, extremes become manifest. Those extremes as such maintain the ascendancy. There thus arises a situation in which everything is brought to a head in the absoluteness of an "either-or." An "in-between situation" comes to prevail in which it becomes evident that, on the one hand, the realization of the highest values hitherto is not being accomplished. The world appears value-less. On the other hand, through this making conscious, the inquiring gaze is directed toward the source of the new positing of values, but without the world's regaining its value at all in the process.

To be sure, something else can still be attempted in face of the tottering of the dominion of prior values. That is, if God in the sense of the Christian god has disappeared from his authoritative position in the suprasensory world, then this authoritative place itself is still always preserved, even though as that which has become empty. The now-empty authoritative realm of the suprasensory and the ideal world can still be adhered to. What is more, the empty place demands to be occupied anew and to have the god now vanished from it replaced by something else. New ideals are set up. That happens, according to Nietzsche's conception (*Will to Power*, Aph. 1021, 1887), through doctrines regarding world happiness, through socialism, and equally through Wagnerian music, i.e., everywhere where "dogmatic Christendom" has "become bankrupt." Thus does "incomplete nihilism" come to prevail. Nietzsche says about the latter: "*Incomplete* nihilism: its forms: we live in the midst of it. Attempts to escape nihilism without revaluing our values so far: they produce the opposite, make the problem more acute" (*Will to Power*, Aph. 28, 1887).

We can grasp Nietzsche's thoughts on incomplete nihilism more explicitly and exactly by saying: Incomplete nihilism does indeed replace the former values with others, but it still posits the latter always in the old position of authority that is, as it were, gratuitously maintained as the ideal realm of the suprasensory. Completed nihilism, however, must in addition do away even with the place of value itself, with the suprasensory as a realm, and accordingly must posit and revalue values differently.

From this it becomes clear that the "revaluing of all previous values" does indeed belong to complete, consummated, and

therefore classical nihilism, but the revaluing does not merely replace the old values with new. Revaluing becomes the overturning of the nature and manner of valuing. The positing of values requires a new principle, i.e., a new principle from which it may proceed and within which it may maintain itself. The positing of values requires another realm. The principle can no longer be the world of the suprasensory become lifeless. Therefore nihilism, aiming at a revaluing understood in this way, will seek out what is most alive. Nihilism itself is thus transformed into "the ideal of superabundant life" (*Will to Power*, Aph. 14, 1887). In this new highest value there is concealed another appraisal of life, i.e., of that wherein lies the determining essence of everything living. Therefore it remains to ask what Nietzsche understands by life.

The allusion to the various levels and forms of nihilism shows that nihilism according to Nietzsche's interpretation is, throughout, a history in which it is a question of values—the establishing of values, the devaluing of values, the revaluing of values; it is a question of the positing of values anew and, ultimately and intrinsically, a question of the positing of the principle of all value-positing—a positing that values differently. The highest purposes, the grounds and principles of whatever is, ideals and the suprasensory, God and the gods—all this is conceived in advance as value. Hence we grasp Nietzsche's concept of nihilism adequately only when we know what Nietzsche understands by value. It is from here that we understand the pronouncement "God is dead" for the first time in the way in which it is thought. A sufficiently clear exposition of what Nietzsche thinks in the word "value" is the key to an understanding of his metaphysics.

It was in the nineteenth century that talk of values became current and thinking in terms of values became customary. But only after the dissemination of the writings of Nietzsche did talk of values become popular. We speak of the values of life, of cultural values, of eternal values, of the hierarchy of values, of spiritual values, which we believe we find in the ancients, for example. Through scholarly preoccupation with philosophy and through the reconstructions of Neo-Kantianism, we arrive at value-philosophy. We build systems of values and pursue in ethics classifications of values. Even in Christian theology we

define God, the *summum ens qua summum bonum*, as the highest value. We hold science to be value-free and relegate the making of value judgments to the sphere of world views. Value and the valuable become the positivistic substitute for the metaphysical. The frequency of talk about values is matched by a corresponding vagueness of the concept. This vagueness, for its part, corresponds to the obscurity of the essential origin of value from out of Being. For allowing that value, so often invoked in such a way, is not nothing, it must surely have its essence in Being.

What does Nietzsche understand by value? Wherein is the essence of value grounded? Why is Nietzsche's metaphysics the metaphysics of values?

Nietzsche says in a note (1887–88) what he understands by value: "The point-of-view of 'value' is the point-of-view constituting the *preservation-enhancement conditions* with respect to complex forms of relative duration of life within becoming" (*Will to Power*, Aph. 715).[10]

The essence of value lies in its being a point-of-view. Value means that upon which the eye is fixed. Value means that which is in view for a seeing that aims at something or that, as we say, reckons upon something and therewith must reckon with something else. Value stands in intimate relation to a so-much, to quantity and number. Hence values are related to a "numerical and mensural scale" (*Will to Power*, Aph. 710, 1888). The question still remains: Upon what is the scale of increase and decrease, in its turn, grounded?

Through the characterization of value as a point-of-view there results the one consideration that is for Nietzsche's concept of value essential: as a point-of-view, value is posited at any given time by a seeing and for a seeing. This seeing is of such a kind that it sees inasmuch as it has seen, and that it has seen inasmuch as it has set before itself and thus posited what is sighted, as a

10. Italics Heidegger's. "Point-of-view" (*Gesichtspunkt*) is hyphenated in order to differentiate it from its usual meaning, point of view as a subjective opinion or standpoint. The latter meaning is present in *Gesichtspunkt* as it is used here; but Heidegger stresses immediately that what is mainly involved in valuing for Nietzsche is, rather, a focusing on the point that is in view.

particular something. It is only through this positing which is a representing that the point that is necessary for directing the gaze toward something, and that in this way guides the path of sight, becomes the aim in view—i.e., becomes that which matters in all seeing and in all action guided by sight. Values, therefore, are not antecedently something in themselves so that they can on occasion be taken as points-of-view.

Value is value inasmuch as it counts.[11] It counts inasmuch as it is posited as that which matters. It is so posited through an aiming at and a looking toward that which has to be reckoned upon. Aim, view, field of vision, mean here both the sight beheld and seeing, in a sense that is determined from out of Greek thought, but that has undergone the change of *idea* from *eidos* to *perceptio*. Seeing is that representing which since Leibniz has been grasped more explicitly in terms of its fundamental characteristic of striving (*appetitus*). All being whatever is a putting forward or setting forth, inasmuch as there belongs to the Being of whatever is in being the *nisus*—the impetus to come forward—that enjoins anything to arise (to appear) and thus determines its coming forth. The essence of everything that is—an essence thus possessed of *nisus*—lays hold of itself in this way and posits for itself an aim in view. That aim provides the perspective that is to be conformed to. The aim in view is value.

According to Nietzsche, with values as points-of-view, "*preservation-enhancement conditions*" are posited. Precisely through this way of writing, in which the "and" is omitted between "preservation" and "enhancement" and replaced with a hyphen, Nietzsche wants to make clear that values as points-of-view are essentially and therefore constantly and simultaneously conditions of preservation *and* enhancement. Where values are posited, both ways of serving as conditions must be constantly kept in view in such a way that they remain unitively related to one another. Why? Obviously, simply because any being which, as such, represents and strives, itself so is in its essence that it requires these twofold aims in view. For what do values as points-of-view serve as conditions, if they must function simul-

11. *gilt.* The verb *gelten* has a range of meaning extending from to be of worth or force; through to have influence, to pass current, and to be real or true; to, to rest upon or have at stake.

taneously as conditions of preservation as well as of enhancement?

Preservation and enhancement mark the fundamental tendencies of life, tendencies that belong intrinsically together. To the essence of life belongs the will to grow, enhancement. Every instance of life-preservation stands at the service of life-enhancement. Every life that restricts itself to mere preservation is already in decline. The guaranteeing of space in which to live, for example, is never the goal for whatever is alive, but is only a means to life-enhancement. Conversely, life that is enhanced heightens in turn its prior need to expand its space. But nowhere is enhancement possible where a stable reserve is not already being preserved as secure, and in this way as capable of enhancement. Anything that is alive is therefore something that is bound together by the two fundamental tendencies of enhancement and preservation, i.e., a "complex form of life." Values, as points-of-view, guide seeing "with respect to complex forms." This seeing is at any given time a seeing on behalf of a view-to-life that rules completely in everything that lives. In that it posits the aims that are in view for whatever is alive, life, in its essence, proves to be value-positing (cf. *Will to Power*, Aph. 556, 1885–86).

"Complex forms of life" are oriented with reference to conditions of preserving and stabilizing, and indeed in such a way that what is stable stands fast only in order to become, in enhancement, what is unstable. The duration of these complex forms of life depends on the reciprocal relationship of enhancement and preservation. Hence duration is something comparative. It is always the "relative duration" of what is alive, i.e., of life.

Value is, according to Nietzsche's words, the "point-of-view constituting the preservation-enhancement conditions with respect to complex forms of relative duration of life within becoming." Here and in the conceptual language of Nietzsche's metaphysics generally, the stark and indefinite word "becoming" does not mean some flowing together of all things or a mere change of circumstances; nor does it mean just any development or unspecified unfolding. "Becoming" means the passing over from something to something, that moving and being moved

which Leibniz calls in the *Monadology* (chap. 11) the *changements naturels*, which rule completely the *ens qua ens*, i.e., the *ens percipiens et appetens* [perceptive and appetitive being]. Nietzsche considers that which thus rules to be the fundamental characteristic of everything real, i.e., of everything that is, in the widest sense. He conceives as the "will to power" that which thus determines in its *essentia* whatever is.

When Nietzsche concludes his characterization of the essence of value with the word "becoming," then this closing word gives the clue to the fundamental realm within which alone values and value-positing properly belong. "Becoming" is, for Nietzsche, the "will to power." The "will to power" is thus the fundamental characteristic of "life," which word Nietzsche often uses also in the broad sense according to which, within metaphysics (cf. Hegel), it has been equated with "becoming." "Will to power," "becoming," "life," and "Being" in the broadest sense—these mean, in Nietzsche's language, the Same (*Will to Power*, Aph. 582, 1885–86, and Aph. 689, 1888). Within becoming, life—i.e., aliveness—shapes itself into centers of the will to power particularized in time. These centers are, accordingly, ruling configurations. Such Nietzsche understands art, the state, religion, science, society, to be. Therefore Nietzsche can also say: "Value is essentially the point-of-view for the increasing or decreasing of these dominating centers" (that is, with regard to their ruling character) (*Will to Power*, Aph. 715, 1887–88).

Inasmuch as Nietzsche, in the above-mentioned defining of the essence of value, understands value as the condition—having the character of point-of-view—of the preservation and enhancement of life, and also sees life grounded in becoming as the will to power, the will to power is revealed as that which posits that point-of-view. The will to power is that which, out of its "internal principle" (Leibniz) as the *nisus esse* of the *ens*, judges and esteems in terms of values. The will to power is the ground of the necessity of value-positing and of the origin of the possibility of value judgment. Thus Nietzsche says: "*Values and their changes* are related to the *increase in power of that which posits them*" (*Will to Power*, Aph. 14, 1887).[12]

12. Italics Heidegger's.

Here it is clear: values are the conditions of itself posited by the will to power. Only where the will to power, as the fundamental characteristic of everything real, comes to appearance, i.e., becomes true, and accordingly is grasped as the reality of everything real, does it become evident from whence values originate and through what all assessing of value is supported and directed. The principle of value-positing has now been recognized. Henceforth value-positing becomes achievable "in principle," i.e., from out of Being as the ground of whatever is.

Hence the will to power is, as this recognized, i.e., willed, principle, simultaneously the principle of a value-positing that is new. It is new because for the first time it takes place consciously out of the knowledge of its principle. This value-positing is new because it itself makes secure to itself its principle and simultaneously adheres to this securing as a value posited out of its own principle. As the principle of the new value-positing, however, the will to power is, in relation to previous values, at the same time the principle of the revaluing of all such values. Yet, because the highest values hitherto ruled over the sensory from the height of the suprasensory, and because the structuring of this dominance was metaphysics, with the positing of the new principle of the revaluing of all values there takes place the overturning of all metaphysics. Nietzsche holds this overturning of metaphysics to be the overcoming of metaphysics. But every overturning of this kind remains only a self-deluding entanglement in the Same that has become unknowable.

Inasmuch as Nietzsche understands nihilism as the intrinsic law of the history of the devaluing of the highest values hitherto, but explains that devaluing as a revaluing of all values, nihilism lies, according to Nietzsche's interpretation, in the dominance and in the decay of values, and hence in the possibility of value-positing generally. Value-positing itself is grounded in the will to power. Therefore Nietzsche's concept of nihilism and the pronouncement "God is dead" can be thought adequately only from out of the essence of the will to power. Thus we will complete the last step in the clarifying of that pronouncement when we explain what Nietzsche thinks in the name coined by him, "the will to power."

The name "will to power" is considered to be so obvious

in meaning that it is beyond comprehension why anyone would be at pains specifically to comment on this combination of words. For anyone can experience for himself at any time what "will" means. To will is to strive after something. Everyone today knows, from everyday experience, what power means as the exercise of rule and authority. Will "to" power is, then, clearly the striving to come into power.

According to this opinion the appellation "will to power" presupposes two disparate factors and puts them together into a subsequent relation, with "willing" on one side and "power" on the other. If we ask, finally, concerning the ground of the will to power, not in order merely to express it in other words but also simultaneously to explain it, then what we are shown is that it obviously originates out of a feeling of lack, as a striving after that which is not yet a possession. Striving, the exercise of authority, feeling of lack, are ways of conceiving and are states (psychic capacities) that we comprehend through psychological knowledge. Therefore the elucidation of the essence of the will to power belongs within psychology.

The view that has just been presented concerning the will to power and its comprehensibility is indeed enlightening, but it is a thinking that in every respect misses both what Nietzsche thinks in the word "will to power" and the manner in which he thinks it. The name "will to power" is a fundamental term in the fully developed philosophy of Nietzsche. Hence this philosophy can be called the metaphysics of the will to power. We will never understand what "will to power" in Nietzsche's sense means with the aid of just any popular conception regarding willing and power; rather we will understand only on the way that is a reflection beyond metaphysical thinking, and that means at the same time beyond the whole of the history of Western metaphysics.

The following elucidation of the essence of the will to power thinks out of these contexts. But it must at the same time, even while adhering to Nietzsche's own statements, also grasp these more clearly than Nietzsche himself could immediately utter them. However, it is always only what already has become more meaningful for us that becomes clearer to us. What is meaningful is that which draws closer to us in its essence. Everywhere

here, in what has preceded and in what follows, everything is thought from out of the *essence* of metaphysics and not merely from out of one of its phases.

In the second part of *Thus Spoke Zarathustra*, which appeared the year after the work *The Gay Science* (1883), Nietzsche for the first time names the "will to power" in the context out of which it must be understood: "Where I found the living, there I found will to power; and even in the will of those who serve I found the will to be master."

To will is to will-to-be-master. Will so understood is also even in the will of him who serves. Not, to be sure, in the sense that the servant could aspire to leave his role of subordinate to become himself a master. Rather the subordinate as subordinate, the servant as servant, always wills to have something else under him, which he commands in the midst of his own serving and of which he makes use. Thus is he as subordinate yet a master. Even to be a slave is to will-to-be-master.

The will is not a desiring, and not a mere striving after something, but rather, willing is in itself a commanding (cf. *Thus Spoke Zarathustra*, parts I and II; see also *Will to Power*, Aph. 668, 1888). Commanding has its essence in the fact that the master who commands has conscious disposal over the possibilities for effective action. What is commanded in the command is the accomplishing of that disposal. In the command, the one who commands (not only the one who executes) is obedient to that disposing and to that being able to dispose, and in that way obeys himself. Accordingly, the one who commands proves superior to himself in that he ventures even his own self. Commanding, which is to be sharply distinguished from the mere ordering about of others, is self-conquest and is more difficult than obeying. Will is gathering oneself together for the given task. Only he who cannot obey himself must still be expressly commanded. What the will wills it does not merely strive after as something it does not yet have. What the will wills it has already. For the will wills its will. Its will is what it has willed. The will wills itself. It mounts beyond itself. Accordingly, the will as will wills out beyond itself and must at the same time in that way bring itself behind itself and beneath itself. Therefore Nietzsche can say: "To will at all is the same thing as to

will to become *stronger*, to will to grow . . . " (*Will to Power*, Aph. 675, 1887–88).[13] "Stronger" means here "more power," and that means: only power. For the essence of power lies in being master over the level of power attained at any time. Power is power only when and only so long as it remains power-enhancement and commands for itself "more power." Even a mere pause in power-enhancement, even a mere remaining at a standstill at a level of power, is already the beginning of the decline of power. To the essence of power belongs the over-powering of itself. Such overpowering belongs to and springs from power itself, in that power is command and as command empowers itself for the overpowering of its particular level of power at any given time. Thus power is indeed constantly on the way to itself, but not as a will, ready at hand somewhere for itself, which, in the sense of a striving, seeks to come to power. Moreover, power does not merely empower itself for the over-powering of its level of power at any given time, for the sake of reaching the next level; but rather it empowers itself for this reason alone: to attain power over itself in the unconditionality belonging to its essence. Willing is, according to this defining of its essence, so little a striving that, rather, all striving is only a vestigial or an embryonic form of willing.

In the name "will to power" the word "power" connotes nothing less than the essence of the way in which the will wills itself inasmuch as it is a commanding. As a commanding the will unites itself to itself, i.e., it unites itself to what it wills. This gathering itself together is itself power's assertion of power. Will for itself does not exist any more than does power for itself. Hence, also, will and power are, in the will to power, not merely linked together; but rather the will, as the will to will,[14] is itself the will to power in the sense of the empowering to power. But power has its essence in the fact that it stands to the will as the will standing within that will. The will to power is the essence

13. Here Nietzsche italicizes "to will." Heidegger italicizes "stronger."

14. Here and subsequently the second word "will" in the phrase "will to will" (*Wille zum Willen*) is a noun, not a verb, a distinction impossible to show in English. "Will to will" immediately parallels "will to power" (*Wille zur Macht*).

of power. It manifests the unconditional essence of the will, which as pure will wills itself.

Hence the will to power also cannot be cast aside in exchange for the will to something else, e.g., for the "will to Nothing"; for this latter will also is still the will to will, so that Nietzsche can say, "It (the will) will rather will *Nothing*, than *not* will" (*Genealogy of Morals*, 3, Section I, 1887).[15]

"Willing Nothing" does not in the least mean willing the mere absence of everything real; rather it means precisely willing the real, yet willing the latter always and everywhere as a nullity and, through this, willing only annihilation. In such willing, power always further secures to itself the possibility of command and the ability-to-be-master.

The essence of the will to power is, as the essence of will, the fundamental trait of everything real. Nietzsche says: The will to power is "the innermost essence of Being" (*Will to Power*, Aph. 693, 1888). "Being" means here, in keeping with the language of metaphysics, that which is as a whole. The essence of the will to power and the will to power itself, as the fundamental character of whatever is, therefore cannot be identified through psychological observations; but on the contrary psychology itself first receives its essence, i.e., the positability and knowability of its object, through the will to power. Hence Nietzsche does not understand the will to power psychologically, but rather, conversely, he defines psychology anew as the "morphology and the doctrine of the development of the will to power" (*Beyond Good and Evil*, Aph. 23).[16] Morphology is the ontology of *on* whose *morphē*, transformed through the change of *eidos* to *perceptio*, appears, in the *appetitus* of *perceptio*, as the will to power. The fact that metaphysics—which from ancient times thinks that which is, in respect to its Being, as the *hypokeimenon*, *sub-iectum*—is transformed into the psychology thus defined only testifies, as a consequent phenomenon, to the essential event, which consists in a change in the beingness of what is. The *ousia* (beingness) of the *subiectum* changes into the subjectness

15. Parenthesis Heidegger's.
16. Heidegger omits Nietzsche's italicization of "the development of the will to power."

of self-assertive self-consciousness, which now manifests its es-
sence as the will to will.[17] The will is, as the will to power, the
command to more power. In order that the will in its overpower-
ing of itself may surpass its particular level at any given time,
that level, once reached, must be made secure and held fast.
The making secure of a particular level of power is the necessary
condition for the heightening of power. But this necessary con-
dition is not sufficient for the fact that the will is able to will
itself, for the fact, that is, that a willing-to-be-stronger, an en-
hancement of power, *is*. The will must cast its gaze into a field
of vision and first open it up so that, from out of this, possi-
bilities may first of all become apparent that will point the way
to an enhancement of power. The will must in this way posit a
condition for a willing-out-beyond-itself. The will to power
must, above all, posit conditions for power-preservation and
power-enhancement. To the will belongs the positing of these
conditions that belong intrinsically together.

"*To will* at all is the same thing as to will to become *stronger*,
to will to grow—and, in addition, to will the *means* thereto"
(*Will to Power*, Aph. 675, 1887–88).[18]

The essential means are the conditions of itself posited by the
will to power itself. These conditions Nietzsche calls values. He
says, "In all will there is valuing . . . " (XIII, Aph. 395, 1884).[19]
To value means to constitute and establish worth. The will to
power values inasmuch as it constitutes the conditions of en-
hancement and fixes the conditions of preservation. The will to

17. The German noun *Selbstbewusstsein* means both self-assertion and
self-consciousness. In all other instances of its occurrence, it will be trans-
lated simply as "self-consciousness." As the discussion here in progress
shows, connotations of self-assertion should always be heard in Heidegger's
references to self-consciousness.

18. Heidegger italicizes "stronger" and "means."

19. When, as here, Heidegger cites a work by Roman numeral, he is
referring to the collection of Nietzsche's works called the *Grossoktavaus-
gabe*, which was edited under the general supervision of Elizabeth Förster
Nietzsche and published by Kröner in Leipzig. Heidegger's references are
always to those volumes included in the second section (Volumes IX–XVI)
entitled *Nachlass*. First published between 1901 and 1911, they contain
"notes, fragments, and other materials not published by Nietzsche himself."
See Walter Kaufmann, *Nietzsche: Philosopher, Psychologist, Antichrist*
(New York: Random House, 1968), p. 481. A Kaufmann translation of these
volumes of the *Nachlass* is not available.

power is, in its essence, the value-positing will. Values are the preservation-enhancement conditions within the Being of whatever is. The will to power is, as soon as it comes expressly to appearance in its pure essence, itself the foundation and the realm of value-positing. The will to power does not have its ground in a feeling of lack; rather it itself is the ground of superabundant life. Here life means the will to will. "Living: that already means 'to ascribe worth' " (loc. cit.).

Inasmuch as the will wills the overpowering of itself, it is not satisfied with any abundance of life. It asserts power in overreaching—i.e., in the overreaching of its own will. In this way it continually comes as the selfsame back upon itself as the same.[20] The way in which that which is, in its entirety—whose *essentia* is the will to power—exists, i.e., its *existentia*, is "the eternal returning of the same."[21] The two fundamental terms of

20. In this sentence both "selfsame" and "same" translate *gleich* (equal, equivalent, even, like). Subsequently in this discussion *gleich* will be translated simply with "same." "Same" and "selfsame" must here be taken to carry the meaning of "equivalence." They should not be understood to connote sameness in the sense of simple identity, for they allude to an equivalence resident in the self-relating movement of what is intrinsically one. This latter meaning should be clearly distinguished from that of the "Same," namely, the identity of belonging *together*, which is fundamental for Heidegger's own thinking. See p. 57 n. 6 above. Because of possible confusion, "selfsame" and "same" have been used here only with reluctance, but none of the usual translations of *gleich* prove suitable for the phrasing of the translation.

21. Nietzsche's phrase *die ewige Wiederkunft des Gleichen*, here translated as "the eternal returning of the same," is usually translated as "the eternal recurrence (or return) of the same." The translation "returning" has been chosen in accordance with the burden of Heidegger's present discussion of the will to power as turning back upon itself. The phrase might well be rendered here the "perpetual returning of the selfsame."

The turning back of the will to power upon itself, that it may move forward *as* the will to power, has its correlate for Heidegger in the reflexive movement characteristic of what is as such. "The eternal returning of the same," as the *existentia* of the *essentia*, the will to power, is taken by Heidegger to speak of that mode of Being of all that is which he elsewhere calls "subiectness" (*Subjektität*). Just as the will to power, as the Being of what is, simultaneously and necessarily turns back upon itself in going beyond itself; so, correspondingly, whatever is, in its Being, simultaneously and necessarily goes out beyond itself while yet underlying itself, thereby perpetuating and securing itself. Thus, "Everywhere the Being of whatever is lies in setting-itself-before-itself and thus in setting-itself-up" (p. 100). This is that self-objectifying, self-establishing character of what is which

Nietzsche's metaphysics, "will to power" and "eternal returning of the same," define whatever is, in its Being—*ens qua ens* in the sense of *essentia* and *existentia*—in accordance with the views that have continually guided metaphysics from ancient times.

The essential relationship that is to be thought in this way, between the "will to power" and the "eternal returning of the same," cannot as yet be directly presented here, because metaphysics has neither thought upon nor even merely inquired after the origin of the distinction between *essentia* and *existentia*.

When metaphysics thinks whatever is, in its Being, as the will to power, then it necessarily thinks it as value-positing. It thinks everything within the sphere of values, of the authoritative force of value, of devaluing and revaluing. The metaphysics of the modern age begins with and has its essence in the fact that it seeks the unconditionally indubitable, the certain and assured [*das Gewisse*], certainty.[22] It is a matter, according to the words of Descartes, of *firmum et mansurum quid stabilire*, of bringing to a stand something that is firmly fixed and that remains. This standing established as object is adequate to the

is its character as "representing" and which corresponds to the will to power's simultaneously advancing to greater power and establishing a reserve on the basis of which it can so advance.

22. *Gewiss* (certain) and *Gewissheit* (certainty) are allied to the verb *wissen* (to know). Both words carry a strong connotation of sureness, firmness—the sureness of that which is known. During the discussion that here ensues, the connotations of sureness should always be felt in the words "certain" and "certainty." In particular, "certainty" must never be taken to refer to some sort of merely intellectual certainty. For, as the discussion itself makes clear, the sure certainty here in question partakes of a being secure (n. 28 below). This note of "secureness" will here dominate Heidegger's presentation at length, culminating in the discussion of "justice" (pp. 89 ff.), which, as here under consideration, involves "making secure." The words "knowing" (*wissen*), "self-knowing-itself" (*Sich-selbstwissen*), "gathering-of-knowing" (*Ge-wissen* [normally *Gewissen*, consciousness, conscience]), "conscious" (*bewusst*), and "consciousness" (*Bewusstsein*), which Heidegger will subsequently introduce here, all originate from the same root *wiss* that is found in *gewiss* and *Gewissheit*, and must be seen to lie closely within the sphere of meaning just pointed out for those words.

The most fundamental root meaning resident in *wissen* and its cognates is that of seeing, and this meaning should here also be kept in view, for it doubtless has a part in the meaning that Heidegger intends for truth—which is for him unconcealment—when he speaks of truth as certainty (*Gewissheit*) and of the true as the certain (*das Gewisse*) that is represented, i.e., set before.

essence, ruling from of old, of what is as the constantly presenc-
ing, which everywhere already lies before (*hypokeimenon, sub-
iectum*). Descartes also asks, as does Aristotle, concerning the
hypokeimenon. Inasmuch as Descartes seeks this *subiectum*
along the path previously marked out by metaphysics, he, think-
ing truth as certainty, finds the *ego cogito* to be that which pres-
ences as fixed and constant. In this way, the *ego sum* is
transformed into the *subiectum*, i.e., the subject becomes self-
consciousness. The subjectness of the subject is determined out
of the sureness, the certainty, of that consciousness.

The will to power, in that it posits the preservation, i.e., the
securing, of its own constancy and stability as a necessary value,
at the same time justifies the necessity of such securing in every-
thing that is which, as something that by virtue of its very
essence represents—sets in place before—is something that
also always holds-to-be-true. The making secure that constitutes
this holding-to-be-true is called certainty. Thus, according to
Nietzsche's judgment, certainty as the principle of modern meta-
physics is grounded, as regards its truth, solely in the will to
power, provided of course that truth is a necessary value and
certainty is the modern form of truth. This makes clear in what
respect the modern metaphysics of subjectness is consummated
in Nietzsche's doctrine of the will to power as the "essence" of
everything real.

Therefore Nietzsche can say: "The question of value is more
fundamental than the question of certainty: the latter becomes
serious only by presupposing that the value question has already
been answered" (*Will to Power*, Aph. 588, 1887–88).

However, when once the will to power is recognized as the
principle of value-positing, the inquiry into value must immedi-
ately ponder what the highest value is that necessarily follows
from this principle and that is in conformity with it. Inasmuch
as the essence of value proves itself to be the preservation-
enhancement condition posited in the will to power, the perspec-
tive for a characterization of the normative structuring of value
has been opened up.

The preservation of the level of power belonging to the will
reached at any given time consists in the will's surrounding
itself with an encircling sphere of that which it can reliably

grasp at, each time, as something behind itself, in order on the basis of it to contend for its own security. That encircling sphere bounds off the constant reserve of what presences (*ousia*, in the everyday meaning of this term for the Greeks) that is immediately at the disposal of the will.[23] This that is steadily constant, however, is transformed into the fixedly constant, i.e., becomes that which stands steadily at something's disposal, only in being brought to a stand through a setting in place. That setting in place has the character of a producing that sets before.[24] That which is steadily constant in this way is that which remains. True to the essence of Being (Being = enduring presence) holding sway in the history of metaphysics, Nietzsche calls this that is steadily constant "that which is in being." Often he calls that which is steadily constant—again remaining true to the manner of speaking of metaphysical thinking—"Being." Since the beginning of Western thinking, that which is has been considered to be the true and truth, while yet, in connection with this, the meaning of "being" and "true" has changed in manifold ways. Despite all his overturnings and revaluings of metaphysics, Nietzsche remains in the unbroken line of the metaphysical tradition when he calls that which is established and made fast in the will to power for its own preservation purely and simply Being, or what is in being, or truth. Accordingly, truth is a condition posited in the essence of the will to power, namely, the condition of the preservation of power. Truth is, as this condition, a value.

23. "Constant reserve" renders *Bestand*. Cf. QT 17. *Bestand* does not here have the fully developed meaning of the "standing-reserve" present in that chronologically later essay, but does already approach it. "The constant reserve of what presences," i.e., of what is as such, that the will to power needs for its own preservation and enhancement, becomes, when viewed with regard to man as accepting and accomplishing the dominion of the will to power, that which must be made secure as available for man. Heidegger speaks later in this essay of a making secure of "the stably constant reserve of what is for a willing of the greatest possible uniformity and equality" (p. 102); and the constant reserve is secured that it may be used as a secure resource for every aspect of man's life (p. 107). Here must lie close at hand for us the thought of the standing-reserve as the undifferentiated reserve of the available that is ready for use. In keeping with this, Heidegger's discussion of man under the dominion of the will to power has a close parallel in his discussion of the rule of Enframing in the modern age. Cf. also p. 100 below, QT 19 ff.

24. *Dieses Stellen hat die Art des vor-stellenden Herstellens.*

But because the will can will only from out of its disposal over something steadily constant, truth is a necessary value precisely from out of the essence of the will to power, for that will. The word "truth" means now neither the unconcealment of what is in being, nor the agreement of a judgment with its object, nor certainty as the intuitive isolating and guaranteeing of what is represented. Truth is now, and indeed through an essentially historical origin out of the modes of its essence just mentioned, that which—making stably constant—makes secure the constant reserve, belonging to the sphere from out of which the will to power wills itself.

With respect to the making secure of the level of power that has been reached at any given time, truth is the necessary value. But it does not suffice for the reaching of a level of power; for that which is stably constant, taken alone, is never able to provide what the will requires before everything else in order to move out beyond itself, and that means to enter for the first time into the possibilities of command. These possibilities are given only through a penetrating forward look that belongs to the essence of the will to power; for, as the will to more power, it is, in itself, perspectively directed toward possibilities. The opening up and supplementing of such possibilities is that condition for the essence of the will to power which—as that which in the literal sense goes before—overtops and extends beyond the condition just mentioned. Therefore Nietzsche says: "But truth does not count as the supreme standard of value, even less as the supreme power" (*Will to Power*, Aph. 853, 1887–88).

The creating of possibilities for the will on the basis of which the will to power first frees itself to itself is for Nietzsche the essence of art. In keeping with this metaphysical concept, Nietzsche does not think under the heading "art" solely or even primarily of the aesthetic realm of the artist. Art is the essence of all willing that opens up perspectives and takes possession of them: "The work of art, where it appears *without* an artist, e.g., as body, as organization (Prussian officer corps, Jesuit Order). To what extent the artist is only a preliminary stage. The world as a work of art that gives birth to itself" (*Will to Power*, Aph. 796, 1885–86).[25]

25. Italics Heidegger's.

The essence of art, understood from out of the will to power, consists in the fact that art excites the will to power first of all toward itself [i.e., toward the will] and goads it on to willing out beyond itself. Because Nietzsche, in fading reminiscence of the zōē and *physis* of early Greek thinkers, often also calls the will to power, as the reality of the real, life, he can say that art is "the great stimulant of life" (*Will to Power*, Aph. 851, 1888).

Art is the condition posited in the essence of the will to power for the will's being able, as the will that it is, to ascend to power and to enhance that power. Because it conditions in this way, art is a value. As that condition which—in the hierarchy of the conditioning pertaining to the making secure of a constant reserve—takes the lead and in that way precedes all conditioning, it is the value that first opens all heights of ascent. Art is the highest value. In relation to the value truth, it is the higher value. The one, ever in a fresh way, calls forth the other. Both values determine in their value-relation the unitive essence of the intrinsically value-positing will to power. The will to power is the reality of the real or, taking the word more broadly than Nietzsche usually is accustomed to using it: the Being of that which is. If metaphysics must in its utterance exhibit that which is, in respect to Being, and if therewith after its manner it names the ground of that which is, then the grounding principle of the metaphysics of the will to power must state this ground. The principle declares what values are posited essentially and in what value hierarchy they are posited within the essence of the value-positing will to power as the "essence" [*Essenz*] of that which is. The principle runs: "Art is *worth more* than truth" (*Will to Power*, Aph. 853, 1887–88).

The grounding principle of the metaphysics of the will to power is a value-principle.

It becomes clear from the highest value-principle that value-positing as such is essentially twofold. In it, whether expressly articulated or not, a necessary and a sufficient value are always posited, although both are posited from out of the prevailing relationship of the two to one another. This twofoldness of value-positing corresponds to its principle. That from out of which value-positing as such is supported and guided is the will to power. From out of the unity of its essence it both craves

and is sufficient for the conditions of the enhancement and preservation of itself. The reference to the twofold essence of value-positing brings thinking expressly before the question concerning the essential unity of the will to power. Inasmuch as the will to power is the "essence" of that which is as such, which means moreover that it is the true of metaphysics, we are asking concerning the truth of this true when we ponder the essential unity of the will to power. With that, we attain to the highest point of this and every metaphysics. But what does "highest point" mean here? We shall explain what we mean with reference to the essence of the will to power, and shall thus remain within the bounds that have been drawn for this discussion.

The essential unity of the will to power can be nothing other than the will itself. This unity is the way in which the will to power, as will, brings itself before itself. It orders the will forth into the will's own testing and sets it before the latter in such a way that in such testing the will first represents [repräsentiert] itself purely and therewith in its highest form. Here, representation [Repräsentation] is, however, in no way a presenting [Darstellung] that is supplementary; but rather the presence [Präsenz] determined from out of that presenting is the mode in which and as which the will to power is.

Yet this mode in which the will is, is at the same time the manner in which the will sets itself forth into the unconcealment[26] of itself. And therein lies the will's truth. The question concerning the essential unity of the will to power is the question concerning the type of that truth in which the will to power is as the Being of whatever is. This truth, moreover, is at the same time the truth of that which is as such, and it is as that truth that metaphysics is. The truth concerning which we are now asking is accordingly not that truth which the will to power itself posits as the necessary condition of that which is, as something in being; but rather it is the truth in which the condition-positing will to power as such already comes to presence [west]. This One in which the will to power comes to presence, its essential unity, concerns the will to power itself.

26. das Unverborgene. In this passage, Heidegger's central characterization of truth as unconcealment (Unverborgenheit) must be kept in mind.

But now of what type is this truth of the Being of whatever is? It can be defined only from out of that whose truth it is. However, inasmuch as within modern metaphysics the Being of whatever is has determined itself as will and therewith as self-willing, and, moreover, self-willing is already inherently self-knowing-itself, therefore that which is, the *hypokeimenon*, the *subiectum*, comes to presence in the mode of self-knowing-itself. That which is (*subiectum*) presents itself [*präsentiert sich*], and indeed presents itself to itself, in the mode of the *ego cogito*. This self-presenting, this re-presentation [*Re-präsentation*] (setting-before [*Vor-stellung*]), is the Being of that which is in being *qua subiectum*. Self-knowing-itself is transformed into subject purely and simply. In self-knowing-itself, all knowing and what is knowable for it gathers itself together. It is a gathering together of knowing, as a mountain range is a gathering together of mountains. The subjectivity of the subject is, as such a gathering together, *co-agitatio* (*cogitatio*), *conscientia*, a gathering of knowing [*Ge-wissen*], consciousness (*conscience*).[27] But the *co-agitatio* is already, *in itself*, *velle*, willing. In the subjectness of the subject, will comes to appearance as the essence of subjectness. Modern metaphysics, as the metaphysics of subjectness, thinks the Being of that which is in the sense of will.

It belongs to subjectness, as the primary determination of its essence, that the representing subject makes itself sure of itself—and that means makes itself sure continually also of what it represents—as a particular something. In accordance with such a making sure, the truth of that which is, as certainty [*Gewissheit*], has its character of sureness [*Sicherheit*] (*certitudo*).[28] The self-knowing-itself, wherein is certainty as such, remains

27. The French word *conscience*. On the meaning of the prefix ge- as "gathering," see QT 19.

28. *Sicherheit* (certainty, security, trustworthiness, safeguard) very closely parallels *Gewissheit* (certainty, sureness, certitude, firmness), although in it the connotation of making secure is present in a way not found in *Gewissheit*. This nuance, resident heretofore in Heidegger's discussion in the verb *sichern* (to make secure, to guarantee, to make safe), is now, with this use of *Sicherheit*—in conjunction with *sich versichern* (to assure oneself, to attain certainty, to insure one's life, to arrest [someone]) and *Versicherung* (insurance, assurance, guarantee)—brought forward into the pivotal position it maintains in the discussion immediately following.

for its part a derivative of the former essence of truth, namely, of the correctness (*rectitudo*) of a representing. However, now the correct no longer consists in an assimilation to something presencing that is unthought in its presence. Correctness consists now in the arranging of everything that is to be represented, according to the standard that is posited in the claim to knowledge of the representing *res cogitans sive mens* [thinking thing or mind]. This claim moves toward the secureness that consists in this, that everything to be represented and representing itself are driven together into the clarity and lucidity of the mathematical *idea* and there assembled. The *ens* is the *ens coagitatum perceptionis* [the being that is driven together and consists in perceiving]. The representing is now correct when it is right in relation to this claim to secureness. Proved correct [*richtig*] in this way, it is, as "rightly dealt with" [*recht gefertigt*] and as at our disposal, made right, justified [*gerecht-fertigt*].[29] The truth of anything that is in being, in the sense of the self-certainty of subjectness, is, as secureness (*certitudo*), fundamentally the making-right, the justifying, of representing and of what it represents before representing's own clarity. Justification (*iustificatio*) is the accomplishing of *iustitia* [justice or rightness] and is thus justice [*Gerechtigkeit*] itself.[30] Since the subject

29. Note that Heidegger here brings together three words, all of which are derived from the stem *recht* (right). By so doing, he is able implicitly to show that much of the truth of his statement lies in the words themselves. The discussion that now ensues includes a variety of *recht* words that can be translated accurately in English only by introducing the stem "just." The full significance of this discussion can be appreciated only if we bear constantly in mind the intimate relationship that these *recht* words have to one another. Thus: *richtig* (correct), *rechtfertigen* and *Rechtfertigung* (to justify; justification), *Gerechtigkeit* (justice, rightness, or righteousness), *Gerecht* (right, just, righteous), *das Rechte* (the morally right).

30. The English word "justice" carries strong connotations of an apportioning in an ethical or legal sense. *Iustitia* (justice), as used in medieval and Reformation theology, has a more ample meaning. It alludes to the entire rightness of man's life and the rightness of his relationship to God, i.e., his righteousness. Heidegger here points to the roots of the modern philosophical understanding of justice in this theological tradition. The German word *Gerechtigkeit* (justice or righteousness), because of the centrally formative influence exerted by Luther's translation of the Bible on the modern German language, inevitably carries something of this theological connotation, and the range of its meaning colors Heidegger's present discussion.

is forever subject, it makes itself certain of its own secureness. It justifies itself before the claim to justice that it itself has posited.

At the beginning of the modern age the question was freshly raised as to how man, within the totality of what is, i.e., before that ground of everything in being which is itself most in being (God),[31] can become certain and remain certain of his own sure continuance, i.e., his salvation. This question of the certainty of salvation is the question of justification, i.e., of justice (*iustitia*).

Within modern metaphysics it is Leibniz who first thinks the *subiectum* as *ens percipiens et appetens* [the perceptive and appetitive being]. He is the first to think clearly—in the *vis*-character [force-character] of the *ens*—the volitional essence of the Being of whatever is. In a modern manner he thinks the truth of whatever is in being as sureness and certainty [*Gewiss-heit*]. In his *Twenty-four Theses on Metaphysics*, Leibniz says (Thesis 20): *Iustitia nihil aliud est quam ordo seu perfectio circa mentes.*[32] The *mentes*, i.e., the *res cogitantes* [thinking things], are, according to Thesis 22, the *primariae mundi unitates* [primary units of the world]. Truth as certainty is the making secure of secureness; it is order (*ordo*) and thoroughgoing establishment, i.e., full and utter completion (*per-fectio*). The making secure that characterizes that which primarily and genuinely is, in its Being, is *iustitia* (justice).

Kant, in his laying of the critical foundations of metaphysics, thinks the ultimate self-securing of transcendental subjectivity as the *quaestio iuris* of the transcendental deduction. This is the legal question of the making right, the justification, of the representing subject, which has itself firmly fixed its essence in the self-justifiedness of its "I think."[33]

In the essence of truth as certainty—certainty thought as the

31. *vor dem seiendsten Grund aller Seienden (Gott).*
32. "Justice is nothing but the order and perfection that obtains in respect to minds."
33. "Self-justifiedness" is the translation of *Selbst-Gerechtigkeit. Selbst-gerechtigkeit*, without a hyphen, is always translated "self-righteousness." By hyphenating it here, Heidegger lets it show what in the context of this discussion might be called its more fundamental meaning of self-justified-ness.

truth of subjectness, and subjectness thought as the Being of whatever is—is concealed justice, experienced in terms of the justification having to do with secureness. Indeed, justice holds sway as the essence of the truth of subjectness, although in the metaphysics of subjectness justice is not thought as the truth of that which is. Yet, on the other hand, justice must in fact confront modern metaphysical thinking as the self-knowing Being of everything in being as soon as the Being of whatever is appears as the will to power. The latter knows itself as that which is essentially value-positing, as that which, in its positing of values as the conditions of the constant reserve belonging to its own essence, makes itself secure, and in that way perpetually becomes just and right to itself and in such becoming is justice. It is in justice and as justice that the unique essence of the will to power must represent [repräsentieren], and that means, when thought according to modern metaphysics: be. Just as in Nietzsche's metaphysics the idea of value is more fundamental than the grounding idea of certainty in the metaphysics of Descartes, inasmuch as certainty can count as the right only if it counts as the highest value, so, in the age of the consummation of Western metaphysics in Nietzsche, the intuitive self-certainty of subjectness proves to be the justification belonging to the will to power, in keeping with the justice holding sway in the Being of whatever is.

Already in an earlier and more generally known work, the second Untimely Meditation, "Of the Use and Disadvantage of History" (1874), Nietzsche substitutes "justice" for the objectivity of the historical sciences (fragment 6). But otherwise Nietzsche is silent on the subject of justice. Only in the decisive years 1884–85, when the "will to power" stands before his mind's eye as the fundamental characteristic of whatever is in being, does he write down two ideas on justice without publishing them.

The first note (1884) bears the title: "The Ways of Freedom." It reads: "Justice, as building, separating, annihilating mode of thinking, out of value-judgments; highest representative of life itself" (XIII, Aph. 98).

The second note (1885) says: "Justice, as function of a power having a wide range of vision, which sees out beyond the narrow

perspectives of good and evil, thus has a wider horizon of *interest* —the aim, to preserve Something that is *more* than this or that particular person" (XIV, Aph. 158).[34]

A thorough exposition of these thoughts would extend beyond the limits of the reflection being attempted here. An indication of the essential sphere within which the justice that is thought by Nietzsche belongs will have to suffice. To prepare ourselves for an understanding of the justice that Nietzsche has in view, we must rid ourselves of those conceptions of justice that stem from Christian, humanistic, Enlightenment, bourgeois, and socialist morality. For Nietzsche does not at all understand justice primarily as it is defined in the ethical and juridical realms. Rather, he thinks it from out of the Being of what is as a whole, i.e., from out of the will to power. The just is that which is in conformity with the right. But what is right is determined from out of that which, as whatever is, is in being. Thus Nietzsche says: "Right = the will to eternalize a momentary power relation. Satisfaction with that relation is its presupposition. Everything sacred is drawn toward it to let the right appear as eternal" (XIII, Aph. 462, 1883).

With this belongs the note from the following year: "The problem of *justice*. What is first and most powerful, of course, is precisely the will to and the strength for suprapower. The ruler establishes 'justice' only afterward, i.e., he measures things according to *his* standard; if he is *very powerful*, he can go very far toward *giving free rein* to and recognizing the individual who *tries*" (XIV, Aph. 181). Nietzsche's metaphysical concept of justice may well seem strange when compared with our familiar conception, and this is to be expected; yet for all that, it touches squarely the essence of the justice that at the beginning of the consummation of the modern age, amidst the struggle for mastery of the earth, is already historically true, and that therefore determines all human activity in this period, whether explicitly or not, whether secretly or openly.

The justice thought by Nietzsche is the truth of what is— which now *is* in the mode of the will to power. And yet Nietzsche neither thought justice explicitly as the essence of the truth of

34. Heidegger italicizes "interest" and "more."

what is nor brought to utterance from out of such thought the metaphysics of completed subjectness. Justice is, however, the truth of whatever is, the truth determined by Being itself. As this truth it is metaphysics itself in its modern completion. In metaphysics as such is concealed the reason why Nietzsche can indeed experience nihilism metaphysically as the history of value-positing, yet nevertheless cannot think the essence of nihilism.

We do not know what concealed form, ordained from out of the essence of justice as its truth, was reserved for the metaphysics of the will to power. Scarcely has its first fundamental principle been articulated; and when it has, it has not once been experienced in the form of a principle. To be sure, within this metaphysics the principle-character of that principle is of a peculiar kind. Certainly the first value-principle is not the major premise for a deductive system of propositions. If we take care to understand the designation "fundamental principle of metaphysics" as naming the essential ground of whatever is as such, i.e., as naming the latter in the unity of its essence, then this principle remains sufficiently broad and intricate to determine at any given time, according to the particular type of metaphysics, the way in which the latter declares that ground.

Nietzsche articulated the first value-principle of the metaphysics of the will to power in still another form: "We possess *art* lest we *perish of the truth*" (*Will to Power*, Aph. 822).

We must not, of course, understand in terms of our everyday conceptions of truth and art this principle that concerns the metaphysical relation pertaining to essence—i.e., the metaphysical value-relation—that subsists between art and truth. If that happens, everything becomes banal and, what is all the more ominous, takes from us the possibility of attempting an essential discussion with the concealed position of the metaphysics of our world age—a metaphysics now coming to completion—in order that we may free our own historical essence from being clouded by historiography and world views.

In the formulation of the fundamental principle of the metaphysics of the will to power just cited, art and truth are thought as the primary forms of the holding-sway of the will to power in relation to man. How the essential relation of the truth of what is as such to man's essence is to be thought at all within meta-

physics in keeping with the latter's essence remains veiled to our thinking. The question is scarcely asked, and because of the predominance of philosophical anthropology it is hopelessly confused. In any case, however, it would be erroneous were we to take the formulation of the value-principle as testimony that Nietzsche philosophizes existentially. That he never did. But he did think metaphysically. We are not yet mature enough for the rigor of a thought of the kind found in the following note that Nietzsche wrote down at about the time when he was doing the thinking for his projected masterpiece, *The Will to Power*: "Around the hero everything turns into tragedy; around the demi-god, into a satyr-play; and around God—what?—perhaps into 'world'?" (*Beyond Good and Evil*, Aph. 150, 1886).

But the time has come for us to learn to perceive that Nietzsche's thinking, although it must display another mien when judged historiographically and on the basis of the label assigned it, is no less possessed of matter and substance and is no less rigorous than is the thinking of Aristotle, who in the fourth book of his *Metaphysics* thinks the principle of contradiction as the primary truth regarding the Being of whatever is. The comparison between Nietzsche and Kierkegaard that has become customary, but is no less questionable for that reason, fails to recognize, and indeed out of a misunderstanding of the essence of thinking, that Nietzsche as a metaphysical thinker preserves a closeness to Aristotle. Kierkegaard remains essentially remote from Aristotle, although he mentions him more often. For Kierkegaard is not a thinker but a religious writer, and indeed not just one among others, but the only one in accord with the destining belonging to his age. Therein lies his greatness, if to speak in this way is not already a misunderstanding.

In the fundamental principle of Nietzsche's metaphysics the unity of the essence of the will to power is named with the naming of the essential relation between art and truth. Out of this unity of essence belonging to what is as such, the metaphysical essence of value is determined. Value is the twofold condition of the will to power itself, posited in the will to power for the will to power.

Because Nietzsche experiences the Being of everything that is as the will to power, his thinking must think out toward value.

Thus it is valid, everywhere and before everything else, to pose the question of value. This questioning comes to experience itself as historical.

How does it stand with the highest values up to now? What does the devaluing of those values mean in relation to the revaluing of all values? Because thinking in terms of values is grounded in the metaphysics of the will to power, Nietzsche's interpretation of nihilism as the event of the devaluing of the highest values and the revaluing of all values is a metaphysical interpretation, and that in the sense of the metaphysics of the will to power. However, inasmuch as Nietzsche understands his own thinking—the doctrine of the will to power as the "principle of the new value-positing"—in the sense of the actual consummation of nihilism, he no longer understands nihilism merely negatively as the devaluing of the highest values, but at the same time he understands it positively, that is, as the overcoming of nihilism; for the reality of the real, now explicitly experienced, i.e., the will to power, becomes the origin and norm of a new value-positing. Its values directly determine human representing and in like manner inspire human activity. Being human is lifted into another dimension of happening.

In the passage quoted from *The Gay Science* (Aph. 125), the madman says this of the act of men whereby God was killed, i.e., whereby the suprasensory world was devalued: "There has never been a greater deed; and whoever will be born after us—for the sake of this deed he will be part of a higher history than all history hitherto."

With the consciousness that "God is dead," there begins the consciousness of a radical revaluing of the highest values hitherto. Man himself, according to this consciousness, passes over into another history that is higher, because in it the principle of all value-positing, the will to power, is experienced and accepted expressly *as* the reality of the real, as the Being of everything that is. With this, the self-consciousness in which modern humanity has its essence completes its last step. It wills itself as the executer of the unconditional will to power. The decline of the normative values is at an end. Nihilism, "that the highest values are devaluing themselves," has been overcome. The humanity which wills its own being human as the will to power,

and experiences that being human as belonging within the reality determined in its entirety by the will to power, is determined by a form of man's essence that goes beyond and surpasses man hitherto.

The name for this form of man's essence that surpasses the race of men up to now is "overman."[35] By this name Nietzsche does not mean any isolated exemplar of man in whom the abilities and purposes of man as ordinarily known are magnified and enhanced to gigantic proportions. "Overman" is also not that form of man that first originates upon the path of the practical application of Nietzsche's philosophy to life. The name "overman" designates the essence of humanity, which, as modern humanity, is begining to enter into the consummation belonging to the essence of its age. "Overman" is man who *is* man from out of the reality determined through the will to power, and for that reality.

Man whose essence is that essence which is willing, i.e., ready, from out of the will to power is overman. The willing that characterizes the essence of man that is willing in this way must correspond to the will to power as to the Being of whatever is. Therefore, simultaneously with the thinking that thinks the will to power, there necessarily arises the question: In what form must the essence of man that becomes willing from out of the Being of what is, present itself and unfold, in order that it may be adequate to the will to power and may thus be capable of receiving dominion over all that is? Unexpectedly, and above all in a way unforeseen, man finds himself, from out of the Being of what is, set before the task of taking over dominion of the

35. "Overman" is the translation of *der Übermensch*, which ordinarily means superhuman being, demigod, superman. The term "overman," introduced into Nietzsche translation by Walter Kaufmann, has the advantage of avoiding the misinterpretations that lie ready to hand in the usual translation as "superman." In keeping with Nietzsche's presentation of *der Übermensch* in the figure of Zarathustra, Kaufmann regularly uses "the overman." Here the article has been dropped in the translation of the noun in accordance with the fact that, as Heidegger's ensuing discussion itself makes clear, *Übermensch* is not intended in that discussion to refer at all to an individual man. Rather, the noun has a generic meaning—it refers to man, to humanity. *Übermensch* might almost be translated "man-beyond," for overman stands in contrast with man hitherto and goes beyond (*hinausgeht . . . über*) the latter in his surpassing of him.

earth. Has man hitherto sufficiently considered in what mode
the Being of what is has meanwhile appeared? Has man hitherto
assured himself as to whether his essence has the maturity and
strength to correspond to the claim of that Being? Or does man
hitherto simply get along with the help of expedients and detours
that drive him away ever anew from experiencing that which is?[36]
Man hitherto would like to remain man hitherto; and yet he is
at the same time already the one who, of all that is, is willing—
whose Being is beginning to appear as the will to power. Man
hitherto is, in his essence, not yet at all prepared for Being,
which all the while has been holding complete sway over what
is. In the latter there rules the necessity that man go beyond man
hitherto, not out of mere desire or mere arbitrariness, but solely
for the sake of Being.

Nietzsche's thought that thinks overman arises from the think-
ing that thinks whatever is ontologically as what is in being, and
it thus accommodates itself to the essence of metaphysics, yet
without being able to experience that essence from within meta-
physics. For this reason the respect in which the essence of man
is determined from out of the essence of Being remains concealed
for Nietzsche, just as it does in all metaphysics before him. There-
fore, the ground of the essential connection between the will to
power and the essence of overman necessarily veils itself in
Nietzsche's metaphysics. Yet in every veiling there already rules
simultaneously an appearing. The *existentia* that belongs to the
essentia of whatever is, i.e., to the will to power, is the eternal
returning of the same. The Being that is thought in that return-
ing contains the relation to the essence of overman. But this
relation necessarily remains unthought in its essence as that
essence relates to Being. It thus remains obscure even to Nietzsche
himself what connection the thinking that thinks overman in the
figure of Zarathustra has with the essence of metaphysics. Hence
the character of the work *Thus Spoke Zarathustra* as a *work*
remains concealed. Only when some future thought is brought
into the situation of thinking this "Book for All and None"

36. Here, "that which is" exceptionally translates *das . . . was ist*, rather
than *das Seiende*. This allusion will return below (p. 102) in the question,
"What is?" where the reference in question is Being itself and not any
particular being. Cf. T 46.

together with Schelling's *Investigations on the Essence of Human Freedom* (1809)—and that means at the same time also with Hegel's work *The Phenomenology of Mind* (1807), and also with the *Monadology* (1714) of Leibniz—and only when it is brought into the situation of thinking these works not only metaphysically but from out of the essence of metaphysics will there be established the right and duty as well as the foundation and horizon for an explication.

It is easy but irresponsible to be indignant at the idea and figure of overman, which has clothed itself in the very misunderstanding that attaches to it, and to make this indignation pass for a refutation. It is difficult, but for future thinking it will be inescapable, to attain to the high responsibility out of which Nietzsche pondered the essence of that humanity which, in the destining of Being as the will to power, is being determined toward the assuming of dominion over the earth. The essence of overman is no license for the frenzy of self-will. It is the law grounded in Being itself of a long chain of the highest of self-conquests that are first making man mature for that which is, which, as that which is, belongs to Being—to Being that, as the will to power, is bringing to appearance its essence as will, and through that appearing is making an epoch, namely, the ultimate epoch of metaphysics.

Man hitherto is called this, according to Nietzsche's metaphysics, because, although his essence is indeed determined by the will to power as the fundamental characteristic of all that is, he has still not experienced and accepted the will to power as that principal characteristic. Man who surpasses man up to now takes the will to power, as the principal characteristic of all that is, up into his own willing and in that way wills himself in the manner of the will to power. All that is, *is* as that which is posited within this will. That which formerly conditioned and determined the essence of man in the manner of purpose and norm has lost its unconditional and immediate, above all its ubiquitously and infallibly operative power of effective action. That suprasensory world of purposes and norms no longer quickens and supports life. That world has itself become lifeless, dead. There will be Christian faith here and there. But the love holding sway in that world is not the effectively work-

ing and operative principle of what is happening now. The supra-sensory ground consisting of the suprasensory world, thought as the operative, working reality of everything real, has become unreal.[37] That is the metaphysical meaning of the word "God is dead," thought metaphysically.

Will we persist in closing our eyes in face of the truth of this word, to be thought in this way? If we do so, the word will certainly not become untrue through this curious blindness. God is still not a living God when we persist in trying to master the real without taking God's reality seriously and calling it in question beforehand, and when we persist in this without pondering whether man has so matured for the essence into which, from out of Being, he is being drawn, that he may withstand and surmount that destining genuinely from out of his essence and not do so with the sham help of mere expedients.

The attempt to experience the truth of that word concerning the death of God without illusions is something different from an espousing of Nietzsche's philosophy. Were the latter our intention, thinking would not be served through such assent. We show respect for a thinker only when we think. This demands that we think everything essential that is thought in his thought.

When God and the gods are dead in the sense of the metaphysical experience just elucidated, and when the will to power is deliberately willed as the principle of all positing of the conditions governing whatever is, i.e., as the principle of value-positing, then dominion over that which is as such, in the form of dominion over the earth, passes to the new willing of man determined by the will to power. Nietzsche closes the first part of *Thus Spoke Zarathustra*, which appeared one year after *The Gay Science*, in 1883, with the statement: "*Dead are all gods: now we will that overman live!*"

We could believe, were we thinking crassly, that this pronouncement says that dominion over all that is, is passing from God to man or, even more crassly, that Nietzsche puts man in the place of God. Those who believe thus do not, of course, think

37. *Der übersinnliche Grund der übersinnlichen Welt ist, als die wirksame Wirklichkeit alles Wirklichen gedacht, unwirklich geworden.* On the meaning of the "real" (*das Wirkliche*), as shown through the meaning of *wirken* (to work), see SR 159 ff.

in a very godly way about the divine essence. Never can man put himself in the place of God, because the essence of man never reaches the essential realm belonging to God. On the contrary, compared with this impossibility something far more uncanny can happen, something whose essence we have scarcely begun to consider. Thought metaphysically, the place that is peculiar to God is the place of the causative bringing about and preserving of whatever is, as something created. That place of God can remain empty. Instead of it, another, i.e., a place corresponding metaphysically, can loom on the horizon—a place that is identical neither with the essential realm belonging to God nor with that of man, but with which man comes once more into a distinctive relationship. Overman never enters at all into the place of God; rather the place into which his willing enters is another realm belonging to another grounding of what is, in its other Being. This other Being of what is, meanwhile—and this marks the beginning of modern metaphysics—has become subjectness.

All that is, is now either what is real [*das Wirkliche*] as the object or what works the real [*das Wirkende*], as the objectifying within which the objectivity of the object takes shape. Objectifying, in representing, in setting before, delivers up the object to the *ego cogito*. In that delivering up, the *ego* proves to be that which underlies its own activity (the delivering up that sets before), i.e., proves to be the *subiectum*. The subject is subject for itself. The essence of consciousness is self-consciousness. Everything that is, is therefore either the object of the subject or the subject of the subject. Everywhere the Being of whatever is lies in setting-itself-before-itself and thus in setting-itself-up. Man, within the subjectness belonging to whatever is, rises up into the subjectivity of his essence. Man enters into insurrection. The world changes into object. In this revolutionary objectifying of everything that is, the earth, that which first of all must be put at the disposal of representing and setting forth, moves into the midst of human positing and analyzing. The earth itself can show itself only as the object of assault, an assault that, in human willing, establishes itself as unconditional objectification. Nature appears everywhere—because willed from out of the essence of Being—as the object of technology.

From the same period, 1881–82, in which the passage "The

Madman" originated comes this note of Nietzsche's: "The time is coming when the struggle for dominion over the earth will be carried on. It will be carried on in the name of *fundamental philosophical doctrines*" (XII, 441).[38]

This does not mean that the struggle for unlimited exploitation of the earth as the sphere of raw materials and for the realistic utilization of "human material," in the service of the unconditional empowering of the will to power in its essence, would specifically have recourse to an appeal to a philosophy. On the contrary, it is to be conjectured that philosophy as the doctrine and image of culture will disappear, and that also in its present form it can disappear; for insofar as it has been genuine it has already brought the reality of the real to utterance and in that way has brought that which is as such into the history of its Being. "Fundamental philosophical doctrines" does not mean the doctrines of scholars but the language of the truth of what is as such, which truth metaphysics itself is in the form of the metaphysics of the unconditional subjectness of the will to power.

The struggle for dominion over the earth is in its historical essence already the result of the fact that whatever is as such is appearing in the mode of the will to power without yet being recognized or without being understood at all as that will. At any rate, the doctrines of action and the conceptual ideologies that are commonly subscribed to never utter that which *is*, and which therefore is happening. With the beginning of the struggle for dominion over the earth, the age of subjectness is driving toward its consummation. To this completion belongs the fact that whatever is—which *is* in the manner of the will to power— is, after its fashion and in every respect, becoming certain and therefore also conscious of its own truth about itself. Making conscious is a necessary instrument of the willing that wills from out of the will to power. It happens, in respect to objectification, in the form of planning. It happens, in the sphere of the uprising of man into self-willing, through the ceaseless dissecting of the historical situation. Thought metaphysically, the "situation" is constantly the stage for the action of a subject. Every analysis

38. Italics Heidegger's.

of the situation is grounded, whether it knows it or not, in the metaphysics of subjectness.

"The great noon" is the time of the brightest brightness, namely, of the consciousness that unconditionally and in every respect has become conscious of itself as that knowing which consists in deliberately willing the will to power as the Being of whatever is; and, as such willing, in rebelliously withstanding and subjugating to itself every necessary phase of the objectifying of the world, thus making secure the stably constant reserve of what is for a willing of the greatest possible uniformity and equality. In the willing of this will, however, there comes upon man the necessity that he concomitantly will the conditions, the requirements, of such a willing. That means: to posit values and to ascribe worth to everything in keeping with values. In such a manner does value determine all that is in its Being. This brings us to the question:

What *is* now, in the age when the unconditional dominion of the will to power is openly dawning, and this openness and its public character are themselves becoming a function of this will? What is? We are not asking about events and facts, for every one of which at any time, in the realm of the will to power, testimonies may always be brought forward and laid aside on demand.

What is? We do not ask concerning this or that particular being, but rather we ask concerning the Being of whatever is. More especially, we are asking what is happening to Being itself. Furthermore, we do not ask at random, but with a view to the truth of what is as such, which is coming to utterance in the form of the metaphysics of the will to power. What is happening to Being in the age of the dominion, now beginning, of the unconditional will to power?

Being has been transformed into a value.[39] The making con-

39. Within the highly elliptical connection between this and the following sentence in the text lies Heidegger's understanding of the complex interrelation of Being, what is, and man. That meaning might, in the context of the present discussion of the will to power, be suggested as follows.

The "Being" to which Heidegger here refers is, first of all, the Being possessed by what is. The metaphysics of the will to power, which thinks Being in thinking the truth, the unconcealedness of what is, takes the Being of what is—a Being linked indissolubly with the security and certainty

stant of the stability of the constant reserve[40] is a necessary condition of its own securing of itself, which the will to power itself posits. Can Being possibly be more highly esteemed than through being expressly raised to a value? Yet, in that Being is accorded worth as a value, it is already degraded to a condition posited by the will to power itself. Already from of old, insofar as Being itself has been esteemed at all and thus given worth, it has been despoiled of the dignity of its essence. When the Being of whatever is, is stamped as a value and its essence is thereby sealed off, then within this metaphysics—and that means continually within the truth of what is as such during this age—every way to the experiencing of Being itself is obliterated. Here, in speaking in such a way, we presuppose what we should perhaps not presuppose at all, that such a way to Being has at some

of the objectively represented—as a value, a determining condition directing power-actualizing willing. Hence the metaphysics of the will to power can, with Nietzsche, take Being to be a value (cf. p. 84); or it might say that to be is to have value. And it is Being itself, ruling in the modern age in the mode of the will to power, that gives itself to the thinking of metaphysics in this way. Yet, at the same time, metaphysics is not here thinking Being itself. It is not thinking Being *as Being*, "presencing specifically as presencing, from out of its truth" (p. 109). Being, in manifesting itself precisely as value through the thinking belonging to the metaphysics of the will to power, is, at the same time, concealing itself as regards that which it is as *Being*.

Metaphysics, for Heidegger, "grounds an age" (AWP 115). In interpreting or in laying out (*auslegen*), i.e., in thinking forth, the Being of what is precisely as a value, that is, in making Being manifest—insofar as it is given to metaphysics to apprehend and manifest Being at all in the latter's holding-sway in the mode of the will to power—the metaphysics of the will to power, as the consummation of the modern metaphysics begun with Descartes, provides the thought-out basis for the activity of modern man. And Being needs that activity, undergirded by that thinking, in order to endure as present and to rule in the manner that is now proper to it. Precisely when Being has become a value, when to *be* is to have value, the metaphysical basis has been consummately given for that human activity through which whatever is—offering itself in the manner governed by the will to power—is fixed as a stable reserve that has value and can be of use just in virtue of its *being* and of its being available for future "willing to will" and "empowering to power." And precisely through just that metaphysically grounded activity and through it alone, the holding-sway of Being—of Being now manifesting itself in the mode of the will to power—is accomplishing itself through the only open center through which it can ever find accomplishment, namely, through man.

40. *Beständigung der Beständigkeit des Bestandes*.

time existed and that a thinking on Being has already thought Being as Being.

Unmindful of Being and its own truth, Western thinking has since its beginning continually been thinking what is in being as such. All the while, this thinking has been thinking Being only in *such* truth, so that it brings the name "Being" to utterance only with considerable awkwardness and in a manifoldness of meaning that remains confused because it is not experienced. This thinking that has remained unmindful of Being itself is the simple and all-sustaining, thus enigmatic and unexperienced, coming-to-pass [*Ereignis*] of that Western history which meanwhile is on the point of broadening out into world history. Finally, in metaphysics, Being has debased itself to a value. Herein lies the testimony that Being has not been accepted and acknowledged as Being. What does this mean?

What is happening to Being? *Nothing* is happening to Being.[41] But what if, precisely in that, the essence of nihilism, which has been veiled up to now, were first to proclaim itself? Would thinking in terms of values then itself be pure nihilism? But surely Nietzsche understands the metaphysics of the will to power specifically as the overcoming of nihilism. And in fact, so long as nihilism is understood only as the devaluing of the highest values, and the will to power, as the principle of the revaluing of all values, is thought from out of a re-positing of the highest values, the metaphysics of the will to power is indeed an overcoming of nihilism. But in this overcoming of nihilism value-thinking is elevated to a principle.

If, however, value does not let Being be Being, does not let it be what it is as Being itself, then this supposed overcoming is above all the consummation of nihilism. For now metaphysics not only does not think Being itself, but this not-thinking of Being clothes itself in the illusion that it does think Being in the most exalted manner, in that it esteems Being as a value, so that

41. *Wie ist es mit dem Sein? Mit dem Sein ist es nichts.* Here and in the two preceding instances of this question, the verb "happening"—usually reserved for the translation of the German verb *geschehen*—has been used so as to preserve the colloquial force of Heidegger's words. Subsequently this construction will be translated using the verb "befall" instead of "happen."

all questions concerning Being become and remain superfluous. But if the thinking that thinks everything in terms of values is nihilism when thought in relation to Being itself, then even Nietzsche's own experience of nihilism, i.e., that it is the devaluing of the highest values, is after all a nihilistic one. The interpretation of the suprasensory world, the interpretation of God as the highest value, is not thought from out of Being itself. The ultimate blow against God and against the suprasensory world consists in the fact that God, the first of beings,[42] is degraded to the highest value. The heaviest blow against God is not that God is held to be unknowable, not that God's existence is demonstrated to be unprovable, but rather that the god held to be real is elevated to the highest value. For this blow comes precisely not from those who are standing about, who do not believe in God, but from the believers and their theologians who discourse on the being that is of all beings most in being,[43] without ever letting it occur to them to think on Being itself, in order thereby to become aware that, seen from out of faith, their thinking and their talking is sheer blasphemy if it meddles in the theology of faith.

Now, for the first time a faint light begins to penetrate the darkness enveloping the question that earlier we wanted to direct to Nietzsche while we were hearing the passage about the madman. How can it happen at all that men are ever capable of killing God? But obviously it is precisely this that Nietzsche is thinking. For in the entire passage there are only two sentences expressly placed in italics. The one reads: "*We have killed him,*" namely, God. The other reads: "*And yet they have done it themselves,*" which is to say men have performed the deed of killing God, even though today they have still heard nothing about it.

The two italicized sentences give the interpretation for the word "God is dead." The pronouncement does not mean—as though it were spoken out of denial and common hatred—there is no god. The pronouncement means something worse: God has been killed. In this way the decisive thought first comes to appearance. Yet, nevertheless, the understanding of it becomes more difficult. For the word "God is dead" would be much more

42. *das Seiende des Seienden.*
43. *vom Seiendsten alles Seienden.*

readily grasped if it declared: God himself, of his own accord, has distanced himself from his living presence. But that God should be killed by others and indeed by men is unthinkable. Nietzsche himself is astounded at this thought. It is only for that reason that immediately after the decisive words, *"We have killed him*—you and I. All of us are his murderers," he allows the madman to ask: "But how have we done this?" Nietzsche elucidates the question as he repeats it, spelling out what is asked in three images: "How were we able to drink up the sea? Who gave us the sponge to wipe away the entire horizon? What did we do when we unchained this earth from its sun?"

To the last question we could answer: What men did when they unchained the earth from its sun is told in the last three and a half centuries of European history. What, then, has happened at the foundation of this history to that which is? When Nietzsche names the relationship between the sun and the earth he is not thinking merely of the Copernican revolution in the modern understanding of nature. The word "sun" at once recalls Plato's allegory. According to the latter, the sun and the realm of its light are the sphere in which that which is appears according to its visible aspect, or according to its many countenances (Ideas). The sun forms and circumscribes the field of vision wherein that which is as such shows itself.[44] "Horizon" refers

44. Here "forms" translates *bildet*. The German *bilden* means to form, to shape, to constitute. In this passage the meaning of "constitute" should be heard within the translation "forms" virtually with the force of "is." The word "sun" speaks, as does the word "horizon" that follows, of the self-manifesting that characterizes what is as such. It speaks of what is as being, in itself, unconcealed. In thinking in his own way Nietzsche's—and Plato's—image of the sun, Heidegger speaks here of what is, the real, as that which is looked at because it lets itself be seen. It is just this character of what is—as what gives itself to sight—that, in what here immediately follows, he sees as transformed in the modern period, so that it appears differently when, under the dominion of the will to power, everything real is transformed into value, i.e., into "point-of-view," that both is seen and permits seeing. When possessed of this new character, what is, is no longer free to show itself directly in itself. It is, rather, either as subject or as object, always at the disposal of assertive self-consciousness, and hence of that mode of Being, the will to power, ruling in the latter. Accordingly, in his discussion of the meaning of value for Nietzsche as "point-of-view," Heidegger has said above (p. 72): "Aim, view, field of vision, mean here both the sight beheld and seeing, in a sense that is determined from out of Greek thought. . . ."

to the suprasensory world as the world that truly is. This is at
the same time that whole which envelops all and in itself in-
cludes all, as does the sea. The earth, as the abode of man, is
unchained from its sun. The realm that constitutes the supra-
sensory, which as such, *is* in itself[45] no longer stands over man
as the authoritative light. The whole field of vision has been
wiped away. The whole of that which is as such, the sea, has been
drunk up by man. For man has risen up into the I-ness of the
ego cogito. Through this uprising, all that is, is transformed into
object. That which is, as the objective, is swallowed up into the
immanence of subjectivity. The horizon no longer emits light of
itself. It is now nothing but the point-of-view posited in the
value-positing of the will to power.

By means of the three key images (sun, horizon, and sea),
which are for thinking presumably something quite other than
images, the three questions elucidate what is meant by the event
of the killing of God. The killing means the act of doing away
with the suprasensory world that *is* in itself—an act accomplished
through man. It speaks of the event wherein that which is as
such does not simply come to nothing, but does indeed become
different in its Being. But above all, in this event man also be-
comes different. He becomes the one who does away with that
which is, in the sense of that which *is* in itself. The uprising of
man into subjectivity transforms that which is into object. But
that which is objective is that which is brought to a stand through
representing. The doing away with that which *is* in itself, i.e.,
the killing of God, is accomplished in the making secure of the
constant reserve by means of which man makes secure for himself
material, bodily, psychic, and spiritual resources, and this for
the sake of his own security, which wills dominion over what-
ever is—as the potentially objective—in order to correspond to
the Being of whatever is, to the will to power.

Making secure, as the creating of secureness, is grounded in
value-positing. Value-positing has brought down and slain be-
neath itself—and has therefore killed as that which *is* for itself—
all that *is* in itself. This ultimate blow in the killing of God is
perpetrated by metaphysics, which, as the metaphysics of the

45. *des an sich seienden Übersinnlichen.*

will to power, accomplishes thinking in the sense of value-thinking. However, Nietzsche himself no longer recognizes this ultimate blow, through which Being is struck down to a mere value, for what the blow is when thought with respect to Being itself. And yet, does not Nietzsche himself say: "All of us are his murderers!—you and I"? Certainly. And according to this, Nietzsche also continues to understand the metaphysics of the will to power as nihilism. To be sure. But this means for Nietzsche only that that metaphysics, as the countermovement in the sense of the revaluing of all former values, brings to completion the previous "devaluing of the highest values hitherto" most radically, because definitively.

And yet Nietzsche can no longer think as killing and nihilism precisely that new positing of value on the basis of the principle of all value-positing. Within the field of vision of the self-willing will to power, i.e., within the perspective of value and value-positing, that new positing of value is no longer a de-valuing.

But what happens to value-positing itself when value-positing is thought in respect to that which is as such, and that means at the same time from out of a view toward Being? Then, thinking in terms of values is radical killing. It not only strikes down that which is as such, in its being-in-itself, but it does away utterly with Being. The latter can, where it is still needed, pass only for a value. The value-thinking of the metaphysics of the will to power is murderous in a most extreme sense, because it absolutely does not let Being itself take its rise, i.e., come into the vitality of its essence. Thinking in terms of values precludes in advance that Being itself will attain to a coming to presence in its truth.

But is this murdering that kills at the roots first and exclusively the way of the metaphysics of the will to power? Is it only the interpretation of Being as value that does not let Being itself be the Being that it is? If this were the case, then metaphysics before Nietzsche would have to have experienced and thought Being itself in its truth, or at least to have questioned concerning it. *But nowhere do we find such experiencing of Being itself.* Nowhere are we confronted by a thinking that thinks the truth of Being itself and therewith thinks truth itself as Being.

This is not thought even where pre-Platonic thinking, as the beginning of Western thinking, prepares for the unfolding of metaphysics in Plato and Aristotle. The *estin* (*eon*) *gar einai* does indeed name Being itself. But it does not think presencing specifically as presencing, from out of its truth. The history of Being begins, and indeed necessarily, *with the forgetting of Being*. It is not due then to metaphysics as the metaphysics of the will to power that Being itself in its truth remains unthought. This strange remaining-away of Being is due only to metaphysics as metaphysics. But what is metaphysics? Do we know its essence? Can it itself know that essence? If it conceives it, it grasps it metaphysically. But the metaphysical concept of metaphysics constantly falls short of its essence. This holds also for every logic, assuming that logic is still at all capable of thinking what *logos* is. Every metaphysics of metaphysics, and every logic of philosophy, that in any way whatever attempts to climb beyond metaphysics falls back most surely beneath metaphysics, without knowing where, precisely in so doing, it has fallen.

Meanwhile, at least one feature of the essence of nihilism has become clearer to our thinking. The essence of nihilism lies in history; accordingly, in the appearing of whatever is as such, in its entirety, Nothing is befalling Being itself and its truth, and indeed in such a way that the truth of what is as such passes for Being, because the truth of Being remains wanting. In the age of that completion and consummation of nihilism which is beginning, Nietzsche indeed experienced some characteristics of nihilism, and at the same time he explained them nihilistically, thus completely eclipsing their essence. And yet Nietzsche never recognized the *essence* of nihilism, just as no metaphysics before him ever did.

But if the essence of nihilism lies in history, so that the truth of Being remains wanting in the appearing of whatever is as such, in its entirety, and if, accordingly, Nothing is befalling Being and its truth, then metaphysics as the history of the truth of what is as such, is, in its essence, nihilism. If, finally, metaphysics is the historical ground of the world history that is being determined by Europe and the West, then that world history is, in an entirely different sense, nihilistic.

Thought from out of the destining of Being, the *nihil* in

"nihilism" means that *Nothing* is befalling Being. Being is not coming into the light of its own essence. In the appearing of whatever is as such, Being itself remains wanting. The truth of Being falls from memory. It remains forgotten.

Thus nihilism would be in its essence a history that runs its course along with Being itself. It would lie in Being's own essence, then, that Being remain unthought because it withdraws. Being itself withdraws into its truth. It harbors itself safely within its truth and conceals itself in such harboring.

In looking toward this self-concealing harboring of its own essence, perhaps we glimpse the essence of that mystery in the guise of which the truth of Being is coming to presence.

According to this, metaphysics itself would not be merely a neglect of a question still to be pondered concerning Being. Surely it would not be an error. Metaphysics, as the history of the truth of what is as such, would have come to pass from out of the destining of Being itself. Metaphysics would be, in its essence, the mystery of Being itself, a mystery that is unthought because withheld. Were it otherwise, a thinking that takes pains to hold to Being in what is to be thought could not unceasingly ask, "What is metaphysics?"

Metaphysics is an epoch[46] of the history of Being itself. But in its essence metaphysics is nihilism. The essence of nihilism belongs to that history as which Being itself comes to presence. However, provided that Nothing in whatever manner also points toward Being, the determination and defining of nihilism from out of the history of Being might well at least indicate antecedently the realm within which the essence of nihilism can be experienced in order to become something thought that concerns our thinking. We are accustomed above all to hearing a false note in the name "nihilism." However, when we ponder the essence of nihilism as belonging to the history of Being, there is at once something dubious in simply hearing a false note. The word "nihilism" indicates that *nihil* (Nothing) *is*, and is essentially, in that which it names. Nihilism means: Nothing is befalling everything and in every respect. "Everything" means whatever is, in its entirety. And whatever is stands there in

46. A self-withholding.

every respect proper to it when it is experienced as that which is. Hence nihilism means that Nothing is befalling whatever is as such, in its entirety. But whatever is, is what it is and how it is from out of Being. Assuming that every "is" lies in Being, the essence of nihilism consists in the fact that Nothing is befalling Being itself. Being *itself* is Being in its *truth*, which truth belongs to Being.

When we hear in the name "nihilism" that other note wherein sounds the essence of that which it names, then we are also hearing differently the language of that metaphysical thinking which has experienced something of nihilism without being able to think its essence. Perhaps with that other note in our ears, we will someday ponder the age of that consummation of nihilism which is now beginning in another way than we have hitherto. Perhaps then we will recognize that neither the political nor the economic nor the sociological, nor the technological and scientific, nor even the metaphysical and the religious perspectives are adequate to think what is happening in that age. What is given to thinking to think is not some deeply hidden underlying meaning, but rather something lying near, that which lies nearest, which, because it is only this, we have therefore constantly already passed over. Through this passing over we are, without noticing it, constantly accomplishing the killing in relation to the Being of whatever is in being.

In order to pay heed to it and to learn to pay heed, it can be enough for us simply to ponder for once what the madman says about the death of God and how he says it. Perhaps we will no longer pass by so quickly without hearing what is said at the beginning of the passage that has been elucidated: that the madman "cried incessantly: I seek God! I seek God!' "

In what respect is this man mad? He is "de-ranged."[47] For he is dis-lodged from the level of man hitherto, where the ideals of the suprasensory world, which have become unreal, are passed off for real while yet their opposite is realizing itself. This de-

47. "De-ranged" translates *ver-rückt*, which, unhyphenated, means mad or insane. Other adjectival translations of related past participles built on *rücken* (to jerk, to pull, to change the place of) follow here: "dislodged" (*ausgerückt*), "carried out beyond" (*hinausgerückt*), and "drawn into" (*eingerückt*).

ranged man is carried out beyond man hitherto. Nevertheless, in this way he has only been drawn utterly into being the pre-determined essence of man hitherto, the *animal rationale*. The man who is deranged in this way has nothing in common with the kind of men standing about in the market place "who do not believe in God." For these men are not unbelievers because God as God has to them become unworthy of belief, but rather because they themselves have given up the possibility of belief, inasmuch as they are no longer able to seek God. They can no longer seek because they no longer think. Those standing about in the market place have abolished thinking and replaced it with idle babble that scents nihilism in every place in which it supposes its own opinion to be endangered. This self-deception, forever gaining the upper hand in relation to genuine nihilism, attempts in this way to talk itself out of its anguished dread in the face of thinking. But that dread is dread in the face of dread.

The madman, on the contrary, is clearly, according to the first, and more clearly still according to the last, sentences of the passage, for him who can hear, the one who seeks God, since he cries out after God. Has a thinking man perhaps here really cried out *de profundis*? And the ear of our thinking, does it still not hear the cry? It will refuse to hear it so long as it does not begin to think. Thinking begins only when we have come to know that reason, glorified for centuries, is the most stiff-necked adversary of thought.

Part III

The Age of the
World Picture

In metaphysics reflection is accomplished concerning the essence of what is and a decision takes place regarding the essence of truth.[1] Metaphysics grounds an age, in that through a specific interpretation of what is and through a specific comprehension of truth it gives to that age the basis upon which it is essentially formed.[2] This basis holds complete dominion over all the phenomena that distinguish the age. Conversely, in order that there may be an adequate reflection upon these phenomena themselves, the metaphysical basis for them must let itself be apprehended

1. "Reflection" translates *Besinnung*. On the meaning of the latter, see SR 155 n. 1. "Essence" will be the translation of the noun *Wesen* in most instances of its occurrence in this essay. Occasionally the translation "coming to presence" will be used. *Wesen* must always be understood to allude, for Heidegger, not to any mere "whatness," but to the manner in which anything, *as* what it is, takes its course and "holds sway" in its ongoing presence, i.e., the manner in which it endures in its presencing. See QT 30, 3 n. 1. "What is" renders the present participle *seiend* used as a noun, *das Seiende*. On the translation of the latter, see T 40 n. 6.

2. *der Grund seines Wesensgestalt.* Heidegger exemplifies the statement that he makes here in his discussion of the metaphysics of Descartes as providing the necessary interpretive ground for the manner in which, in the subjectness of man as self-conscious subject, Being and all that is and man—in their immediate and indissoluble relation—come to presence in the modern age. See Appendix 9, pp. 150 ff.

in them. Reflection is the courage to make the truth of our own presuppositions and the realm of our own goals into the things that most deserve to be called in question (see Appendix 1).[3]

One of the essential phenomena of the modern age is its science. A phenomenon of no less importance is machine technology. We must not, however, misinterpret that technology as the mere application of modern mathematical physical science to praxis. Machine technology is itself an autonomous transformation of praxis, a type of transformation wherein praxis first demands the employment of mathematical physical science. Machine technology remains up to now the most visible outgrowth of the essence of modern technology, which is identical with the essence of modern metaphysics.

A third equally essential phenomenon of the modern period lies in the event of art's moving into the purview of aesthetics. That means that the art work becomes the object of mere subjective experience, and that consequently art is considered to be an expression of human life.[4]

A fourth modern phenomenon manifests itself in the fact that human activity is conceived and consummated as culture. Thus culture is the realization of the highest values, through the nurture and cultivation of the highest goods of man. It lies in the essence of culture, as such nurturing, to nurture itself in its turn and thus to become the politics of culture.

A fifth phenomenon of the modern age is the loss of the gods.[5] This expression does not mean the mere doing away with the gods, gross atheism. The loss of the gods is a twofold process. On the one hand, the world picture is Christianized inasmuch as the cause of the world is posited as infinite, unconditional,

3. Heidegger's explanatory appendixes begin on p. 137.

4. *Erlebnis*, translated here as "subjective experience" and later as "life-experience," is a term much used by life philosophers such as Dilthey and generally connotes adventure and event. It is employed somewhat pejoratively here. The term *Erfahrung*, which is regularly translated in this volume as "experience," connotes discovery and learning, and also suffering and undergoing. Here and subsequently (i.e., "mere religious experience"), "mere" is inserted to maintain the distinction between *Erlebnis* and *Erfahrung*.

5. *Entgötterung*, here inadequately rendered as "loss of the gods," actually means something more like "degodization."

absolute. On the other hand, Christendom transforms Christian doctrine into a world view (the Christian world view), and in that way makes itself modern and up to date. The loss of the gods is the situation of indecision regarding God and the gods. Christendom has the greatest share in bringing it about. But the loss of the gods is so far from excluding religiosity that rather only through that loss is the relation to the gods changed into mere "religious experience." When this occurs, then the gods have fled. The resultant void is compensated for by means of historiographical and psychological investigation of myth.

What understanding of what is, what interpretation of truth, lies at the foundation of these phenomena?

We shall limit the question to the phenomenon mentioned first, to science [Wissenschaft].

In what does the essence of modern science lie?

What understanding of what is and of truth provides the basis for that essence? If we succeed in reaching the metaphysical ground that provides the foundation for science as a modern phenomenon, then the entire essence of the modern age will have to let itself be apprehended from out of that ground.

When we use the word "science" today, it means something essentially different from the doctrina and scientia of the Middle Ages, and also from the Greek epistēmē. Greek science was never exact, precisely because, in keeping with its essence, it could not be exact and did not need to be exact. Hence it makes no sense whatever to suppose that modern science is more exact than that of antiquity. Neither can we say that the Galilean doctrine of freely falling bodies is true and that Aristotle's teaching, that light bodies strive upward, is false; for the Greek understanding of the essence of body and place and of the relation between the two rests upon a different interpretation of beings and hence conditions a correspondingly different kind of seeing and questioning of natural events. No one would presume to maintain that Shakespeare's poetry is more advanced than that of Aeschylus. It is still more impossible to say that the modern understanding of whatever is, is more correct than that of the Greeks. Therefore, if we want to grasp the essence of modern science, we must first free ourselves from the habit of

comparing the new science with the old solely in terms of degree, from the point of view of progress.

The essence of what we today call science is research. In what does the essence of research consist?

In the fact that knowing [*das Erkennen*] establishes itself as a procedure within some realm of what is, in nature or in history. Procedure does not mean here merely method or methodology. For every procedure already requires an open sphere in which it moves. And it is precisely the opening up of such a sphere that is the fundamental event in research. This is accomplished through the projection within some realm of what is—in nature, for example—of a fixed ground plan[6] of natural events. The projection sketches out in advance the manner in which the knowing procedure must bind itself and adhere to the sphere opened up. This binding adherence is the rigor of research.[7] Through the projecting of the ground plan and the prescribing of rigor, procedure makes secure for itself its sphere of objects within the realm of Being. A look at that earliest science, which is at the same time the normative one in the modern age, namely, mathematical physics, will make clear what we mean. Inasmuch as modern atomic physics still remains physics, what is essential—and only the essential is aimed at here—will hold for it also.

Modern physics is called mathematical because, in a remarkable way, it makes use of a quite specific mathematics. But it can proceed mathematically in this way only because, in a deeper sense, it is already itself mathematical. *Ta mathēmata* means for the Greeks that which man knows in advance in his observation of whatever is and in his intercourse with things: the corporeality of bodies, the vegetable character of plants, the animality of animals, the humanness of man. Alongside these, belonging also to that which is already-known, i.e., to the mathematical, are numbers. If we come upon three apples on the table, we

6. *Grundriss.* The verb *reissen* means to tear, to rend, to sketch, to design, and the noun *Riss* means tear, gap, outline. Hence the noun *Grundriss*, first sketch, ground plan, design, connotes a fundamental sketching out that is an opening up as well.

7. "Binding adherence" here translates the noun *Bindung.* The noun could also be rendered "obligation." It could thus be said that rigor is the obligation to remain within the realm opened up.

recognize that there are three of them. But the number three, threeness, we already know. This means that number is something mathematical. Only because numbers represent, as it were, the most striking of always-already-knowns, and thus offer the most familiar instance of the mathematical, is "mathematical" promptly reserved as a name for the numerical. In no way, however, is the essence of the mathematical defined by numberness. Physics is, in general, the knowledge of nature, and, in particular, the knowledge of material corporeality in its motion; for that corporeality manifests itself immediately and universally in everything natural, even if in a variety of ways. If physics takes shape explicitly, then, as something mathematical, this means that, in an especially pronounced way, through it and for it something is stipulated in advance as what is already-known. That stipulating has to do with nothing less than the plan or projection of that which must henceforth, for the knowing of nature that is sought after, *be* nature: the self-contained system of motion of units of mass related spatiotemporally. Into this ground plan of nature, as supplied in keeping with its prior stipulation, the following definitions among others have been incorporated: Motion means change of place. No motion or direction of motion is superior to any other. Every place is equal to every other. No point in time has preference over any other. Every force is defined according to—i.e., *is* only—its consequences in motion, and that means in magnitude of change of place in the unity of time. Every event must be seen so as to be fitted into this ground plan of nature. Only within the perspective of this ground plan does an event in nature become visible as such an event. This projected plan of nature finds its guarantee in the fact that physical research, in every one of its questioning steps, is bound in advance to adhere to it. This binding adherence, the rigor of research, has its own character at any given time in keeping with the projected plan. The rigor of mathematical physical science is exactitude. Here all events, if they are to enter at all into representation as events of nature, must be defined beforehand as spatiotemporal magnitudes of motion. Such defining is accomplished through measuring, with the help of number and calculation. But mathematical research

into nature is not exact because it calculates with precision; rather it must calculate in this way because its adherence to its object-sphere has the character of exactitude. The humanistic sciences, in contrast, indeed all the sciences concerned with life, must necessarily be inexact just in order to remain rigorous. A living thing can indeed also be grasped as a spatiotemporal magnitude of motion, but then it is no longer apprehended as living. The inexactitude of the historical humanistic sciences is not a deficiency, but is only the fulfillment of a demand essential to this type of research. It is true, also, that the projecting and securing of the object-sphere of the historical sciences is not only of another kind, but is much more difficult of execution than is the achieving of rigor in the exact sciences.

Science becomes research through the projected plan and through the securing of that plan in the rigor of procedure. Projection and rigor, however, first develop into what they are in methodology. The latter constitutes the second essential characteristic of research. If the sphere that is projected is to become objective, then it is a matter of bringing it to encounter us in the complete diversity of its levels and interweavings. Therefore procedure must be free to view the changeableness in whatever encounters it. Only within the horizon of the incessant-otherness of change does the plenitude of particularity—of facts—show itself. But the facts must become objective [gegenständlich]. Hence procedure must represent [vorstellen] the changeable in its changing,[8] must bring it to a stand and let the motion be a motion nevertheless. The fixedness of facts and the constantness of their change as such is "rule." The constancy of change in the necessity of its course is "law." It is only within the purview of rule and law that facts become clear as the facts that they are. Research into facts in the realm of nature is intrinsically the establishing and verifying of rule and law. Methodology, through which a sphere of objects comes into representation,

8. Throughout this essay the literal meaning of vorstellen, which is usually translated with "to represent," is constantly in the foreground, so that the verb suggests specifically a setting-in-place-before that is an objectifying, i.e., a bringing to a stand as object. See pp. 127, 129–30, 132; cf. Appendix 9, pp. 148 ff. Heidegger frequently hyphenates vorstellen in this essay and its appendixes so as to stress the meaning that he intends.

has the character of clarifying on the basis of what is clear—of explanation. Explanation is always twofold. It accounts for an unknown by means of a known, and at the same time it verifies that known by means of that unknown. Explanation takes place in investigation. In the physical sciences investigation takes place by means of experiment, always according to the kind of field of investigation and according to the type of explanation aimed at. But physical science does not first become research through experiment; rather, on the contrary, experiment first becomes possible where and only where the knowledge of nature has been transformed into research. Only because modern physics is a physics that is essentially mathematical can it be experimental. Because neither medieval *doctrina* nor Greek *epistēmē* is science in the sense of research, for these it is never a question of experiment. To be sure, it was Aristotle who first understood what *empeiria* (*experientia*) means: the observation of things themselves, their qualities and modifications under changing conditions, and consequently the knowledge of the way in which things as a rule behave. But an observation that aims at such knowledge, the *experimentum*, remains essentially different from the observation that belongs to science as research, from the research experiment; it remains essentially different even when ancient and medieval observation also works with number and measure, and even when that observation makes use of specific apparatus and instruments. For in all this, that which is decisive about the experiment is completely missing. Experiment begins with the laying down of a law as a basis. To set up an experiment means to represent or conceive [*vorstellen*] the conditions under which a specific series of motions can be made susceptible of being followed in its necessary progression, i.e., of being controlled in advance by calculation. But the establishing of a law is accomplished with reference to the ground plan of the object-sphere. That ground plan furnishes a criterion and constrains the anticipatory representing of the conditions. Such representing in and through which the experiment begins is no random imagining. That is why Newton said, *hypothesis non fingo*, "the bases that are laid down are not arbitrarily invented." They are developed out of the ground plan of nature and are sketched into it. Experiment is that methodology which, in its planning

and execution, is supported and guided on the basis of the fundamental law laid down, in order to adduce the facts that either verify and confirm the law or deny it confirmation. The more exactly the ground plan of nature is projected, the more exact becomes the possibility of experiment. Hence the much-cited medieval Schoolman Roger Bacon can never be the fore-runner of the modern experimental research scientist; rather he remains merely a successor of Aristotle. For in the meantime, the real locus of truth has been transferred by Christendom to faith—to the infallibility of the written word and to the doctrine of the Church. The highest knowledge and teaching is theology as the interpretation of the divine word of revelation, which is set down in Scripture and proclaimed by the Church. Here, to know is not to search out; rather it is to understand rightly the authoritative Word and the authorities proclaiming it. There-fore, the discussion of the words and doctrinal opinions of the various authorities takes precedence in the acquiring of knowl-edge in the Middle Ages. The *componere scripta et sermones*, the *argumentum ex verbo*,[9] is decisive and at the same time is the reason why the accepted Platonic and Aristotelian philosophy that had been taken over had to be transformed into scholastic dialectic. If, now, Roger Bacon demands the *experimentum*—and he does demand it—he does not mean the experiment of science as research; rather he wants the *argumentum ex re* instead of the *argumentum ex verbo*, the careful observing of things themselves, i.e., Aristotelian *empeiria*, instead of the discussion of doctrines.

The modern research experiment, however, is not only an observation more precise in degree and scope, but is a methodology essentially different in kind, related to the verification of law in the framework, and at the service, of an exact plan of nature. Source criticism in the historical humanistic sciences cor-responds to experiment in physical research. Here the name "source criticism" designates the whole gamut of the discovery, examination, verification, evaluation, preservation, and inter-pretation of sources. Historiographical explanation, which is

9. "The comparing of the writings with the sayings, the argument from the word." *Argumentum ex re*, which follows shortly, means "argument from the thing."

based on source criticism, does not, it is true, trace facts back to laws and rules. But neither does it confine itself to the mere reporting of facts. In the historical sciences, just as in the natural sciences, the methodology aims at representing what is fixed and stable and at making history an object. History can become objective only when it is past. What is stable in what is past, that on the basis of which historiographical explanation reckons up the solitary and the diverse in history, is the always-has-been-once-already, the comparable. Through the constant comparing of everything with everything, what is intelligible is found by calculation and is certified and established as the ground plan of history. The sphere of historiographical research extends only so far as historiographical explanation reaches. The unique, the rare, the simple—in short, the great—in history is never self-evident and hence remains inexplicable. It is not that historical research denies what is great in history; rather it explains it as the exception. In this explaining, the great is measured against the ordinary and the average. And there is no other historiographical explanation so long as explaining means reduction to what is intelligible and so long as historiography remains research, i.e., an explaining. Because historiography as research projects and objectifies the past in the sense of an explicable and surveyable nexus of actions and consequences, it requires source criticism as its instrument of objectification. The standards of this criticism alter to the degree that historiography approaches journalism.

Every science is, as research, grounded upon the projection of a circumscribed object-sphere and is therefore necessarily a science of individualized character. Every individualized science must, moreover, in the development of its projected plan by means of its methodology, particularize itself into specific fields of investigation. This particularizing (specialization) is, however, by no means simply an irksome concomitant of the increasing unsurveyability of the results of research. It is not a necessary evil, but is rather an essential necessity of science as research. Specialization is not the consequence but the foundation of the progress of all research. Research does not, through its methodology, become dispersed into random investigations,

so as to lose itself in them; for modern science is determined by a third fundamental event: ongoing activity (Appendix 2).[10]

By this is to be understood first of all the phenomenon that a science today, whether physical or humanistic, attains to the respect due a science only when it has become capable of being institutionalized. However, research is not ongoing activity because its work is accomplished in institutions, but rather institutions are necessary because science, intrinsically as research, has the character of ongoing activity. The methodology through which individual object-spheres are conquered does not simply amass results. Rather, with the help of its results it adapts [richtet sich . . . ein] itself for a new procedure. Within the complex of machinery that is necessary to physics in order to carry out the smashing of the atom lies hidden the whole of physics up to now. Correspondingly, in historiographical research, funds of source materials become usable for explanation only if those sources are themselves guaranteed on the basis of historiographical explanation. In the course of these processes, the methodology of the science becomes circumscribed by means of its results. More and more the methodology adapts itself to the possibilities of procedure opened up through itself. This having-to-adapt-itself to its own results as the ways and means of an advancing methodology is the essence of research's character as ongoing activity. And it is that character that is the intrinsic basis for the necessity of the institutional nature of research.

In ongoing activity the plan of an object-sphere is, for the first time, built into whatever is. All adjustments that facilitate a plannable conjoining of types of methodology, that further the reciprocal checking and communication of results, and that regulate the exchange of talents are measures that are by no means only the external consequences of the fact that research work is expanding and proliferating. Rather, research work becomes the distant sign, still far from being understood, that modern science is beginning to enter upon the decisive phase of its his-

10. "Ongoing activity" is the rendering of *Betrieb*, which is difficult to translate adequately. It means the act of driving on, or industry, activity, as well as undertaking, pursuit, business. It can also mean management, or workshop or factory.

tory. Only now is it beginning to take possession of its own complete essence.

What is taking place in this extending and consolidating of the institutional character of the sciences? Nothing less than the making secure of the precedence of methodology over whatever is (nature and history), which at any given time becomes objective in research. On the foundation of their character as ongoing activity, the sciences are creating for themselves the solidarity and unity appropriate to them. Therefore historiographical or archeological research that is carried forward in an institutionalized way is essentially closer to research in physics that is similarly organized than it is to a discipline belonging to its own faculty in the humanistic sciences that still remains mired in mere erudition. Hence the decisive development of the modern character of science as ongoing activity also forms men of a different stamp. The scholar disappears. He is succeeded by the research man who is engaged in research projects. These, rather than the cultivating of erudition, lend to his work its atmosphere of incisiveness. The research man no longer needs a library at home. Moreover, he is constantly on the move. He negotiates at meetings and collects information at congresses. He contracts for commissions with publishers. The latter now determine along with him which books must be written (Appendix 3).

The research worker necessarily presses forward of himself into the sphere characteristic of the technologist in the essential sense. Only in this way is he capable of acting effectively, and only thus, after the manner of his age, is he real. Alongside him, the increasingly thin and empty Romanticism of scholarship and the university will still be able to persist for some time in a few places. However, the effective unity characteristic of the university, and hence the latter's reality, does not lie in some intellectual power belonging to an original unification of the sciences and emanating from the university because nourished by it and preserved in it. The university is real as an orderly establishment that, in a form still unique because it is administratively self-contained, makes possible and visible the striving apart of the sciences into the particularization and peculiar unity that belong to ongoing activity. Because the forces intrinsic to the essence of modern science come immediately and unequiv-

ocally to effective working in ongoing activity, therefore, also, it is only the spontaneous ongoing activities of research that can sketch out and establish the internal unity with other like activities that is commensurate with themselves.

The real system of science consists in a solidarity of procedure and attitude with respect to the objectification of whatever is— a solidarity that is brought about appropriately at any given time on the basis of planning. The excellence demanded of this system is not some contrived and rigid unity of the relationships among object-spheres, having to do with content, but is rather the greatest possible free, though regulated, flexibility in the shifting about and introducing of research apropos of the leading tasks at any given time. The more exclusively science individualizes itself with a view to the total carrying on and mastering of its work process, and the more realistically these ongoing activities are shifted into separate research institutes and professional schools, the more irresistibly do the sciences achieve the con-summation of their modern essence. But the more uncondition-ally science and the man of research take seriously the modern form of their essence, the more unequivocally and the more immediately will they be able to offer themselves for the common good, and the more unreservedly too will they have to return to the public anonymity of all work useful to society.

Modern science simultaneously establishes itself and differ-entiates itself in its projections of specific object-spheres. These projection-plans are developed by means of a corresponding methodology, which is made secure through rigor. Methodology adapts and establishes itself at any given time in ongoing activ-ity. Projection and rigor, methodology and ongoing activity, mutually requiring one another, constitute the essence of modern science, transform science into research.

We are reflecting on the essence of modern science in order that we may apprehend in it its metaphysical ground. What understanding of what is and what concept of truth provide the basis for the fact that science is being transformed into research?

Knowing, as research, calls whatever is to account with regard to the way in which and the extent to which it lets itself be put at the disposal of representation. Research has disposal over

anything that is when it can either calculate it in its future course in advance or verify a calculation about it as past. Nature, in being calculated in advance, and history, in being historiographically verified as past, become, as it were, "set in place" [*gestellt*].[11] Nature and history become the objects of a representing that explains. Such representing counts on nature and takes account of history. Only that which becomes object in this way *is*—is considered to be in being. We first arrive at science as research when the Being of whatever is, is sought in such objectiveness.

This objectifying of whatever is, is accomplished in a setting-before, a representing, that aims at bringing each particular being before it in such a way that man who calculates can be sure, and that means be certain, of that being. We first arrive at science as research when and only when truth has been transformed into the certainty of representation. What it is to be is for the first time defined as the objectiveness of representing, and truth is first defined as the certainty of representing, in the metaphysics of Descartes. The title of Descartes's principal work reads: *Meditationes de prima philosophia* [*Meditations on First Philosophy*]. *Prōtē philosophia* is the designation coined by Aristotle for what is later called metaphysics. The whole of modern metaphysics taken together, Nietzsche included, maintains itself within the interpretation of what it is to be and of truth that was prepared by Descartes (Appendix 4).

Now if science as research is an essential phenomenon of the modern age, it must be that that which constitutes the metaphysical ground of research determines first and long beforehand the essence of that age generally. The essence of the modern age can be seen in the fact that man frees himself from the bonds of the Middle Ages in freeing himself to himself. But

11. The verb *stellen*, with the meanings to set in place, to set upon (i.e., to challenge forth), and to supply, is invariably fundamental in Heidegger's understanding of the modern age. See in this essay the discussion of the setting in place of the world as picture, p. 129. For the use of *stellen* to characterize the manner in which science deals with the real, see SR 167–168 for a discussion in which *stellen* and the related noun *Ge-stell* serve centrally to characterize and name the essence of technology in this age, see QT 14 ff.

this correct characterization remains, nevertheless, superficial. It leads to those errors that prevent us from comprehending the essential foundation of the modern age and, from there, judging the scope of the age's essence. Certainly the modern age has, as a consequence of the liberation of man, introduced subjectivism and individualism. But it remains just as certain that no age before this one has produced a comparable objectivism and that in no age before this has the non-individual, in the form of the collective, come to acceptance as having worth. Essential here is the necessary interplay between subjectivism and objectivism. It is precisely this reciprocal conditioning of one by the other that points back to events more profound.

What is decisive is not that man frees himself to himself from previous obligations, but that the very essence of man itself changes, in that man becomes subject. We must understand this word *subiectum*, however, as the translation of the Greek *hypokeimenon*. The word names that-which-lies-before, which, as ground, gathers everything onto itself. This metaphysical meaning of the concept of subject has first of all no special relationship to man and none at all to the I.

However, when man becomes the primary and only real *subiectum*, that means: Man becomes that being upon which all that is, is grounded as regards the manner of its Being and its truth. Man becomes the relational center of that which is as such. But this is possible only when the comprehension of what is as a whole changes. In what does this change manifest itself? What, in keeping with it, is the essence of the modern age?

When we reflect on the modern age, we are questioning concerning the modern world picture [*Weltbild*].[12] We characterize the latter by throwing it into relief over against the medieval and the ancient world pictures. But why do we ask concerning a world picture in our interpreting of a historical age? Does every period of history have its world picture, and indeed in such a way as to concern itself from time to time about that world

12. The conventional translation of *Weltbild* would be "conception of the world" or "philosophy of life." The more literal translation, "world picture," is needed for the following of Heidegger's discussion; but it is worth noting that "conception of the world" bears a close relation to Heidegger's theme of man's representing of the world as picture.

picture? Or is this, after all, only a modern kind of representing, this asking concerning a world picture?

What is a world picture? Obviously a picture of the world. But what does "world" mean here? What does "picture" mean? "World" serves here as a name for what is, in its entirety. The name is not limited to the cosmos, to nature. History also belongs to the world. Yet even nature and history, and both interpenetrating in their underlying and transcending of one another, do not exhaust the world. In this designation the ground of the world is meant also, no matter how its relation to the world is thought (Appendix 5).

With the word "picture" we think first of all of a copy of something. Accordingly, the world picture would be a painting, so to speak, of what is as a whole. But "world picture" means more than this. We mean by it the world itself, the world as such, what is, in its entirety, just as it is normative and binding for us. "Picture" here does not mean some imitation, but rather what sounds forth in the colloquial expression, "We get the picture" [literally, we are in the picture] concerning something. This means the matter stands before us exactly as it stands with it for us. "To get into the picture" [literally, to put oneself into the picture] with respect to something means to set whatever is, itself, in place before oneself just in the way that it stands with it, and to have it fixedly before oneself as set up in this way. But a decisive determinant in the essence of the picture is still missing. "We get the picture" concerning something does not mean only that what is, is set before us, is represented to us, in general, but that what is stands before us—in all that belongs to it and all that stands together in it—as a system. "To get the picture" throbs with being acquainted with something, with being equipped and prepared for it. Where the world becomes picture, what is, in its entirety, is juxtaposed as that for which man is prepared and which, correspondingly, he therefore intends to bring before himself and have before himself, and consequently intends in a decisive sense to set in place before himself (Appendix 6). Hence world picture, when understood essentially, does not mean a picture of the world but the world conceived and grasped as picture. What is, in its entirety, is now taken in such a way that it first is in being and only is in being

to the extent that it is set up by man, who represents and sets forth.[13] Wherever we have the world picture, an essential decision takes place regarding what is, in its entirety. The Being of whatever is, is sought and found in the representedness of the latter.

However, everywhere that whatever is, is *not* interpreted in this way, the world also cannot enter into a picture; there can be no world picture. The fact that whatever is comes into being in and through representedness transforms the age in which this occurs into a new age in contrast with the preceding one. The expressions "world picture of the modern age" and "modern world picture" both mean the same thing and both assume something that never could have been before, namely, a medieval and an ancient world picture. The world picture does not change from an earlier medieval one into a modern one, but rather the fact that the world becomes picture at all is what distinguishes the essence of the modern age [*der Neuzeit*].[14] For the Middle Ages, in contrast, that which is, is the *ens creatum*, that which is created by the personal Creator-God as the highest cause. Here, to be in being means to belong within a specific rank of the order of what has been created—a rank appointed from the beginning—and as thus caused, to correspond to the cause of creation (*analogia entis*) (Appendix 7). But never does the Being of that which is consist here in the fact that it is brought before man as the objective, in the fact that it is placed in the realm of man's knowing and of his having disposal, and that it is in being only in this way.

The modern interpretation of that which is, is even further from the interpretation characteristic of the Greeks. One of the oldest pronouncements of Greek thinking regarding the Being of that which is runs: *To gar auto noein estin te kai einai*.[15] This sentence of Parmenides means: The apprehending of whatever is belongs to Being because it is demanded and determined by

13. *durch den vorstellenden-herstellenden Menschen gestellt ist.*

14. *Die Neuzeit* is more literally "the new age." Having repeatedly used this word in this discussion, Heidegger will soon elucidate the meaning of the "newness" of which it speaks (pp. 130 ff.).

15. The accepted English translation of this fragment is, "For thought and being are the same thing" (Nahm).

Being. That which is, is that which arises and opens itself, which, as what presences, comes upon man as the one who presences, i.e., comes upon the one who himself opens himself to what presences in that he apprehends it. That which is does not come into being at all through the fact that man first looks upon it, in the sense of a representing that has the character of subjective perception. Rather, man is the one who is looked upon by that which is; he is the one who is—in company with itself—gathered toward presencing, by that which opens itself. To be beheld by what is, to be included and maintained within its openness and in that way to be borne along by it, to be driven about by its oppositions and marked by its discord—that is the essence of man in the great age of the Greeks. Therefore, in order to fulfill his essence, Greek man must gather (*legein*) and save (*sōzein*), catch up and preserve,[16] what opens itself in its openness, and he must remain exposed (*alētheuein*) to all its sundering confusions. Greek man *is* as the one who apprehends [*der Vernehmer*] that which is,[17] and this is why in the age of the Greeks the world cannot become picture. Yet, on the other hand, that the beingness of whatever is, is defined for Plato as *eidos* [aspect, view] is the presupposition, destined far in advance and long ruling indirectly in concealment, for the world's having to become picture (Appendix 8).

In distinction from Greek apprehending, modern representing, whose meaning the word *repraesentatio* first brings to its earliest expression, intends something quite different. Here to represent [*vor-stellen*] means to bring what is present at hand [*das Vorhandene*] before oneself as something standing over against, to relate it to oneself, to the one representing it, and to force it back into this relationship to oneself as the normative realm. Wherever this happens, man "gets into the picture" in precedence over whatever is. But in that man puts himself into the picture in this way, he puts himself into the scene, i.e., into the open

16. "Preserve" translates *bewahren*. The verb speaks of a preserving that as such frees and allows to be manifest. On the connotations resident in *wahren* and related words formed from *wahr*, see T 42 n. 9.

17. The noun *Vernehmer* is related to the verb *vernehmen* (to hear, to perceive, to understand). *Vernehmen* speaks of an immediate receiving, in contrast to the setting-before (*vor-stellen*) that arrests and objectifies.

sphere of that which is generally and publicly represented. Therewith man sets himself up as the setting in which whatever is must henceforth set itself forth, must present itself [*sich . . . präsentieren*], i.e., be picture. Man becomes the representative [*der Repräsentant*] of that which is, in the sense of that which has the character of object.

But the newness in this event by no means consists in the fact that now the position of man in the midst of what is, is an entirely different one in contrast to that of medieval and ancient man. What is decisive is that man himself expressly takes up this position as one constituted by himself, that he intentionally maintains it as that taken up by himself, and that he makes it secure as the solid footing for a possible development of humanity. Now for the first time is there any such thing as a "position" of man. Man makes depend upon himself the way in which he must take his stand in relation to whatever is as the objective. There begins that way of being human which mans the realm of human capability as a domain given over to measuring and executing, for the purpose of gaining mastery over that which is as a whole. The age that is determined from out of this event is, when viewed in retrospect, not only a new one in contrast with the one that is past, but it settles itself firmly in place expressly as the new. To be new is peculiar to the world that has become picture.

When, accordingly, the picture character of the world is made clear as the representedness of that which is, then in order fully to grasp the modern essence of representedness we must track out and expose the original naming power of the worn-out word and concept "to represent" [*vorstellen*]: to set out before oneself and to set forth in relation to oneself. Through this, whatever is comes to a stand as object and in that way alone receives the seal of Being. That the world becomes picture is one and the same event with the event of man's becoming *subiectum* in the midst of that which is (Appendix 9).

Only because and insofar as man actually and essentially has become subject is it necessary for him, as a consequence, to confront the explicit question: Is it as an "I" confined to its own preferences and freed into its own arbitrary choosing or as the "we" of society; is it as an individual or as a community; is it

as a personality within the community or as a mere group member in the corporate body; is it as a state and nation and as a people or as the common humanity of modern man, that man will and ought to be the subject that in his modern essence he *already is*? Only where man is essentially already subject does there exist the possibility of his slipping into the aberration of subjectivism in the sense of individualism. But also, only where man *remains* subject does the positive struggle against individualism and for the community as the sphere of those goals that govern all achievement and usefulness have any meaning.

The interweaving of these two events, which for the modern age is decisive—that the world is transformed into picture and man into *subiectum*—throws light at the same time on the grounding event of modern history, an event that at first glance seems almost absurd. Namely, the more extensively and the more effectually the world stands at man's disposal as conquered, and the more objectively the object appears, all the more subjectively, i.e., the more importunately, does the *subiectum* rise up, and all the more impetuously, too, do observation of and teaching about the world change into a doctrine of man, into anthropology. It is no wonder that humanism first arises where the world becomes picture. It would have been just as impossible for a humanism to have gained currency in the great age of the Greeks as it would have been impossible to have had anything like a world picture in that age. Humanism, therefore, in the more strict historiographical sense, is nothing but a moral-aesthetic anthropology. The name "anthropology" as used here does not mean just some investigation of man by a natural science. Nor does it mean the doctrine established within Christian theology of man created, fallen, and redeemed. It designates that philosophical interpretation of man which explains and evaluates whatever is, in its entirety, from the standpoint of man and in relation to man (Appendix 10).

The increasingly exclusive rooting of the interpretation of the world in anthropology, which has set in since the end of the eighteenth century, finds its expression in the fact that the fundamental stance of man in relation to what is, in its entirety, is defined as a world view (*Weltanschauung*). Since that time this word has been admitted into common usage. As soon as

the world becomes picture, the position of man is conceived as a world view. To be sure, the phrase "world view" is open to misunderstanding, as though it were merely a matter here of a passive contemplation of the world. For this reason, already in the nineteenth century it was emphasized with justification that "world view" also meant and even meant primarily "view of life." The fact that, despite this, the phrase "world view" asserts itself as the name for the position of man in the midst of all that is, is proof of how decisively the world became picture as soon as man brought his life as *subiectum* into precedence over other centers of relationship. This means: whatever is, is considered to be in being only to the degree and to the extent that it is taken into and referred back to this life, i.e., is lived out, and becomes life-experience. Just as unsuited to the Greek spirit as every humanism had to be, just so impossible was a medieval world view, and just as absurd is a Catholic world view. Just as necessarily and legitimately as everything must change into life-experience for modern man the more unlimitedly he takes charge of the shaping of his essence, just so certainly could the Greeks at the Olympian festivals never have had life-experiences.

The fundamental event of the modern age is the conquest of the world as picture. The word "picture" [*Bild*] now means the structured image [*Gebild*] that is the creature of man's producing which represents and sets before.[18] In such producing, man contends for the position in which he can be that particular being who gives the measure and draws up the guidelines for everything that is. Because this position secures, organizes, and articulates itself as a world view, the modern relationship to that which is, is one that becomes, in its decisive unfolding, a confrontation of world views; and indeed not of random world views, but only of those that have already taken up the fundamental position of man that is most extreme, and have done

18. *Gebild* is Heidegger's own word. The noun *Gebilde* means thing formed, creation, structure, image. *Gebild* is here taken to be close to it in meaning, and it is assumed—with the use of "structured"—that Heidegger intends the force of the prefix *ge-*, which connotes a gathering, to be found in the word (cf. QT 19 ff.). "Man's producing which represents and sets before" translates *des vorstellenden Herstellens*.

so with the utmost resoluteness. For the sake of this struggle of world views and in keeping with its meaning, man brings into play his unlimited power for the calculating, planning, and molding of all things. Science as research is an absolutely necessary form of this establishing of self in the world; it is one of the pathways upon which the modern age rages toward fulfillment of its essence, with a velocity unknown to the participants. With this struggle of world views the modern age first enters into the part of its history that is the most decisive and probably the most capable of enduring (Appendix 11).

A sign of this event is that everywhere and in the most varied forms and disguises the gigantic is making its appearance. In so doing, it evidences itself simultaneously in the tendency toward the increasingly small. We have only to think of numbers in atomic physics. The gigantic presses forward in a form that actually seems to make it disappear—in the annihilation of great distances by the airplane, in the setting before us of foreign and remote worlds in their everydayness, which is produced at random through radio by a flick of the hand. Yet we think too superficially if we suppose that the gigantic is only the endlessly extended emptiness of the purely quantitative. We think too little if we find that the gigantic, in the form of continual not-ever-having-been-here-yet, originates only in a blind mania for exaggerating and excelling. We do not think at all if we believe we have explained this phenomenon of the gigantic with the catchword "Americanism" (Appendix 12).

The gigantic is rather that through which the quantitative becomes a special quality and thus a remarkable kind of greatness. Each historical age is not only great in a distinctive way in contrast to others; it also has, in each instance, its own concept of greatness. But as soon as the gigantic in planning and calculating and adjusting and making secure shifts over out of the quantitative and becomes a special quality, then what is gigantic, and what can seemingly always be calculated completely, becomes, precisely through this, incalculable. This becoming incalculable remains the invisible shadow that is cast around all things everywhere when man has been transformed into *subiectum* and the world into picture (Appendix 13).

By means of this shadow the modern world extends itself out into a space withdrawn from representation, and so lends to the incalculable the determinateness peculiar to it, as well as a historical uniqueness. This shadow, however, points to something else, which it is denied to us of today to know (Appendix 14). But man will never be able to experience and ponder this that is denied so long as he dawdles about in the mere negating of the age. The flight into tradition, out of a combination of humility and presumption, can bring about nothing in itself other than self-deception and blindness in relation to the historical moment.

Man will know, i.e., carefully safeguard into its truth,[19] that which is incalculable, only in creative questioning and shaping out of the power of genuine reflection. Reflection transports the man of the future into that "between" in which he belongs to Being and yet remains a stranger amid that which is (Appendix 15). Hölderlin knew of this. His poem, which bears the superscription "To the Germans," closes:

> How narrowly bounded is our lifetime,
> We see and count the number of our years.
> But have the years of nations
> Been seen by mortal eye?
>
> If your soul throbs in longing
> Over its own time, mourning, then
> You linger on the cold shore
> Among your own and never know them.[20]

19. *Wissen, d.h., in seine Wahrheit verwahren, wird der Mensch.* . . . Here the verb *wissen* (to know), strongly emphasized by its placement in the sentence, is surely intended to remind of science (*Wissenschaft*) with whose characterization this essay began. On such knowing—an attentive beholding that watches over and makes manifest—as essential to the characterizing of science as such, see SR 180 ff.

20. Wohl ist enge begrenzt unsere Lebenzeit,
 Unserer Jahre Zahl sehen und zählen wir,
 Doch die Jahre der Völker,
 Sah ein sterbliches Auge sie?

 Wenn die Seele dir auch über die eigene Zeit
 Sich die sehnende schwingt, trauernd verweilest du
 Dann am kalten Gestade
 Bei den Deinen und kennst sie nie.

APPENDIXES

1. Such reflection is not necessary for all, nor is it to be accomplished or even found bearable by everyone. On the other hand, absence of reflection belongs to a very great extent to certain definite stages of achieving and moving forward. And yet the questioning belonging to reflection never becomes either groundless or beyond all question, because, in anticipation, it questions concerning Being. Being is for it that which is most worthy of questioning. Reflection finds in Being its most extreme resistance, which constrains it to deal seriously with whatever is as the latter is brought into the light of its Being. Reflection on the essence of the modern age puts thinking and decision into the sphere of effective working that belongs to the genuinely essential forces of this age. These forces work as they will, beyond the reach of all everyday valuation. In the face of these forces, there is only a readiness for their decisive issue or, instead, an evasive turning away into the ahistorical. In this connection, however, it is not sufficient to affirm technology, for example, or, out of an attitude incomparably more essential, to set up "total mobilization" as an absolute once it is recognized as being at hand.[21] It is a matter of constantly grasping in advance the essence of the age from out of the truth of Being holding sway

21. Heidegger refers here to the central theme of Ernst Jünger's "Die Totale Mobilmachung," first published in 1931 as the preliminary sketch for his monumental book *Der Arbeiter* [The worker] (Hamburg: Hanseatische Verlaganstalt, 1932). Originally, on the basis of his experience of World War I, Jünger sees "total mobilization" as the fundamental characteristic of modern warfare. Primarily a confrontation between man and technology, war shows itself to be a "gigantic labor process" (*gigantischer Arbeitsprozess*). (See "Die Totale Mobilmachung" in *Blätter und Steine* [Hamburg: Hanseatische Verlaganstalt, 1934], p. 130.) In the evolution of Jünger's thinking, the meaning of the term "total mobilization" extends itself to denote the phenomenon which for him is the essence of modern times: man's dominating of the earth by means of his technological will. "The war front and the labor front are identical" (*Der Arbeiter*, p. 109). Viewing Jünger's thinking in the light of Nietzsche's, Heidegger understands "total mobilization" as the final realization of the metaphysics of the will to power, or as the final phase of "active nihilism." See *The Question of Being* [*Zur Seinsfrage*], trans. William Klubach and Jean T. Wilde (New York: Twayne, 1958), pp. 41 ff.

within it; for only thus, simultaneously, is that which is most worthy of questioning experienced, i.e., that which radically carries forward and constrains a creating into the future, out beyond what is at hand, and lets the transformation of man become a necessity springing forth from Being itself. No age lets itself be done away with by a negating decree. Negation only throws the negator off the path. The modern age requires, however, in order to be withstood in the future, in its essence and on the very strength of its essence, an originality and range of reflection for which we of today are perhaps preparing somewhat, but over which we certainly can never gain mastery.

2. The phrase "ongoing activity" [Betrieb] is not intended here in a pejorative sense. But because research is, in essence, ongoing activity, the industrious activity of mere "busyness" [des blossen Betriebs], which is always possible, gives the impression of a higher reality behind which the burrowing activity proper to research work is accomplished. Ongoing activity becomes mere busyness whenever, in the pursuing of its methodology, it no longer keeps itself open on the basis of an ever-new accomplishing of its projection-plan, but only leaves that plan behind itself as a given; never again confirms and verifies its own self-accumulating results and the calculation of them, but simply chases after such results and calculations. Mere busyness must at all times be combated precisely because research is, in its essence, ongoing activity. If we seek what is scientific in science solely in serene erudition, then of course it seems as though the disowning of practical activity also means the denying of the fact that research has the essential character of ongoing activity. It is true that the more completely research becomes ongoing activity, and in that way mounts to its proper level of performance, the more constantly does the danger of mere industriousness grow within it. Finally a situation arises in which the distinction between ongoing activity and busyness not only has become unrecognizable, but has become unreal as well. Precisely this balancing out of the essential and the aberrant into the average that is the self-evident makes research as the embodiment of science, and thus makes the modern age itself, capable of enduring. But whence does re-

search receive the counterpoise to the mere busyness within its ongoing activity?

3. The growing importance of the publishing business is not based merely on the fact that publishers (perhaps through the process of marketing their books) come to have the best ear for the needs of the public or that they are better businessmen than are authors. Rather their peculiar work takes the form of a procedure that plans and that establishes itself with a view to the way in which, through the prearranged and limited publication of books and periodicals, they are to bring the world into the picture for the public and confirm it publicly. The preponderance of collections, of sets of books, of series and pocket editions, is already a consequence of this work on the part of publishers, which in turn coincides with the aims of researchers, since the latter not only are acknowledged and given consideration more easily and more rapidly through collections and sets, but, reaching a wider public, they immediately achieve their intended effect.

4. The fundamental metaphysical position of Descartes is taken over historically from the Platonic-Aristotelian metaphysics and moves, despite its new beginning, within the same question: What is it to be?* That this question, formulated in this way, does not come to the fore in Descartes's *Meditations* only proves how essentially the change in the answer to it already determines the fundamental position. Descartes's interpretation of what it is to be and of truth first creates the presupposition underlying the possibility of a theory of knowledge or a metaphysics of knowledge. Through Descartes, realism is first put in the position of having to prove the reality of the outer world, of having to save that which is as such.

The essential modifications of the fundamental position of Descartes that have been attained in German thinking since Leibniz do not in any way overcome that fundamental position itself. They simply expand its metaphysical scope and create the presuppositions of the nineteenth century, still the most obscure

* *Was ist das Seiende?* Literally, "What is being?"

of all the centuries of the modern age up to now. Indirectly those modifications confirm the fundamental position of Descartes in a form in which they themselves are almost unrecognizable, though they are not for that reason the less real. In contrast, mere Cartesian Scholasticism, with its rationalism, has lost all power further to shape modern times. With Descartes begins the completion and consummation of Western metaphysics. And yet, because such a consummation is only possible once again as metaphysics, modern thinking has its own greatness.

With the interpretation of man as *subiectum*, Descartes creates the metaphysical presupposition for future anthropology of every kind and tendency. In the rise of the anthropologies, Descartes celebrates his greatest triumph. Through anthropology the transition of metaphysics into the event of the simple stopping and setting aside of all philosophy is introduced. The fact that Dilthey disavowed metaphysics, that fundamentally he no longer even understood its question and stood helpless before metaphysical logic, is the inner consequence of his fundamental anthropological position. His "philosophy of philosophy" is an outstanding form of the anthropological abrogation—not the overcoming—of philosophy. This is why every anthropology in which previous philosophy is employed at will but is explained as superfluous *qua* philosophy has the advantage of seeing clearly what is required along with the affirmation of anthropology. Through this, the intellectual situation finds some clarification, while the laborious fabrications of such absurd offshoots as the national-socialist philosophies produce nothing but confusion. The world view does indeed need and use philosophical erudition, but it requires no philosophy, since, as world view, it has already taken over a particular interpretation and structuring of whatever is. But one thing, surely, anthropology cannot do. It cannot overcome Descartes, nor even rise up against him, for how shall the consequence ever attack the ground on which it stands?

Descartes can be overcome only through the overcoming of that which he himself founded, only through the overcoming of modern, and that means at the same time Western, metaphysics. Overcoming means here, however, the primal asking of the question concerning the meaning, i.e., concerning the realm of

the projection or delineation, and thus concerning the truth, of Being—which question simultaneously unveils itself as the question concerning the Being of truth.

5. The concept of world as it is developed in *Being and Time* is to be understood only from within the horizon of the question concerning "openness for Being" [*Da-sein*], a question that, for its part, remains closely conjoined with the fundamental question concerning the meaning of Being (not with the meaning of that which is).

6. What belongs properly to the essence of the picture is standing-together, system. By this is not meant the artificial and external simplifying and putting together of what is given, but the unity of structure in that which is represented [*im Vorgestellten*] as such, a unity that develops out of the projection of the objectivity of whatever is. In the Middle Ages a system is impossible, for there a ranked order of correspondences is alone essential, and indeed as an ordering of whatever is in the sense of what has been created by God and is watched over as his creature. The system is still more foreign to the Greeks, even if in modern times we speak, though quite wrongly, of the Platonic and Aristotelian "systems." Ongoing activity in research is a specific bodying-forth and ordering of the systematic, in which, at the same time, the latter reciprocally determines the ordering. Where the world becomes picture, the system, and not only in thinking, comes to dominance. However, where the system is in the ascendancy, the possibility always exists also of its degenerating into the superficiality of a system that has merely been fabricated and pieced together. This takes place when the original power of the projecting is lacking. The uniqueness of the systematic in Leibniz, Kant, Fichte, Hegel, and Schelling—a uniqueness that is inherently diverse—is still not grasped. The greatness of the systematic in these thinkers lies in the fact that it unfolds not as in Descartes out of the subject as *ego* and *substantia finita*, but either as in Leibniz out of the monad, or as in Kant out of the transcendental essence of finite understanding rooted in the imagination, or as in Fichte out of the infinite I, or as in Hegel out of Spirit as absolute knowledge,

or as in Schelling out of freedom as the necessity of every par-
ticular being which, as such a being, remains determined through
the distinction between ground and existence.

The representation of value is just as essential to the modern
interpretation of that which is, as is the system. Where anything
that is has become the object of representing, it first incurs in a
certain manner a loss of Being. This loss is adequately perceived,
if but vaguely and unclearly, and is compensated for with corre-
sponding swiftness through the fact that we impart value to the
object and to that which is, interpreted as object, and that we take
the measure of whatever is, solely in keeping with the criterion
of value, and make of values themselves the goal of all activity.
Since the latter is understood as culture, values become cultural
values, and these, in turn, become the very expression of the
highest purposes of creativity, in the service of man's making
himself secure as *subiectum*. From here it is only a step to making
values into objects in themselves. Value is the objectification of
needs as goals, wrought by a representing self-establishing
within the world as picture. Value appears to be the expression
of the fact that we, in our position of relationship to it, act
to advance just that which is itself most valuable; and yet that
very value is the impotent and threadbare disguise of the ob-
jectivity of whatever is, an objectivity that has become flat and
devoid of background. No one dies for mere values. We should
note, for the sake of shedding light on the nineteenth century,
the peculiar in-between position of Hermann Lotze, who at the
same time that he was reinterpreting Plato's Ideas as values
undertook, under the title *Microcosmos*, that *Attempt at an An-
thropology* (1856) which still drew sustenance for the nobility
and straightforwardness of its mode of thinking from the spirit
of German idealism, yet also opened that thinking to positivism.
Because Nietzsche's thinking remains imprisoned in value repre-
sentation, he has to articulate what is essential for him in the
form of a reversal, as the revaluation of all values. Only when
we succeed in grasping Nietzsche's thinking independently of
value representation do we come to a standing-ground from
which the work of the last thinker of metaphysics becomes a task

assigned to questioning, and Nietzsche's antagonism to Wagner becomes comprehensible as the necessity of our history.

7. Correspondence [*Die Entsprechung*], thought as the fundamental characteristic of the Being of whatever is, furnishes the pattern for very specific possibilities and modes of setting the truth of this Being, in whatever has being, into the work. The art work of the Middle Ages and the absence of a world picture in that age belong together.

8. But did not a sophist at about the time of Socrates dare to say, "Man is the measure of all things, of those that are [*der seienden*], that they are, of those that are not, that they are not?" Does this statement of Protagoras not sound as though Descartes were speaking? Most importantly, is it not true that the Being of whatever is, is grasped by Plato as that which is beheld, as *idea*? Is the relation to what is as such not for Aristotle *theōria*, pure beholding? And yet it is no more the case that this sophistic statement of Protagoras is subjectivism than it is that Descartes could carry into execution nothing but the overturning of Greek thought. Certainly, through Plato's thinking and through Aristotle's questioning a decisive change takes place in the interpretation of what is and of men, but it is a change that always remains on the foundation of the Greek fundamental experience of what is. Precisely as a struggle against sophism and therefore in dependency upon it, this changed interpretation is so decisive that it proves to be the end of Greek thought, an end that at the same time indirectly prepares the possibility of the modern age.[22] This is why Platonic and Aristotelian thinking has been able to pass for Greek thinking per se, not only in the Middle Ages but throughout the modern age up to now, and why all pre-Platonic thinking could be considered merely a preparation for Plato. It is because from long habituation we see Greek thinking through a modern humanistic interpretation that it remains denied to us

22. The word "end" (*Ende*) should here be taken in its full sense of conclusion, issue, aim, purpose.

to ponder the Being that opened itself to Greek antiquity in such a way as to leave to it its uniqueness and its strangeness. Protagoras' statement runs: *Pantōn chrēmatōn metron estin anthrōpos, tōn men ontōn hōs estin, tōn de mē ontōn hōs ouk estin* (cf. Plato, *Theaetetus*, 152).[23]

"Of all things (those, namely, that man has about him in customary use, and therefore constantly, *chrēmata chrēsthai*) the (particular) man is the measure, of those that presence, that they presence as they presence, but also of those to which it remains denied to presence, that they do not presence." That which is whose Being stands ready for decision is here understood as that which presences of itself within this sphere, within the horizon of man. But who is man? Plato gives details concerning this in the same place, when he has Socrates say: *Oukoun houtos pōs legei, hōs hoia men hekasta emoi phainetai, toiauta men estin emoi, hoia de soi toiauta de au soi' anthrōpos de su te kai egō*:[24] "Does he (Protagoras) not understand this somewhat as follows? Whatever at a given time anything shows itself to me as, of such aspect is it (also) for me; but whatever it shows itself to you as, such is it in turn for you. You are a man as much as I."[25]

Man is here, accordingly, a particular man (I and you and he and she). And this *egō* is not supposed to coincide with the *ego cogito* of Descartes? Never. For everything essential, i.e., that which determines with equal necessity the two fundamental metaphysical positions in Protagoras and Descartes, is different in the

23. Cornford translates: "Man is the measure of all things–alike of the being of things that are and of the not-being of things that are not." Having given his own translation of the quotation at the beginning of this paragraph, Heidegger now proceeds to give, at the beginning of the next, a rendering of it that presents his thinking out of the thought of the Greek passage in his own way.

24. Cornford translates: "He puts it in this sort of way, doesn't he?—that any given thing 'is to me such as it appears to me, and is to you such as it appears to you,' you and I being men."

25. This is a literal translation of the German, as the latter is of the Greek. However, it is impossible in English to bring out one emphasis that Heidegger himself gives. Following the Greek word order, he places *als* (as; Greek *hōs*) at the beginning of the main clause in the sentence, in an atypical German construction. He is thus able to stress by a means not available in English the importance here of the appearance to the particular observer.

two. What is essential in a fundamental metaphysical position embraces:

1. The manner and mode in which man is man, i.e., is himself; the manner of the coming to presence [*Wesensart*] of selfhood, which is not at all synonymous with I-ness, but rather is determined out of the relation to Being as such

2. The interpretation of the coming to presence [*Wesensauslegung*] of the Being of whatever is

3. The delineation of the coming to presence [*Wesensentwurf*] of truth

4. The sense in which, in any given instance, man is measure

None of these essential moments in a fundamental metaphysical position may be understood apart from the others. Each one always betokens, from the outset, the whole of a fundamental metaphysical position. Precisely why and in what respect these four moments sustain and structure in advance a fundamental metaphysical position as such is a question that can no longer be asked or answered from out of metaphysics and by means of metaphysics. It is a question that is already being uttered from out of the overcoming of metaphysics.

To be sure, for Protagoras, that which is does remain related to man as *egō*. What kind of relation to the I is this? The *egō* tarries within the horizon of the unconcealment that is meted out to it always as this particular unconcealment. Accordingly, it apprehends everything that presences within this horizon as something that is. The apprehending of what presences is grounded in this tarrying within the horizon of unconcealment. Through its tarrying [*das Verweilen*] in company with what presences, the belongingness of the I into the midst of what presences *is*. This belonging to what presences in the open fixes the boundaries between that which presences and that which absents itself. From out of these boundaries man receives and keeps safe the measure of that which presences and that which absents. Through man's being limited to that which, at any particular time, is unconcealed, there is given to him the measure that always confines a self to this or that. Man does not, from out of some detached I-ness, set forth the measure to which

everything that is, in its Being, must accommodate itself. Man who possesses the Greeks' fundamental relationship to that which is and to its unconcealment is *metron* (measure [*Mass*]) in that he accepts restriction [*Mässigung*] to the horizon of unconcealment that is limited after the manner of the I; and he consequently acknowledges the concealedness of what is and the insusceptibility of the latter's presencing or absenting to any decision, and to a like degree acknowledges the insusceptibility to decision of the visible aspect of that which endures as present.[26] Hence Protagoras says (Diels, *Fragmente der Vorsokratiker*: Protagoras B, 4): *Peri men theōn ouk echō eidenai, outh hōs eisin, outh hōs ouk eisin, outh hopoioi tines idean.*[27] "I am surely not in a position to know anything (for the Greek, to have anything in 'sight') regarding the gods, neither that they are nor that they are not, nor how they are in their visible aspect (*idea*)."

Polla gar ta kōluonta eidenai, hē t'adēlotes kai brachus on ho bios tou anthrōpou.[28] "For manifold is that which prevents the apprehending of whatever is as what it is, i.e., both the non-disclosedness (concealment) of what is and the brevity of man's historical course."

Need we wonder that Socrates, considering Protagoras' circumspection, says of him, *Eikos mentoi sophon andra mē lērein*: "We may suppose that he (Protagoras), a sensible man, (in his statement about man as *metron*) is not simply babbling on."[29]

The fundamental metaphysical position of Protagoras is only a narrowing down, but that means nonetheless a preserving, of the fundamental position of Heraclitus and Parmenides. Sophism is possible only on the foundation of *sophia*, i.e., on the foundation of the Greek interpretation of Being as presencing and of truth as unconcealment—an unconcealment that itself remains an essential determination of Being, so that what presences is de-

26. *die Unentscheidbarkeit . . . über das Aussehen des Wesenden.*

27. "As to the gods, I have no means of knowing either that they exist or that they do not exist" (Nahm).

28. "For many are the obstacles that impede knowledge, both the obscurity of the question and the shortness of human life" (Nahm).

29. Cornford translates: "Well, what a wise man says is not likely to be nonsense."

termined from out of unconcealment and presencing is determined from out of unconcealedness in its particularity.[30] But just how far removed is Descartes from the beginning of Greek thinking, just how different is the interpretation of man that represents him as subject? Precisely because in the concept of the *subiectum* the coming to presence of Being as experienced by the Greeks—the *hypokeisthai* of the *hypokeimenon*—still resounds in the form of a presencing that has become unrecognizable and unquestioned (namely, the presencing of that which lies fixedly before), therefore the essence of the change in fundamental metaphysical position is to be seen from out of that coming to presence of Being.

It is one thing to preserve the horizon of unconcealment that is limited at any given time through the apprehending of what presences (man as *metron*). It is another to proceed into the unlimited sphere of possible objectification, through the reckoning up of the representable that is accessible to every man and binding for all.

All subjectivism is impossible in Greek sophism, for here man can never be *subiectum*; he cannot become *subiectum* because here Being is presencing and truth is unconcealment.

In unconcealment *fantasia* comes to pass: the coming-into-appearance, as a particular something, of that which presences—for man, who himself presences toward what appears. Man as representing subject, however, "fantasizes," i.e., he moves in *imaginatio*, in that his representing imagines, pictures forth, whatever is, as the objective, into the world as picture.

9. How does it happen at all that that which is displays itself in a pronounced manner as *subiectum*,[31] and that as a conse-

30. In this sentence Heidegger shows the wholly mutual relation that he envisions between Being (*Sein*) and what is (*Seiendes*), i.e., between presencing and what presences, that each is forever determining and determined by the other. Cf. "The Onto-theo-logical Constitution of Metaphysics," in *Identity and Difference*, trans. Joan Stambaugh (New York: Harper & Row, 1969), pp. 61 ff., 128 ff.

31. Here "displays itself" translates *sich auslegt. Auslegen* is usually translated in these essays with "to interpret." For Heidegger the interpreting accomplished in metaphysics is the correlate of the displaying of itself in its Being vouchsafed by that which is.

quence the subjective achieves dominance? For up to Descartes, and also still within his metaphysics, that which is, insofar as it is a particular being, a particular *sub-iectum* (*hypo-keimenon*), is something lying before from out of itself, which, as such, simultaneously lies at the foundation of its own fixed qualities and changing circumstances. The superiority of a *sub-iectum* (as a ground lying at the foundation) that is preeminent because it is in an essential respect unconditional arises out of the claim of man to a *fundamentum absolutum inconcussum veritatis* (self-supported, unshakable foundation of truth, in the sense of certainty). Why and how does this claim acquire its decisive authority? The claim originates in that emancipation of man in which he frees himself from obligation to Christian revelational truth and Church doctrine to a legislating for himself that takes its stand upon itself. Through this liberation, the essence of freedom, i.e., being bound by something obligatory, is posited anew. But because, in keeping with this freedom, self-liberating man himself posits what is obligatory, the latter can henceforth be variously defined. The obligatory can be human reason and its law; or whatever is, arranged and objectively ordered from out of such reason; or that chaos, not yet ordered and still to be mastered through objectification, which demands mastery in a particular age.

But this liberation, although without knowing it, is always still freeing itself from being bound by the revelational truth in which the salvation of man's soul is made certain and is guaranteed for him. Hence liberation *from* the revelational certainty of salvation had to be intrinsically a freeing *to* a certainty [*Gewissheit*] in which man makes secure for himself the true as the known of his own knowing [*Wissens*]. That was possible only through self-liberating man's guaranteeing for himself the certainty of the knowable. Such a thing could happen, however, only insofar as man decided, by himself and for himself, what, for him, should be "knowable" and what knowing and the making secure of the known, i.e., certainty, should mean. Descartes's metaphysical task became the following: to create the metaphysical foundation for the freeing of man to freedom as the self-determination that is certain of itself. That foundation, however, had not only to be itself one that was certain, but since every standard of

measure from any other sphere was forbidden, it had at the same time to be of such a kind that through it the essence of the freedom claimed would be posited as self-certainty. And yet everything that is certain from out of itself must at the same time concomitantly make secure as certain that being for which such certain knowing must be certain and through which everything knowable must be made secure. The *fundamentum*, the ground of that freedom, that which lies at its foundation, the *subiectum*, must be something certain that satisfies the essential demands just mentioned. A *subiectum* distinguished in all these respects becomes necessary. What is this something certain that fashions and gives the foundation? The *ego cogito (ergo) sum*. The something certain is a principle that declares that, simultaneously (conjointly and lasting an equal length of time) with man's thinking, man himself is indubitably co-present, which means now is given to himself. Thinking is representing, setting-before, is a representing relation to what is represented (*idea* as *perceptio*).[32]

To represent means here: of oneself to set something before oneself and to make secure what has been set in place, as something set in place. This making secure must be a calculating, for calculability alone guarantees being certain in advance, and firmly and constantly, of that which is to be represented. Representing is no longer the apprehending of that which presences, within whose unconcealment apprehending itself belongs, belongs indeed as a unique kind of presencing toward that which presences that is unconcealed. Representing is no longer a self-unconcealing for . . . ,[33] but is a laying hold and grasping of. . . . What presences does not hold sway, but rather assault rules. Representing is now, in keeping with the new freedom, a going forth—from out of itself—into the sphere, first to be made secure, of

32. *Perceptio* is from the Latin *percipere (per + capere)*, thoroughly to lay hold of. The *idea*, that which presents itself and is viewed directly, has become the *perceptio*, that which is laid hold of and set in place and is thus known.

33. *das Sich-entbergen für. . . . Sich-entbergen* (self-unconcealing) might be very literally translated "self-harboring forth." The verb speaks of that accepting of bounds from out of which Greek man opened himself toward that which presenced to him. See Appendix 8, pp. 143 ff. For a discussion of *entbergen* and other words formed on *bergen*, see QT 11 n. 10.

what is made secure. That which is, is no longer that which presences; it is rather that which, in representing, is first set over against, that which stands fixedly over against, which has the character of object [*das Gegen-ständige*]. Representing is making-stand-over-against, an objectifying that goes forward and masters.[34] In this way representing drives everything together into the unity of that which is thus given the character of object. Representing is *coagitatio.*

Every relation to something—willing, taking a point of view, being sensible of [something]—is already representing; it is *cogitans*, which we translate as "thinking." Therefore Descartes can cover all the modes of *voluntas* and of *affectus*, all *actiones* and *passiones*, with a designation that is at first surprising: *cogitatio.* In the *ego cogito sum*, the *cogitare* is understood in this essential and new sense. The *subiectum*, the fundamental certainty, is the being-represented-together-with—made secure at any time—of representing man together with the entity represented, whether something human or non-human, i.e., together with the objective. The fundamental certainty is the *me cogitare* = *me esse* that is at any time indubitably representable and represented. This is the fundamental equation of all reckoning belonging to the representing that is itself making itself secure. In this fundamental certainty man is sure that, as the representer of all representing,[35] and therewith as the realm of all representedness, and hence of all certainty and truth, he is made safe and secure, i.e., *is*. Only because in the fundamental certainty (in the *fundamentum absolutum inconcussum* of the *me cogitare* = *me esse*), man is, in this way, necessarily represented-together-with; only because man who frees himself to himself belongs necessarily within the *subiectum* of this freedom—only for this reason can and must this man himself be transformed into an exceptional being, into a subject which, with regard to that which truly (i.e., certainly) is, which is primary,[36] has preeminence among all *subiecta*. That in the fundamental equation of certainty, and then again in the actual *subiectum*, the *ego* is named does not mean that man is now being defined in terms of the I

34. *Das Vor-stellen ist vor-gehende, meisternde Ver-gegen-ständlichung.*
35. Literally, "as the one who sets-before all setting-before."
36. *das erste wahrhaft (d.h. gewiss) Seiende.*

and egoistically. It means simply this: To be subject now becomes the distinction of man as the thinking-representing being [*Wesen*]. The I of man is placed in the service of this *subiectum*. The certainty lying at the foundation of this *subiectum* is indeed subjective, i.e., is holding sway in the essence of the *subiectum*; but it is not egoistic. Certainty is binding for every I as such, i.e., for every I as *subiectum*. In the same way, everything that intends to be established, through representing objectification, as secured and hence as in being, is binding for every man. But nothing can elude this objectification that remains at the same time the decision concerning what must be allowed to count as an object. To the essence of the subjectivity of the *subiectum* and to the essence of man as subject belongs the unconditional delimiting forth [*Entschränkung*] of the realm of possible objectification and the right to decide regarding objectification.[37]

Now it has also been clarified in what sense man as subject intends to be and must be the measure and center of that which is, which means of objects, of whatever stands-over-against. Man is now no longer *metron* in the sense of the restricting of his apprehending to the encircling sphere, particularized at any given time, of the unconcealment belonging to whatever presences toward which each man presences at any given time. As *subiectum*, man is the *co-agitatio* of the *ego*. Man founds and confirms himself as the authoritative measure for all standards of measure with which whatever can be accounted as certain—i.e., as true, i.e., as in being—is measured off and measured out (reckoned up). Freedom is new as the freedom of the *subiectum*. In the *Meditationes de prima philosophia* the freeing of man to the new freedom is brought onto its foundation, the *subiectum*. The freeing of modern man does not first begin with the *ego cogito ergo*

37. The noun *Entschränkung* is peculiar to Heidegger. Related nouns mean bounds or that which is enclosed. On the prefix *ent-*, as meaning forth or out, see QT 11 n. 10. *Entschränkung* expresses Heidegger's view that to set bounds is to free what is enclosed to be what it is (cf. QT 8). Heidegger is using the word in this context to point up the contrast between the position of modern man and that of Greek man, who, far from setting limits, "accepts restriction to the horizon of unconcealment that is limited [*beschränkten*] after the manner of the I," and who, far from deciding about what shall have being, "acknowledges the concealedness of what is and the insusceptibility of the latter's presencing or absenting to any decision." See p. 146.

sum, nor is the metaphysics of Descartes merely a metaphysics subsequently supplied and therefore externally built onto this freedom, in the sense of an ideology. In the *co-agitatio*, representing gathers all that is objective into the "all together" of representedness. The *ego* of the *cogitare* now finds in the self-securing "together" of representedness, in *con-scientia*, its essence. *Conscientia* is the representing setting together of whatever has the character of object, along with representing man, within the sphere of representedness safeguarded by man. Everything that presences receives from out of this representedness the meaning and manner of its presence [*Anwesenheit*]—namely, the meaning and manner of presence [*Praesenz*]—in *repraesentatio*. The *con-scientia* of the *ego* as the *subiectum* of the *coagitatio* determines, as the subjectivity of the *subiectum* that is distinctive in this way, the Being of whatever is.

The *Meditationes de prima philosophia* provide the pattern for an ontology of the *subiectum* with respect to subjectivity defined as *conscientia*. Man has become *subiectum*. Therefore he can determine and realize the essence of subjectivity, always in keeping with the way in which he himself conceives and wills himself. Man as a rational being of the age of the Enlightenment is no less subject than is man who grasps himself as a nation, wills himself as a people, fosters himself as a race, and, finally, empowers himself as lord of the earth. Still, in all these fundamental positions of subjectivity, a different kind of I-ness and egoism is also possible; for man constantly remains determined as I and thou, we and you. Subjective egoism, for which mostly without its knowing it the I is determined beforehand as subject, can be canceled out through the insertion of the I into the we. Through this, subjectivity only gains in power. In the planetary imperialism of technologically organized man, the subjectivism of man attains its acme, from which point it will descend to the level of organized uniformity and there firmly establish itself. This uniformity becomes the surest instrument of total, i.e., technological, rule over the earth.[38] The modern freedom of sub-

38. The reader will recognize in this passage a close foreshadowing of Heidegger's later characterization of the modern age as that wherein—under the rule of Enframing as the essence of technology—everything that is, is, through man, being transformed into and set in order as nothing but standing-reserve. Cf. QT 14 ff.

jectivity vanishes totally in the objectivity commensurate with it. Man cannot, of himself, abandon this destining of his modern essence or abolish it by fiat. But man can, as he thinks ahead, ponder this: Being subject as humanity has not always been the sole possibility belonging to the essence of historical man, which is always beginning in a primal way, nor will it always be. A fleeting cloud shadow over a concealed land, such is the darkening which that truth as the certainty of subjectivity—once prepared by Christendom's certainty of salvation—lays over a disclosing event [Ereignis] that it remains denied to subjectivity itself to experience.

10. Anthropology is that interpretation of man that already knows fundamentally what man is and hence can never ask who he may be. For with this question it would have to confess itself shaken and overcome. But how can this be expected of anthropology when the latter has expressly to achieve nothing less than the securing consequent upon the self-secureness of the *subiectum*?

11. For now the melting down of the self-consummating essence of the modern age into the self-evident is being accomplished. Only when this is assured through world views will the possibility arise of there being a fertile soil for Being to be in question in an original way—a questionableness of Being that will open ample space for the decision as to whether Being will once again become capable of a god, as to whether the essence of the truth of Being will lay claim more primally to the essence of man. Only there where the consummation of the modern age attains the heedlessness that is its peculiar greatness is future history being prepared.

12. "Americanism" is something European. It is an as-yet-uncomprehended species of the gigantic, the gigantic that is itself still inchoate and does not as yet originate at all out of the complete and gathered metaphysical essence of the modern age. The American interpretation [*Interpretation*] of Americanism by means of pragmatism still remains outside the metaphysical realm.

13. Everyday opinion sees in the shadow only the lack of light, if not light's complete denial. In truth, however, the shadow is a manifest, though impenetrable, testimony to the concealed emitting of light. In keeping with this concept of shadow, we experience the incalculable as that which, withdrawn from representation, is nevertheless manifest in whatever is, pointing to Being, which remains concealed.

14. But suppose that denial itself had to become the highest and most austere revealing of Being? What then? Understood from out of metaphysics (i.e., out of the question of Being, in the form What is it to be?), the concealed essence of Being, denial, unveils itself first of all as absolutely not-having-being, as Nothing. But Nothing as that Nothing which pertains to the having-of-being is the keenest opponent of mere negating. Nothing is never nothing; it is just as little a something, in the sense of an object [Gegenstand]; it is Being itself, whose truth will be given over to man when he has overcome himself as subject, and that means when he no longer represents that which is as object [Objekt].

15. This open between is the openness-for-Being [Da-sein], the word understood in the sense of the ecstatic realm of the revealing and concealing of Being.

Science and
Reflection [1]

In keeping with a view now prevalent, let us designate the realm in which the spiritual and creative activity of man is carried out with the name "culture." As part of culture, we count science, together with its cultivation and organization. Thus science is ranked among the values which man prizes and toward which, out of a variety of motives, he directs his attention.

But so long as we take science only in this cultural sense, we

1. "Reflection" is the translation of the noun *Besinnung*, which means recollection, reflection, consideration, deliberation. The corresponding reflexive verb, *sich besinnen*, means to recollect, to remember, to call to mind, to think on, to hit upon. Although "reflection" serves the needs of translation best in this and other essays in this volume, the word has serious inadequacies. Most importantly, reflection—from Latin *reflectere*, to bend back—intrinsically carries connotations uncomfortably close to those in Heidegger's use of *vorstellen*, to represent or set before, and could suggest the mind's observing of itself. Moreover, reflection, like the other nouns available as translations of *Besinnung*, lacks any marked connotation of directionality, of following after. The reader should therefore endeavor to hear in "reflection" fresh meaning. For Heidegger *Besinnung* is a recollecting thinking-on that, as though scenting it out, follows after what is thought. It involves itself with sense (*Sinn*) and meaning, and is at the same time a "calm, self-possessed surrender to that which is worthy of questioning." See below, pp. 180 ff; cf. *What Is Called Thinking?*, trans. Fred D. Wieck and J. Glenn Gray (New York: Harper & Row, 1968), pp. 207 ff.

will never be able to gauge the scope of its essence.[2] This is equally the case for art. Even today we readily name these two together: "art and science." Art also is represented as one sphere of cultural enterprise. But then we experience nothing of its essence. Regarded in terms of its essence, art is a consecration and a refuge in which the real bestows its long-hidden splendor upon man ever anew, that in such light he may see more purely and hear more clearly what addresses itself to his essence.

Science is no more a cultural activity of man than is art. Science is one way, and indeed one decisive way, in which all that is presents itself to us.

Therefore we must say: The reality within which man of today moves and attempts to maintain himself is, with regard to its fundamental characteristics, determined on an increasing scale by and in conjunction with that which we call Western European science.

When we ponder this ongoing event, it becomes evident that, in the Western world and during the eras of its history, science has developed such a power as could never have been met with on the earth before, and that consequently this power is ultimately to be spread over the entire globe.

Is science, then, nothing but a fabrication of man that has been elevated to this dominance in such a way as to allow us to assume that one day it can also be demolished again by the will of man through the resolutions of commissions? Or does a greater destiny rule here? Is there, ruling in science, still something other than a mere wanting to know on the part of man? Thus it is, in fact. Something other reigns. But this other conceals itself from us so long as we give ourselves up to ordinary notions about science.

This other is a state of affairs that holds sway throughout all the sciences, but that remains hidden to the sciences themselves.

2. "Essence" will be the usual translation in this essay for the noun *Wesen*. Occasionally *Wesen* will be translated with "coming to presence." The main argument of the essay is centrally concerned with the "essence" of science. In following the discussion, the reader should keep firmly in mind that for Heidegger the *Wesen* of science—as of anything whatever—is not simply *what* science is, but rather the manner in which it pursues its course through time, the manner in which it comports itself in its enduring as present. See QT 3 n. 1.

In order that this state of affairs may come into view for us, however, there must be adequate clarity about what science is. But how shall we come to know that? Most surely, it seems, simply by describing the scientific enterprise of our day. Such a presentation could show how, for a long time, ever more decisively and at the same time ever more unobtrusively, the sciences have been intersecting in all organizational forms of modern life: in industry, in commerce, in education, in politics, in warfare, in journalism of all kinds. To be acquainted with this intersecting is important. In order to be able to give an exposition of it, however, we must first have experienced that in which the essence of science lies. This may be expressed in one concise statement. It runs: *Science is the theory of the real.*

This statement intends to provide neither a ready definition nor an easy formula. It contains nothing but questions. They emerge only when the statement is clarified. We must observe first of all that the name "science" [*Wissenschaft*] in the statement "Science is the theory of the real" always refers exclusively to the new science of modern times. The statement "Science is the theory of the real" holds neither for the science of the Middle Ages nor for that of antiquity. Medieval *doctrina* is as essentially different from a theory of the real as it is different when contrasted with the *epistēmē* of the ancients. Nevertheless, the essence of modern science, which has become world-wide meanwhile as European science, is grounded in the thinking of the Greeks, which since Plato has been called philosophy.

With these considerations, the revolutionary character of the modern kind of knowing is in no way being weakened. Quite to the contrary, the distinctive character of modern knowing [*Wissens*] consists in the decisive working out of a tendency that still remains concealed in the essence of knowing as the Greeks experienced it, and that precisely needs the Greek knowing in order to become, over against it, another kind of knowing.

Whoever today dares, questioningly, reflectingly, and, in this way already as actively involved, to respond to the profundity of the world shock that we experience every hour, must not only pay heed to the fact that our present-day world is completely dominated by the desire to know of modern science; he must consider also, and above all else, that every reflection upon that

which now is can take its rise and thrive only if, through a dialogue with the Greek thinkers and their language, it strikes root into the ground of our historical existence. That dialogue still awaits its beginning. It is scarcely prepared for at all, and yet it itself remains for us the precondition of the inevitable dialogue with the East Asian world.

But a dialogue with the Greek thinkers—and that means at the same time with the Greek poets—does not imply a modern renaissance of the ancients. Just as little does it imply a historiographical curiosity about that which meanwhile has indeed passed, but which still could serve to explain some trends in the modern world chronologically as regards their origins.

That which was thought and in poetry was sung at the dawn of Greek antiquity is still present today, present in such a way that its essence, which is still hidden from itself, everywhere comes to encounter us and approaches us most of all where we least suspect it, namely, in the rule of modern technology, which is thoroughly foreign to the ancient world, yet nevertheless has in the latter its essential origin.

In order to experience this presence [*Gegenwart*] of history,[3] we must free ourselves from the historiographical representation of history that still continues to dominate. Historiographical representation grasps history as an object wherein a happening transpires that is, in its changeability, simultaneously passing away.

In the statement "Science is the theory of the real" there remains present what was primally thought, primally destined.[4]

We will now elucidate the statement from two points of view. Let us first ask, What does "the real" mean? And next, What does "theory" mean? At the same time our elucidation will show how the two, the real and the theoretical, join one another essentially.

3. The German noun *Gegenwart* means both "presence" and "the present." It thus speaks of presence expressly in the present. In *Was Heisst Denken?* (Tübingen: Max Niemeyer Verlag, 1974), Heidegger writes: *Anwesen und Anwesenheit heisst: Gegenwart. Diese meint das Entgegenweilen* (very literally, "Presencing and presence mean: present-time-presence. The latter means tarrying over against and toward") (p. 141). Cf. *What Is Called Thinking?*, p. 234.

4. Literally, "that which was early thought, early destined." Cf. QT 31.

In order to make clear what the name "real" means in the statement "Science is the theory of the real," let us simply consider the word itself. The real [*das Wirkliche*] brings to fulfillment the realm of working [*des Wirkenden*], of that which works [*wirkt*].[5] What does it mean "to work"? The answer to this question must depend on etymology. But what is decisive is the way in which this happens. The mere identifying of old and often obsolete meanings of terms, the snatching up of these meanings with the aim of using them in some new way, leads to nothing if not to arbitrariness. What counts, rather, is for us, in reliance on the early meaning of a word and its changes, to catch sight of the realm pertaining to the matter in question into which the word speaks. What counts is to ponder that essential realm as the one in which the matter named through the word moves. Only in this way does the word speak, and speak in the complex of meanings into which the matter that is named by it unfolds throughout the history of poetry and thought.

"To work" means "to do" [*tun*]. What does "to do" mean? The word belongs to the Indo-Germanic stem *dhē*; from this also stems the Greek *thesis*: setting, place, position. This doing, however, does not mean human activity only; above all it does not mean activity in the sense of action and agency. Growth also, the holding-sway of nature (*physis*), is a doing, and that in the strict sense of *thesis*. Only at a later time do the words *physis* and *thesis* come into opposition, something which in turn only becomes possible because a sameness determines them. *Physis* is *thesis*: from out of itself to lay something before, to place it here, to bring it hither and forth [*her- und vor-bringen*], that is, into presencing. That which "does" in such a sense is that which works; it is that which presences,[6] in its presencing. The verb

5. Unfortunately it is impossible to show in translation that the word rendered with "real" (*Wirkliche*) belongs immediately to the family of words built on the stem of the verb *wirken* (to work).

6. *das An-wesende*. Most literally, "that which endures unto." Heidegger writes elsewhere: *Die deutsche Präposition "an" bedeutet ursprünglich zugleich: "auf" und "in"* ("The German preposition *an* [unto] originally means simultaneously 'toward' [*auf*] and 'into' [*in*]"). (*Was Heisst Denken?*, p. 143). There, in a discussion of presencing, he says: *Wesen ist her-bei-, ist an-wesen im Streit mit dem ab-wesen* (literally, "*Wesen* [enduring as

"to work" understood in this way—namely, as to bring hither and forth—names, then, one way in which that which presences, presences. To work is to bring hither and forth, whether something brings itself forth hither into presencing of itself or whether the bringing hither and forth of something is accomplished by man. In the language of the Middle Ages our German word *wirken* still means the producing [*Hervorbringen*] of houses, tools, pictures; later, the meaning of *wirken* is narrowed down to producing in the sense of sewing, embroidering, weaving.

The real [*Wirkliche*] is the working, the worked [*Wirkende, Gewirkte*]; that which brings hither and brings forth into presencing, and that which has been brought hither and brought forth. Reality [*Wirklichkeit*] means, then, when thought sufficiently broadly: that which, brought forth hither into presencing, lies before; it means the presencing, consummated in itself, of self-bringing-forth. *Wirken* belongs to the Indo-Germanic stem *uerg*, whence our word *Werk* [work] and the Greek *ergon*. But never can it be sufficiently stressed: the fundamental characteristic of working and work does not lie in *efficere* and *effectus*, but lies rather in this: that something comes to stand and to lie in unconcealment. Even when the Greeks—that is to say, Aristotle—speak of that which the Romans call *causa efficiens*, they never mean the bringing about of an effect. That which consummates itself in *ergon* is a self-bringing-forth into full presencing; *ergon* is that which in the genuine and highest sense presences [*an-west*]. For this reason and only for this reason does Aristotle name the presence of that which actually presences[7] *energeia* and also *entelecheia*: a self-holding in consummation (i.e., consummation of presencing). These names, coined by Aristotle for the actual presencing of what presences, are, in respect to what they express, separated by an abyss from the later modern meanings of *energeia* in the sense of "energy" and of *entelecheia* in the sense of "entelechy"—talent and capacity for work.

Aristotle's fundamental word for presencing, *energeia*, is properly translated by our word *Wirklichkeit* [reality] only if we,

presence] is enduring hither, enduring unto, in strife with enduring away from [absenting]"). Cf. *What Is Called Thinking?*, p. 236.

7. *des eigentlich Anwesenden.*

for our part, think the verb *wirken* [to work] as the Greeks thought it, in the sense of bringing *hither*—into unconcealment, *forth*—into presencing.[8] *Wesen* [to come to presence] is the same word as *währen*, to last or endure. We think presencing [*Anwesen*] as the enduring of that which, having arrived in unconcealment, remains there. Ever since the period following Aristotle, however, this meaning of *energeia*, enduring-in-work, has been suppressed in favor of another. The Romans translate, i.e., think, *ergon* in terms of *operatio* as *actio*, and they say, instead of *energeia*, *actus*, a totally different word, with a totally different realm of meaning. That which is brought hither and brought forth now appears as that which results from an *operatio*. A result is that which follows out of and follows upon an *actio*: the consequence, the out-come [*Er-folg*]. The real is now that which has followed as consequence. The consequence is brought about by the circumstance [*Sache*] that precedes it, i.e., by the cause [*Ursache*] (*causa*). The real appears now in the light of the causality of the *causa efficiens*. Even God is represented in theology—not in faith—as *causa prima*, as first cause. Finally, in the course of the relating of cause and effect,[9] following-after-one-another is thrust into the foreground, and with it the elapsing of time. Kant recognized causality as a principle of temporal succession. In the latest works of Werner Heisenberg, the problem of the causal is the purely mathematical problem of the measuring of time. With this change in the reality of the real, however, is bound up something else no less essential. That which has been brought about [*das Erwirkte*], in the sense of the consequent [*des Erfolgten*], shows itself as a circumstance that has been set forth in a doing[10]—i.e., now, in a performing and

8. her—*ins Unverborgene*, vor—*ins Anwesen*.
9. *der Ursache-Wirkungsbeziehung*.
10. *sich . . . herausgestellt hat*. The verb *herausstellen* means to put out in place or to expose. *Sich herausstellen*, in addition to serving simply as a reflexive form with the meaning to put oneself out in place, means to become manifest, to turn out, to prove. The main component of the verb *stellen* (to set or place) is fundamental to all Heidegger's characterizing of that which is taking place in the modern age (cf. QT 15, AWP 129–130), while the prefix *her-* (hither) is regularly one of his primary vehicles for speaking of a bringing into presencing. The use of *herausstellen* here parallels that of *her-vor-bringen* above (p. 159); see also n. 21 below. *Sich herausstellen* will be translated hereafter with either "to set itself forth" or

executing. That which follows in fact and indeed from such a doing is the factual [*Tatsächliche*].[11] The word "factual" today connotes assurance, and means the same thing as "certain" and "sure." Instead of "It is certainly so," we say "It is in fact so," and "It is really so." Nevertheless, it is neither an accident nor a harmless caprice in the change in meaning of mere terms that, since the beginning of the modern period in the seventeenth century, the word "real" has meant the same thing as "certain."

The "real," in the sense of what is factual, now constitutes the opposite of that which does not stand firm as guaranteed and which is represented as mere appearance or as something that is only believed to be so. Yet throughout these various changes in meaning the real still retains the more primordially fundamental characteristic, which comes less often and differently to the fore, of something that presences which sets itself forth from out of itself.

But now the real presents itself in the taking place of consequences. The consequence demonstrates that that which presences has, through it, come to a secured stand, and that it encounters as such a stand [*Stand*]. The real now shows itself as object, that which stands over against [*Gegen-Stand*].

The word *Gegenstand* first originates in the eighteenth century, and indeed as a German translation of the Latin *obiectum*. There are profound reasons why the words "object" and "objectivity" [*Gegenständlichkeit*] took on special importance for

"to exhibit itself," depending on the exigencies of the particular context in which it appears. The reader should keep in mind that the self-exhibiting of which the verb speaks is a self-setting-forth that involves a setting in place. The importance of the latter nuance of meaning in *sich herausstellen* is shown by the fact that the verb's introduction here leads directly into a discussion of the appearing of the real as object, as that which stands over against—a connection for the verb that will be found repeatedly in the succeeding pages (see especially p. 163 below). Regrettably, none of the translations here employed can overtly suggest either the evocative force or the wide-ranging kinship that *sich herausstellen* possesses in the German text.

11. *Das in der Tat solchen Tuns Erfolgten ist das Tatsächliche. Tatsächlich* (actual, factual), based on the word *Tat* (deed), from *tun* (to do), here makes the connection Heidegger intends in a way that cannot be duplicated in English.

Goethe. But neither medieval nor Greek thinking represents that which presences as object. We shall now name the kind of presence *belonging* to that which presences that appears in the modern age as object: *objectness* [*Gegenständigkeit*].[12]

This is first of all a character belonging to that which presences itself. But how the objectness of what presences is brought to appearance and how what presences becomes an object for a setting-before, a representing [*Vor-stellen*], can show itself to us only if we ask: What is the real in relation to theory, and thus in a certain respect also in and through theory? We now ask, in other words: In the statement "Science is the theory of the real," what does the word "theory" mean? The word "theory" stems from the Greek verb *theōrein*. The noun belonging to it is *theōria*. Peculiar to these words is a lofty and mysterious meaning. The verb *theōrein* grew out of the coalescing of two root words, *thea* and *horaō*. *Thea* (cf. theater) is the outward look, the aspect, in which something shows itself, the outward appearance in which it offers itself. Plato names this aspect in which what presences shows what it is, *eidos*. To have seen this aspect, *eidenai*, is to know [*wissen*].[13] The second root word in *theōrein*, *horaō*, means: to look at something attentively, to look it over, to view it closely. Thus it follows that *theōrein* is *thean horan*, to look attentively on the outward appearance wherein what presences becomes visible and, through such sight—seeing—to linger with it.[14]

That particular way of life (*bios*) that receives its determina-

12. *Gegenständigkeit* (objectness) is a word formed by Heidegger to characterize the peculiar mode of presencing that rules in the modern age. It is not to be confused with the familiar German word *Gegenständlichkeit* (objectivity). In accordance with what Heidegger says elsewhere about the word *Subjektität*, translated in this volume as "subjectness" (cf. WN 68 n. 9), we may perhaps say that "objectness" speaks of the mode in which Being endures as present as determined by what is, as the latter presences as object.

13. The verb *wissen* comes ultimately from the same Indo-European root *weid* as does the Greek *eidenai*. See *The American Heritage Dictionary*, s.v. "Indo-European Roots," p. 1548.

14. *Den Anblick, worin das Anwesende erscheint, ansehen und durch solche Sicht bei ihm sehend verweilen.* On the force of the prefix *an-*, central here, see p. 159 n. 6.

tion from *theōrein* and devotes itself to it the Greeks call *bios theōrētikos*, the way of life of the beholder, the one who looks upon the pure shining-forth of that which presences. In contrast to this, *bios praktikos* is the way of life that is dedicated to action and productivity. In adhering to this distinction, however, we must constantly keep one thing in mind: for the Greeks, *bios theōrētikos*, the life of beholding, is, especially in its purest form as thinking, the highest doing. *Theōria* in itself, and not only through the utility attaching to it, is the consummate form of human existence. For *theōria* is pure relationship to the outward appearances belonging to whatever presences, to those appearances that, in their radiance, concern man in that they bring the presence [*Gegenwart*] of the gods to shine forth. The further characterization of *theōrein*, i.e., that it brings the *archai* and *aitiai* of what presences before man's apprehension and powers of demonstration, cannot be given here; for this would require a reflection on what Greek experience understood in that which we for so long have represented as *principium* and *causa*, ground and cause (See Aristotle, *Nicomachean Ethics*, Bk. VI, chap. 2, 1139 ff).

Bound up with the supremacy accorded *theoria* within Greek *bios* is the fact that the Greeks, who in a unique way thought out of their language, i.e., received from it their human existence,[15] were also able to hear something else in the word *theōria*. When differently stressed, the two root words *thea* and *oraō* can read *theá* and *óra*. *Theá* is goddess. It is as a goddess that *Alētheia*, the unconcealment from out of which and in which that which presences, presences, appears to the early thinker Parmenides. We translate *alētheia* by the Latin word *veritas* and by our German word *Wahrheit* [truth].

The Greek word *ōra* signifies the respect we have, the honor and esteem we bestow. If now we think the word *theōria* in the context of the meanings of the words just cited, then *theōria* is the reverent paying heed to the unconcealment of what presences. Theory in the old, and that means the early but by no means the

15. "Existence" translates *Dasein*. Written as *Da-sein*, it is translated as "openness-for-Being." See Introduction, p. xxxv n. 2. Cf. AWP Appendix 5, p. 141. The latter meaning should be found also in the translation of *Dasein* as "existence"; cf. the discussion of Being's coming to presence in language through the cooperation of man given in T 40–41.

obsolete, sense is the *beholding that watches over truth*.[16] Our old high German word *wara* (whence *wahr, wahren,* and *Wahrheit*)[17] goes back to the same stem as the Greek *horaō, ōra, wora.*

The essence of theory as thought by the Greeks, which is ambiguous and from every perspective high and lofty, remains buried when today we speak of the theory of relativity in physics, of the theory of evolution in biology, of the cyclical theory in history, of the natural rights theory in jurisprudence. Nonetheless, within "theory," understood in the modern way, there yet steals the shadow of the early *theōria*. The former lives out of the latter, and indeed not only in the outwardly identifiable sense of historical dependency. What is taking place here will become clearer when now we ask this question: In distinction from the early *theōria*, what is "the theory" that is named in the statement "Modern science is the theory of the real"?

We shall answer with the necessary brevity, since we shall choose an ostensibly superficial way. Let us take careful note how the Greek words *theōrein* and *theōria* are translated into the Latin and the German languages. Deliberately we say "words" [*die Worte*] and not "terms" [*die Wörter*], in order to emphasize that, each time, in the coming to presence and holding-sway of language, it is a destining that decides.

The Romans translate *theōrein* by *contemplari*, *theōria* by *contemplatio*. This translation, which issues from the spirit of the Roman language, that is, from Roman existence, makes that which is essential in what the Greek words say vanish at a stroke. For *contemplari* means: to partition something off into a separate sector and enclose it therein. *Templum* is the Greek *temenos*, which has its origin in an entirely different experience from that out of which *theōrein* originates. *Temnein* means: to cut, to divide. The uncuttable is the *atmēton*, *a-tomon*, atom.

The Latin *templum* means originally a sector carved out in the heavens and on the earth, the cardinal point, the region of the heavens marked out by the path of the sun. It is within this

16. *das hütende Schauen der Wahrheit.*

17. This passage makes clear how these words *wahr* (true), *wahren* (to keep safe, preserve), *Wahrheit* (truth) all bear, in Heidegger's mind, fundamental connotations of manifesting and watchful safeguarding. Cf. T 42 n. 9.

region that diviners make their observations in order to determine the future from the flight, cries, and eating habits of birds. (See Ernout-Meillet, *Dictionnaire étymologique de la langue latine* (3), 1951, p. 1202: *contemplari dictum est a templo, i.e., loco qui ab omni* parte aspici, *vel ex quo omnis* pars videri *potest, quem antiqui templum nominabant*).[18]

In *theōria* transformed into *contemplatio* there comes to the fore the impulse, already prepared in Greek thinking, of a looking-at that sunders and compartmentalizes. A type of encroaching advance by successive interrelated steps toward that which is to be grasped by the eye makes itself normative in knowing. But even now the *vita contemplativa* still remains distinct from the *vita activa*.

In the language of medieval Christian piety and theology, the above-mentioned distinction gains still another sense. It contrasts the meditative-monastic life with the worldly-active one.

The German translation for *contemplatio* is *Betrachtung* [view or observation]. The Greek *theōrein*, to look attentively upon the aspect of what presences, appears now as to observe or consider [*Betrachten*]. Theory is the viewing, the observation, of the real. But what does observation mean? We speak of a contemplative viewing in the sense of religious meditation and introspection. This kind of viewing belongs in the realm of the *vita contemplativa* just mentioned. We speak also of the viewing of a picture, in looking at which we find release. In such usage, the word *Betrachtung* [view] is close to beholding, and it still seems to be of like meaning with the early *theōria* of the Greeks. And yet the "theory" that modern science shows itself to be is something essentially different from the Greek *theōria*. Thus, when we translate "theory" by "observation" we are giving the word "observation" a different meaning, not an arbitrarily invented one, but rather the one from which it is originally descended. If we take seriously what the German *Betrachtung* means, we shall recognize what is new in the essence of modern science as the theory of the real.

What does *Betrachtung* mean? *Trachten* [to strive] is the Latin

18. "*Contemplari* is derived from *templum*, i.e., from [the name of] the *place which can be seen* from any point, and from which any *point can be seen*. The ancients called this place a *templum*."

tractare, to manipulate, to work over or refine [*bearbeiten*].[19] To strive after something means: to work one's way *toward* something, to pursue it, to entrap it in order to secure it. Accordingly, theory as observation [*Betrachtung*] would be an entrapping and securing refining of the real. But this characterization of science would obviously have to run counter to science's essence. For after all, science as theory is surely "theoretical." It spurns any refining of the real. It stakes everything on grasping the real purely. It does not encroach upon the real in order to change it. Pure science, we proclaim, is "disinterested."

And yet modern science as theory in the sense of an observing that strives after is a refining of the real that does encroach uncannily upon it. Precisely through this refining it corresponds to a fundamental characteristic of the real itself. The real is what presences as self-exhibiting.[20] But what presences shows itself in the modern age in such a way as to bring its presencing to a stand in objectness. Science corresponds to this holding-sway of presencing in terms of objects, inasmuch as it for its part, as theory, challenges forth the real specifically through aiming its objectness.[21] Science sets upon the real.[22] It orders it into place

19. From this point Heidegger continues to use *das Wirkliche* (the real), but he begins to use forms of the verb *arbeiten* (to execute, to work, to fashion; [intrans.] to labor) to set forth the way in which modern science, in corresponding to the manner in which the real now presents itself as object in a causal sequence, performs the doing that brings the real forth into its presencing in the modern age. Thus *arbeiten* and its compounds—*bearbeiten* (to work over or refine), *zuarbeiten* (to work toward), *umarbeiten* (to work around or recast), *herausarbeiten* (to work out)—are juxtaposed to *wirken* (to work), discussed above. It has not been possible to show this juxtaposition in the translation. Indeed, the necessity of sometimes translating the verbs formed around *arbeiten* with uses of the English verb "work" actually functions to obscure it altogether. Heidegger's use here of verbs formed from *arbeiten* recalls his previous statement: "That which has been brought about, in the sense of the consequent, shows itself as a circumstance that has been set forth in a doing,—i.e., now, in a performing and executing" (*Das Erwirkte im Sinne des Erfolgten zeigt sich als Sache, die sich in einem Tun, d.h. jetzt Leisten und Arbeiten herausgestellt hat*) (p. 161).

20. *das sich herausstellende Anwesende.*

21. "Challenges forth" translates *herausfordern* (literally, demands out hither). The structural parallel between the verbs *herausfordern* and *herausstellen* bespeaks the correspondence between the refining of the real wrought by science as an executing and the real's "working" of itself.

22. "Sets upon" translates *stellen*. On the meaning of this verb, see QT

to the end that at any given time the real will exhibit itself as an interacting network,[23] i.e., in surveyable series of related causes. The real thus becomes surveyable and capable of being followed out in its sequences. The real becomes secured in its objectness. From this there result spheres or areas of objects that scientific observation can entrap after its fashion.[24] Entrapping representation, which secures everything in that objectness which is thus capable of being followed out, is the fundamental characteristic of the representing through which modern science corresponds to the real. But then the all-decisive work [*Arbeit*] that such representing performs in every science is that refining of the real which first in any way at all expressly works the real out into an objectness through which everything real is recast in advance into a diversity of objects for the entrapping securing.

The fact that what presences—e.g., nature, man, history, language—sets itself forth as the real in its objectness, the fact that as a complement to this science is transformed into theory that entraps the real and secures it in objectness, would have been as strange to medieval man as it would have been dismaying to Greek thought.

Thus modern science, as the theory of the real, is not anything self-evident. It is neither a mere construct of man nor something extorted from the real. Quite to the contrary, the essence of science is rendered necessary by the presencing of what pres-

15 n. 14. The use of *herausstellen* to characterize the manner in which the real exhibits and sets itself forth in the modern age has already been noted (p. 161, n. 10). A variety of *stellen* verbs follow here in this discussion of the conduct of modern science as theory: *nachstellen* (to entrap), *sicherstellen* (to make secure), *bestellen* (to order or command), *feststellen* (to fix or establish), *vorstellen* (to represent), *umstellen* (to encompass), *erstellen* (to set forth), *beistellen* (to place in association with).

23. "Interacting network" translates *Ge-wirk*. In isolating the prefix *ge-* in the ordinary noun *Gewirk* (web, texture, weaving), Heidegger would have us hear, in accordance with his foregoing discussion, the more fundamental meaning of a *gathering* of that which works and is worked. Cf. the discussion of *ge-*, QT 19.

24. "Spheres or areas of objects" translates *Gebiete von Gegenständen*, a phrase that Heidegger employs only at this one point in the essay. His *Gegenstandsgebiet*, used frequently in the following pages, is translated as "object-area" to distinguish it from the nearly synonymous *Gegenstandsbezirk*, translated as "object-sphere" in AWP.

ences at the moment when presencing sets itself forth into the objectness of the real. This moment remains mysterious, as does every moment of its kind. It is not only the greatest thoughts that come as upon doves' feet; but at any given time it is the change in the presencing of everything that presences that comes thus—and before all else.

Theory makes secure at any given time a region of the real as its object-area. The area-character of objectness is shown in the fact that it specifically maps out in advance the possibilities for the posing of questions. Every new phenomenon emerging within an area of science is refined to such a point that it fits into the normative objective coherence of the theory. That normative coherence itself is thereby changed from time to time. But objectness as such remains unchanged in its fundamental characteristics. That which is represented in advance as the determining basis for a strategy and procedure is, in the strict sense of the word, the essence of what is called "end" or "purpose." When something is in itself determined by an end, then it is pure theory. It is determined by the objectness of what presences. Were objectness to be surrendered, the essence of science would be denied. This is the meaning, for example, of the assertion that modern atomic physics by no means invalidates the classical physics of Galileo and Newton but only narrows its realm of validity. But this narrowing is simultaneously a confirmation of the objectness normative for the theory of nature, in accordance with which nature presents itself for representation as a spatio-temporal coherence of motion calculable in some way or other in advance.

Because modern science is theory in the sense described, therefore in all its observing [Be-trachten] the manner of its striving-after [Trachtens], i.e., the manner of its entrapping-securing procedure, i.e., its method, has decisive superiority. An oft-cited statement of Max Planck reads: "That is real which can be measured." This means that the decision about what may pass in science, in this case in physics, for assured knowledge rests with the measurability supplied in the objectness of nature and, in keeping with that measurability, in the possibilities inherent in the measuring procedure. The statement of Max Planck is true, however, only because it articulates something that belongs to

the essence of modern science, not merely to physical science. The methodology, characterized by entrapping securing, that belongs to all theory of the real is a reckoning-up. We should not, of course, understand this term in the narrow sense of performing an operation with numbers. To reckon, in the broad, essential sense, means: to reckon with something, i.e., to take it into account; to reckon on something, i.e., to set it up as an object of expectation. In this way, all objectification of the real is a reckoning, whether through causal explanation it pursues the consequences of causes, whether through morphology it puts itself into the picture in precedence over objects, or whether in its fundamental elements it secures and guarantees some coherence of sequence and order. Mathematics also is not a reckoning in the sense of performing operations with numbers for the purpose of establishing quantitative results; but, on the contrary, mathematics is the reckoning that, everywhere by means of equations, has set up as the goal of its expectation the harmonizing of all relations of order, and that therefore "reckons" in advance with one fundamental equation for all merely possible ordering.

Because modern science as the theory of the real depends on the precedence that attaches to its method, therefore it must, as a securing of object-areas, delimit these areas over against one another and localize them, as thus delimited, within compartments, i.e., compartmentalize them. The theory of the real is necessarily departmentalized science.

Investigation of an object-area must, in the course of its work, agree with the particular form and modification possessed at any given time by the objects belonging to that area. Such agreement with the particular transforms the procedure of a branch of science into specialized research. Specialization, therefore, is in no way either a deterioration due to some blindness or a manifestation of the decline of modern science. Specialization is also not merely an unavoidable evil. It is a necessary consequence, and indeed the positive consequence, of the coming to presence [*Wesen*] of modern science.

The delimiting of object-areas, the compartmentalizing of these into special provinces, does not split the sciences off from one another, but rather it first yields a border traffic between them

by means of which boundary areas are marked out. Those areas are the source of a special impetus that produces new formulations of questions that are often decisive. We know this fact. The reason for it remains enigmatic, as enigmatic as the entire essence of modern science.

We have, indeed, already characterized this essence by elucidating the statement "Science is the theory of the real" according to its two principal words. This happened in preparation for our second step, which is to ask: What inconspicuous state of affairs conceals itself in the essence of science?[25]

We shall notice this state of affairs the moment that, taking particular sciences as examples, we attend specifically to whatever is the case regarding the ordering—in any given instance—of the objectness belonging to the object-area of those sciences. Physics, which, roughly speaking, now includes macrophysics and atomic physics, astrophysics and chemistry, observes nature (*physis*) insofar as nature exhibits itself as inanimate. In such objectness nature manifests itself as a coherence of motion of material bodies. The fundamental trait of the corporeal is impenetrability, which, for its part, presents itself as a kind of coherence of motion of elementary objects. The elementary objects themselves and their coherence are represented in classical

25. "State of affairs" translates the noun *Sachverhalt. Sachverhalt* might be rendered very literally "relating or conjoining of matters." Heidegger is doubtless here using this word as he does elsewhere, at the outset of the intricate discussion in "Time and Being" (see *On Time and Being*, trans. Joan Stambaugh [New York: Harper & Row, 1972], p. 4, where the word is translated "matter at stake") to point to the wholly singular and self-initiating bringing-to-pass (*Ereignis*)—not brought about by anything from beyond itself and not bringing about anything as its consequence—that takes place as and within Being itself, the bringing-to-pass that, precisely as a disclosing, brings Being and man into their own at any given time in giving them into their needed belonging to one another. Cf. T 45 ff; cf. also "Time and Being," pp. 23 ff. Although "Being" is scarcely mentioned as such in this essay and the word *Ereignis* is never used, the relating of Being—as the Being of whatever is—to man, whose science works over the real, clearly underlies Heidegger's entire discussion and comes tellingly if hiddenly into play with this use of *Sachverhalt* and in the discussion that follows to the end of the essay. The same allusion as that in *Sachverhalt* lies in Heidegger's later discussion of that which is not to be gotten around that is intractable and inaccessible (*das unzugängliche Unumgängliche*); and it sounds somewhat more evidently in his mention of that which is worthy of questioning (*das Fragwürdige*). Cf. AWP, Appendix 1, pp. 137–138.

physics as geometrical point mechanics, in the physics of today under the headings "nucleus" and "field." Accordingly, for classical physics every state of motion of bodies that occupy space is at any time simultaneously determinable—i.e., is precisely calculable in advance, predictable—both as to position and as to velocity. In contrast to this, in atomic physics a state of motion may on principle only be determined either as to position or as to velocity. Correspondingly, classical physics maintains that nature may be unequivocally and completely calculated in advance, whereas atomic physics admits only of the guaranteeing of an objective coherence that has a statistical character.

The objectness of material nature shows in modern atomic physics *fundamental characteristics completely different* from those that it shows in classical physics. The latter, classical physics, can indeed be incorporated within the former, atomic physics, but not vice versa. Nuclear physics does not permit itself to be traced back to classical physics and reduced to it. And yet—modern nuclear and field physics *also* still remains physics, i.e., science, i.e., theory, which entraps objects belonging to the real, in their objectness, in order to secure them in the unity of objectness. For modern physics too it is a question of making secure those elementary objects of which all other objects in its entire area consist. The representing belonging to modern physics is also bent on "being able to write one single fundamental equation from which the properties of all elementary particles, and therewith the behavior of all matter whatever, follow."*

This rough indication of a distinction between epochs within modern physics makes plain where the change from the one to the other takes place:[26] in the experience and determination of the objectness wherein nature sets itself forth. Nevertheless, what does *not* change with this change from geometrizing-classical physics to nuclear and field physics is this: the fact that nature has in advance to set itself in place for the entrapping securing

* Heisenberg, "Die gegenwärtigen Grundprobleme der Atomphysik." See *Wandlungen in den Grundlagen der Naturwissenschaft* (1948 ed.), 8 : 98.

26. For the meaning of "epoch," see T 43 n. 10.

that science, as theory, accomplishes. However, the way in which in the most recent phase of atomic physics even the *object vanishes also,* and the way in which, above all, the subject-object relation as pure relation thus takes precedence *over* the object and the subject, to become secured as standing-reserve, cannot be more precisely discussed in this place.

(Objectness changes into the constancy of the standing-reserve, a constancy determined from out of Enframing. [See "The Question Concerning Technology."] The subject-object relation thus reaches, for the first time, its pure "relational," i.e., ordering, character in which both the subject and the object are sucked up as standing-reserves. That does not mean that the subject-object relation vanishes, but rather the opposite: it now attains to its most extreme dominance, which is predetermined from out of Enframing. It becomes a standing-reserve to be commanded and set in order.)[27]

We are now considering the inconspicuous state of affairs that lies in the holding-sway of objectness.

Theory identifies the real—in the case of physics, inanimate nature—and fixes it into *one* object-area. However, nature is always presencing of itself. Objectification, for its part, is directed toward nature as thus presencing. Even where, as in modern atomic physics, theory—for essential reasons—necessarily becomes the opposite of direct viewing, its aim is to make atoms exhibit themselves for sensory perception, even if this self-exhibiting of elementary particles happens only very indirectly and in a way that technically involves a multiplicity of intermediaries. (Compare the Wilson cloud chamber, the Geiger counter, the free balloon flights to confirm and identify mesons.) Theory never outstrips nature—nature that is already presencing—and in this sense theory never makes its way around nature. Physics may well represent the most general and pervasive lawfulness of nature in terms of the identity of matter and energy; and what is represented by physics is indeed nature itself, but undeniably it is only nature as the object-area, whose objectness is first defined and determined through the refining that is char-

27. For this paragraph Heidegger uses brackets. The reference to QT is his.

acteristic of physics and is expressly set forth in that refining. Nature, in its objectness for modern physical science, is only *one* way in which what presences—which from of old has been named *physis*—reveals itself and sets itself in position for the refining characteristic of science. Even if physics as an object-area is unitary and self-contained, this objectness can never embrace the fullness of the coming to presence of nature. Scientific representation is never able to encompass the coming to presence of nature; for the objectness of nature is, antecedently, only *one* way in which nature exhibits itself. Nature thus remains for the science of physics that which cannot be gotten around. This phrase means two things here. First, nature is not to be "gotten around" inasmuch as theory never passes that which presences by, but rather remains directed toward it. Further, nature is not to be gotten around inasmuch as objectness as such prevents the representing and securing that correspond to it from ever being able to encompass the essential fullness of nature. It is this, at bottom, that haunted Goethe in his abortive struggle with Newtonian physics. Goethe could not yet see that his intuitive representing of nature also moves within the medium of objectness, within the subject-object relation, and therefore in principle is not different from physics and remains the same metaphysically as physics. Scientific representation, for its part, can never decide whether nature, through its objectness, does not rather withdraw itself than bring to appearance the hidden fullness of its coming to presence. Science cannot even ask this question, for, as theory, it has already undertaken to deal with the area circumscribed by objectness.

In the objectness of nature to which physics as objectification corresponds, that which—in a twofold sense—is not to be gotten around holds sway. As soon as we have once caught sight in one science of that which is not to be gotten around and have also considered it somewhat, we see it easily in every other.

Psychiatry strives to observe the life of the human soul in its sick—and that means always simultaneously in its healthy—manifestations. It represents these in terms of the objectness of the bodily-psychical-spiritual unity of the whole man. At any given time human existence, which is already presencing, displays itself in the objectness belonging to psychiatry. The open-

ness-for-Being [*Da-sein*] in which man as man ek-sists, remains that which for psychiatry is not to be gotten around.

Historiography, which ever more urgently is developing into the writing of universal history, accomplishes its entrapping securing in the area that offers itself to its theory as history. The word *Historie* (*historein*) [historiography] means to explore and make visible, and therefore names a kind of representing. In contrast, the word *Geschichte* [history] means that which takes its course inasmuch as it is prepared and disposed in such and such a way, i.e., set in order and sent forth, destined. Historiography is the exploration of history. But historiographical observation does not first create history itself. Everything "historiographical," everything represented and established after the manner of historiography, is historical [*geschichtlich*], i.e., grounded upon the destining resident in happening. But history is never necessarily historiographical.

Whether history reveals itself in its essence only through and for historiography or whether it is not rather concealed through historiographical objectification remains for the science of history something it cannot itself decide. This, however, *is* decided: In the theory of historiography, history holds sway as that which is not to be gotten around.

Philology makes the literature of nations and peoples into the object of its explanation and interpretation. The written word of literature is at any given time the spoken word of a language. When philology deals with language, it treats it in accordance with the objective ways of looking at language that are established through grammar, etymology, and comparative linguistics, through the art of composition and poetics.

Yet language speaks without becoming literature and entirely independently of whether literature for its part attains to the objectness with which the determinations of a literary science correspond. In the theory of philology language holds sway as that which is not to be gotten around.

Nature, man, history, language, all remain for the aforementioned sciences that which is not to be gotten around, already holding sway from within the objectness belonging to them—remain that toward which at any given time those sciences are directed, but that which, in the fullness of its coming to

presence, they can never *encompass* by means of their representing.[28] This impotence of the sciences is not grounded in the fact that their entrapping securing never comes to an end; it is grounded rather in the fact that in principle the objectness in which at any given time nature, man, history, language, exhibit themselves always itself remains only *one* kind of presencing, in which indeed that which presences can appear, but never absolutely must appear.

That which is not to be gotten around, as characterized above, holds sway in the essence of every science. Is this, then, the inconspicuous state of affairs that we should like to bring into view? Yes and no. Yes, inasmuch as that which is not to be gotten around belongs to the state of affairs referred to; no, insofar as what is not to be gotten around, as mentioned above, of itself alone still does not constitute that state of affairs. This is already evident in the fact that what is not to be gotten around still itself occasions a further essential question.

That which is not to be gotten around holds sway in the essence of science. Accordingly, it would have to be expected that science itself could find present within itself that which is not to be gotten around, and could define it as such. But it is precisely this that does not come about, and indeed because anything like it is essentially impossible. What is the basis for our knowing this? If the sciences themselves should at any time be able to find at hand within themselves what is not to be gotten around of which we are speaking, they would have before all else to be in a position to conceive and represent their own essence. But they are never in a position to do this.

Physics as physics can make no assertions about physics. All the assertions of physics speak after the manner of physics. Physics itself is not a possible object of a physical experiment. The same holds for philology. As the theory of language and literature, philology is never a possible object of philological observation. This is equally the case for every science.

Nevertheless, an objection could arise. Historiography, as a science, has a history as do all the rest of the sciences. Thus the science of history is able to observe itself in the sense of apply-

28. *durch ihr Vorstellen nie um-stellen können.*

ing its own method and thematic procedure to itself. To be sure.
Through such observation, historiography grasps the history of
the science that it itself is. But through doing this historiography
never grasps its essence as historiography, i.e., as a science. If
we want to assert something about mathematics as theory, then
we must leave behind the object-area of mathematics, together
with mathematics' own way of representing. We can never
discover through mathematical reckoning what mathematics
itself is.

It remains the case, then, that the sciences are not in a position
at any time to represent themselves to themselves, to set them-
selves before themselves, by means of their theory and through
the modes of procedure belonging to theory.

If it is entirely denied to science scientifically to arrive at its
own essence, then the sciences are utterly incapable of gaining
access to that which is not to be gotten around holding sway in
their essence.

Here something disturbing manifests itself. That which in the
sciences is not at any time to be gotten around—nature, man,
history, language—is, *as* that which is not to be gotten around
[*Unumgängliche*], intractable and inaccessible [*unzugänglich*]
for the sciences and through the sciences.[29]

Only when we also pay heed to this inaccessibility of that
which is not to be gotten around does that state of affairs come
into view which holds complete sway throughout the essence
of science.

But why do we call that which is inaccessible and not to be
gotten around the inconspicuous [*unscheinbare*] state of affairs?[30]

29. *Unumgängliche* and *unzugänglich* are built on the stem of the verb
gehen (to go). In this passage Heidegger uses several forms of *gehen* itself:
eingehen (to arrive at), *zugehen* (to gain access to), *gehen* (to move), *über-
gehen* (to pass over). And subsequently *das Übergangene*, translated with
"that which is passed over," will also be used. In most cases it has been
impossible to translate these words so as to show the close connection
existing among them. Hence this passage carries in the German a force
arising out of repetition, which the translation cannot reproduce. And it
evinces, in that repetition, the interrelated unitariness of that about which
Heidegger is speaking.

30. *Unscheinbar* means literally, "not shining," "not bright." The verb in
the sentence that follows here, *auffallen*, means not only to strike as strange,
but first of all, to fall upon, to fall open. Heidegger clearly intends hat the

The inconspicuous does not strike us as strange. It may be seen, yet without being particularly heeded. Does the state of affairs shown us in the essence of science remain unnoticed only because we think too little and too seldom on the essence of science? *That* scarcely anyone could justifiably maintain. On the contrary, many evidences speak for the fact that, not only through physics but through all the sciences, there moves a strange restiveness. Before this, however, in past centuries of intellectual and scientific history in the West, attempts to delimit and define the essence of science have made themselves felt again and again. The passionate and incessant troubling over this is therefore above all a fundamental characteristic of modern times. How, then, could that state of affairs remain unheeded? Today we speak of "the crisis at the foundations" of the sciences. That crisis, in fact, touches only the fundamental concepts of the individual sciences. It is in no way a crisis of science as such. Today science goes its way more securely than ever before.

That which is inaccessible and not to be gotten around, which holds sway throughout the sciences and in that way renders their essence enigmatic, is, however, something far more, i.e., something essentially other, than a mere unsureness in the providing of fundamental concepts by means of which at any given time an area is placed in association with the sciences. Thus the restiveness in the sciences extends far beyond the mere precariousness of their fundamental concepts. We are restive in the sciences and yet cannot say for what reason or to what end, despite multifarious discussions about the sciences. Today we philosophize about the sciences from the most diverse standpoints. Through such philosophical efforts, we fall in with the self-exhibiting that is everywhere being attempted by the sciences themselves in the form of synthetic résumés and through the recounting of the history of science.

But for all that, what is inaccessible and not to be gotten around remains in inconspicuousness. Therefore the inconspicuousness of the state of affairs cannot lie only in the fact that it

meanings that the translation here displays should be heard as primary in these two words at this point. But at the same time both also contain connotations of self-manifestation, which he will bring out as the discussion proceeds.

does not astound *us* and that *we* do not notice it. The incon-
spicuousness of the state of affairs, its failure to shine forth, is
grounded rather in the fact that it, of itself, does not come to
appearance. The fact that that which is inaccessible and not to be
gotten around is continually passed over depends on it itself as
such. Inasmuch as such inconspicuousness is a fundamental
characteristic of the aforementioned state of affairs itself, the
latter is defined adequately only when we say:

The state of affairs that holds sway throughout the essence
of science, i.e., throughout the theory of the real, is that which is
inaccessible and not to be gotten around, which is constantly
passed over.[31]

The inconspicuous state of affairs conceals itself in the sciences.
But it does not lie in them as an apple lies in a basket. Rather
we must say: The sciences, for their part, lie in the incon-
spicuous state of affairs as the river lies in its source.

Our aim was to point to that state of affairs, in order that it
itself might beckon us into the region from out of which stems
the essence of science.

What have we achieved? We have become attentive to that
which is inaccessible and not to be gotten around, which is con-
stantly passed over. It shows itself to us in [*an*] the objectness
into which the real sets itself forth and through whose whole ex-
tent theory entraps objects in order, for the sake of representa-
tion, to secure those objects and their coherence in the object-area
of a particular science at a particular time. The inconspicuous
state of affairs holds sway throughout the objectness in which the
reality of the real as well as the theory of the real moves freely,
and in which consequently the entire essence, the coming to pres-
ence, of the modern science of this new era moves freely also.

We shall be satisfied with having pointed to the inconspicuous
state of affairs. To bring out what it is in itself would require
that we pose further questions. Through this pointing to the in-
conspicuous state of affairs we are, however, directed onto a
way that brings us before that which is worthy of questioning.
In contradistinction to all that is merely questionable, as well as
to everything that is "without question," that which is worthy

31. *das stets übergangene unzugängliche Unumgängliche.*

of questioning alone affords, from out of itself, the clear impetus and untrammeled pause through which we are able to call toward us and call near that which addresses itself to our essence.[32] Traveling in the direction that is a way toward that which is worthy of questioning is not adventure but homecoming.

To follow a direction that is the way that something has, of itself, already taken is called, in our language, *sinnan, sinnen* [to sense]. To venture after sense or meaning [*Sinn*] is the essence of reflecting [*Besinnen*]. This means more than a mere making conscious of something. We do not yet have reflection when we have only consciousness. Reflection is more. It is calm, self-possessed surrender to that which is worthy of questioning.

Through reflection so understood we actually arrive at the place where, without having experienced it and without having seen penetratingly into it, we have long been sojourning. In reflection we gain access to a place from out of which there first opens the space traversed at any given time by all our doing and leaving undone.

Reflection is of a different essence from the making conscious and the knowing that belong to science; it is of a different essence also from intellectual cultivation [*Bildung*]. The word *bilden* [to form or cultivate] means first: to set up a preformed model [*Vor-bild*] and to set forth a preestablished rule [*Vor-schrift*]. It means, further, to give form to inherent tendencies. Intellectual cultivation brings before man a model in the light of which he shapes and improves all that he does. Cultivating the intellect requires a guiding image rendered secure in advance, as well as a standing-ground fortified on all sides. The putting forward of a common ideal of culture and the rule of that ideal presuppose a situation and bearing of man that is not in question and that is secured in every direction. This presupposition, for its part, must be based on a belief in the invincible power of an immutable reason and its principles.

As over against this, reflection first brings us onto the way

32. In this sentence the reader will recognize, although in a very different guise, a portrayal much like that which Heidegger gives in "The Turning" of the manifesting, freeing, restoring, that may take place from *within* and *for* Being—as the Being of whatever is—and for man in the coming to presence of modern technology.

toward the place of our sojourning. This sojourning is constantly a historical sojourning—i.e., one allotted to us—no matter whether we represent, analyze, and classify it historiographically or whether we believe that we can artificially detach ourselves from history by means of a merely voluntary turning away from historiography.

How and by what means our historical sojourn adds to and enlarges the dwelling proper to it[33]—about this, reflection can decide nothing directly.

The age of intellectual cultivation is coming to an end, not because the uncultured are gaining the ascendancy, but because the signs are appearing of a world-age in which that which is worthy of questioning will someday again open the door that leads to what is essential in all things and in all destinings.

We will respond to the claim from afar, to the claim of the prevailing demeanor [des Verhaltens] of that world-age, when we begin to reflect by venturing onto the way already taken by that state of affairs [Sachverhalt] which shows itself to us in the essence of science—though not only there.

Nevertheless, reflection remains more provisional, more forbearing and poorer in relation to its age than is the intellectual cultivation that was fostered earlier. Still, the poverty of reflection is the promise of a wealth whose treasures glow in the resplendence of that uselessness which can never be included in any reckoning.

The ways of reflection constantly change, ever according to the place on the way at which a path begins, ever according to the portion of the way that it traverses, ever according to the distant view that opens along the way into that which is worthy of questioning.

Even if the sciences, precisely in following their ways and using their means, can never press forward to the essence of science, still every researcher and teacher of the sciences, every

33. *sein wohnen an- und ausbaut.* Like the verb *bilden* (to form) used above, *bauen* (to build) has as one of its meanings to cultivate. In using *bauen* in these compounds (*anbaut,* "adds to"; *ausbaut,* "enlarges") in the midst of his juxtaposing of intellectual cultivation and reflection, Heidegger undoubtedly intends that *bauen* point up that contrast—an intention that has been impossible to preserve in the translation.

man pursuing a way through a science, can move, as a thinking being,[34] on various levels of reflection and can keep reflection vigilant.

Yet even there where once, through a special favor, the highest level of reflection might be attained, reflection would have to be content only with preparing a readiness for the exhortation and consolation that our human race today needs.

Reflection is not needed, however, in order that it may remove some chance perplexity or break down an antipathy to thinking. Reflection is needed as a responding that forgets itself in the clarity of ceaseless questioning away at the inexhaustibleness of That which is worthy of questioning—of That from out of which, in the moment properly its own, responding loses the character of questioning and becomes simply saying.

34. *als denkenden Wesen.*